E. H. GOMBRICH

MEDITATIONS

ON A HOBBY HORSE

MEDITATIONS
ON A HOBBY HORSE

AND OTHER ESSAYS

ON THE THEORY OF ART

BY

E·H·GOMBRICH

WITH 140 ILLUSTRATIONS

PHAIDON · LONDON AND NEW YORK

PHAIDON PRESS LIMITED, 5 CROMWELL PLACE, LONDON SW7

PUBLISHED IN THE UNITED STATES OF AMERICA BY
PHAIDON PUBLISHERS, INC.
AND DISTRIBUTED BY PRAEGER PUBLISHERS INC.,
III FOURTH AVENUE, NEW YORK, N.Y. 10003

FIRST PUBLISHED IN VOLUME FORM 1963
REPRINTED 1965
SECOND EDITION 1971

ISBN 0 7148 1258 7 (CLOTH)
ISBN 0 7148 1493 8 (PAPER)
LIBRARY OF CONGRESS CATALOG CARD NUMBER: 64-1059

PRINTED IN GREAT BRITAIN BY BUTLER & TANNER LIMITED
FROME AND LONDON

CONTENTS

PREFACE

WRITTEN at different times and for a variety of purposes, the papers, lectures and articles assembled in this volume still, I hope, have more in common than their authorship. They all represent an historian's reactions to problems raised by the art of his time. Twentieth-century criticism centres on two main issues—abstraction and expression. The former is usually discussed in its relation to representation, the latter in its twin aspects of self-expression and of the expression of the age. These are the themes which will be found recurring in the pages of this volume. For all its old-fashioned look the hobby horse was sired out of history by contemporary art.

To indicate this common pre-occupation in the title proved less easy. The term 'the theory of art', which I have used for this purpose, has caused me some misgivings, for I realize that it has not been as fully naturalized in English as were the equivalent terms in Italian, French and German. But these misgivings were somewhat allayed when I remembered that a great critic and master of English, Roger Fry, deplored the absence of such a term from the language. When giving his Inaugural Lecture as Slade Professor of Fine Art in Cambridge in 1933, Fry remarked on the significance of the fact 'that we have no convenient word by which to designate that body of studies which the Germans call *Kunstforschung*—a body of studies of which actual history of Art is only a part'.

Terminology does not much matter here. It is hardly the German term *Kunstforschung* which fully applies, but another word, perhaps even less euphonious to English ears, *Kunstwissenschaft* (literally the science of art). Its very composition states the claim of its practitioners to operate on the same level of abstraction and precision as do the other scientists. It is for this reason that I chose to adopt the term 'the theory of art' rather than aesthetics or criticism. For though this book happens to contain many passages in which I take issue with certain favourite tenets of German *Kunstwissenschaft* (including tenets about the nature of science) such criticism should not obscure my debt to this tradition. I still think that Roger Fry was right when he spoke of our 'crying need for systematic study in which scientific methods will be followed wherever possible, where at all events the scientific attitude may be fostered and the sentimental attitude discouraged'.

He was doubly right when he stressed that this study needs the co-operation of many sciences and should be 'inextricably interwoven' with Anthropology, the History of Religion and with Classics, being also 'at many points in close

ix

touch with Psychology'. It sounds a daunting programme and indeed no student of the theory of art would ever claim to be at home in all these fields. His ambition is merely to formulate his results in such a way that they lose something of their idiosyncratic and esoteric character and become accessible to his colleagues in other departments, just as he tries to benefit from their accessible findings.

The essays in this volume, then, strive to conform to this ideal of intellectual co-operation. It is natural that this should be so, for at least thirteen of the fourteen were written in response to specific requests to join, in one way or another, in debates which extend beyond the narrow confines of a specialist's field. Four were contributions to 'symposia' of the non-drinking variety in which topical problems were to be discussed by representatives of various disciplines. I am deeply grateful to their imaginative and enterprising organizers for inviting an historian of art thus to exchange ideas with philosophers, psychologists, artists and scientists.

The three lectures reprinted here were also composed for occasions of the more formal kind which involve an obligation to publish, and the need to select a theme that can interest an academic audience drawn from various faculties. Two of the articles, on the other hand, were commissioned by widely read American magazines and thus deal with questions that concern us all—the status and success of recent artistic experiments. I hope they will be found to be nicely balanced, for while the essay on the *Vogue of Abstract Art* critically dissects the social conditions that have led to the eager acceptance of an art form that has still to prove its potentialities, the paper on *Illusion and Visual Deadlock* draws attention to exciting discoveries which we owe to the artistic movements of the last fifty years.

Finally there are the four review articles, that is the debates with individual authors. The inclusion, in particular, of dissenting opinions may need a word of explanation. It would hardly be justified to resuscitate harsh words about a book which was not in my opinion worth writing. But this is emphatically not the case here. Mr. Arnold Hauser's *Social History of Art* constitutes the most considered application of dialectical materialism to the history of art, and the questions of method which it raises certainly transcend any personal polemic. In fact the specific criticism of this approach which I felt compelled to make does not apply to the author's subsequent book on the *Philosophy of Art History*. If Mr. Hauser thus afforded me the opportunity of defining my attitude towards the 'Hegelian left' M. Malraux now represents the 'Hegelian right'; the continued influence of this philosophy (with which I am also concerned in other essays) seems to me of sufficient importance to justify the reprinting of a critical analysis of his *Voices of Silence* which should not obscure my respect for many of its insights. I trust that

the inclusion of a review of Mr. Sterling's standard work on *Still Life Painting* will even less be taken as an attack against a colleague whose scholarship and perceptiveness I profoundly admire. It so happens, however, that the subject of his book provided a welcome challenge to examine another influential theory concerning the nature of art, Benedetto Croce's aesthetics.

The odd-man-out in this collection is an article on *Achievement in Medieval Art* which I wrote in 1935, shortly before leaving my native Vienna to take up employment with the Warburg Institute in London. It, too, starts from a critical discussion, but an unsolicited one. It was sparked off by a thought-provoking article by the late Ernst von Garger, one of the most vigorous and unconventional students of these problems it has been my good fortune to meet. On re-reading my response after so many years I realized how frequently I have since returned to the questions which irked me at the age of twenty-six.

To some extent this applies to all the issues raised in these pages. The title essay formed the starting point for my book on *Art and Illusion* (New York and London 1960), where some of its themes are taken up in the chapter on 'Pygmalion's Power', The concluding chapter of that book, on the other hand, which deals with the topic of expression, supplements some of the papers previously written and is elaborated in its turn in several essays published in and after that year. I am afraid I have still not finished with any of these questions. I still regard them as open, and I hope to continue the debate as opportunity offers. It is mainly for this reason that I have resisted the temptation to revise and supplement my formulations beyond the restoration of a few passages cut by editors and the elimination of a few factual, grammatical or logical errors to which my attention was drawn by my kind editor, Dr. Michael Podro, who also undertook the selection and arrangement, translated the early paper which was originally written in German, and compiled the index. Without his interest and help this volume could not have taken shape.

In dedicating this volume to the memory of Dr. Horovitz I have thought not only of my debt to the publisher of *The Story of Art*, who set an entirely fresh standard in the production of art books accessible to a wider public. I have also remembered one of our first conversations on the top of a London bus when we had both begun to discover the pitfalls and powers of English prose and he recommended Bacon's essays to me, while I drew his attention to David Hume's. We later discussed the form which my studies in the theory of art should take, and he advised me to treat the subject 'like mathematics'. I do not think that I have lived up to this ideal, but I should like to believe that he would not have disapproved of his successor's sponsorship of this collection.

It is to this successor, Mr. H. I. Miller, finally, that I want to express my thanks for his intention to let this volume be followed in due course by a similar collection of papers on historical topics; studies, that is, which are less concerned with the issues of 'my time' than with those of 'my period'—the Italian Renaissance. For in a sense the two belong together and may therefore illuminate each other. In fact I was glad to see that it was not always easy to decide in which of the two categories an individual study belonged. The discussions of still life, and of cartoons, for instance, which are included in the present volume, draw much on historical evidence, while some of the essays still to be published apply ideas developed here. How could it be otherwise? The Warburg Institute, with which I have been connected for most of my working life, has always been committed to the breaking down of conventional barriers between the so-called departments of study. The very arrangement of its library and the composition of its staff suggest a permanent 'symposium' on the changing significance of the classical heritage in Western Civilization, and thus its historical studies have always remained responsive to the questionings of the living. This does not mean that I do not especially enjoy the moments when I can dismount from my hobby horse and seek the peaceful haven of the book-stacks. Without this comforting contact with the past I, for one, would not want to face the demands and distractions of the present.

July 1963 E. H. GOMBRICH

Meditations on a Hobby Horse
or the Roots of Artistic Form

THE subject of this article is a very ordinary hobby horse. It is neither meta-
phorical nor purely imaginary, at least not more so than the broomstick on
which Swift wrote his meditations. It is usually content with its place in the corner
of the nursery and it has no aesthetic ambitions. Indeed it abhors frills. It is satisfied
with its broomstick body and its crudely carved head which just marks the upper
end and serves as holder for the reins. How should we address it? Should we
describe it as an 'image of a horse'? The compilers of the *Pocket Oxford Dictionary*
would hardly have agreed. They defined *image* as 'imitation of object's external
form' and the 'external form' of a horse is surely not 'imitated' here. So much the
worse, we might say, for the 'external form', that elusive remnant of the Greek
philosophical tradition which has dominated our aesthetic language for so long.
Luckily there is another word in the *Dictionary* which might prove more accom-
modating: *representation*. To *represent*, we read, can be used in the sense of 'call
up by description or portrayal or imagination, figure, place likeness of before mind
or senses, serve or be meant as likeness of . . . stand for, be specimen of, fill place
of, be substitute for'. A portrayal of a horse? Surely not. A substitute for a horse?
Yes. That it is. Perhaps there is more in this formula than meets the eye.

I

LET us first ride our wooden steed into battle against a number of ghosts which
still haunt the language of art criticism. One of them we even found entrenched in
the *Oxford Dictionary*. The implication of its definition of an image is that the artist
'imitates' the 'external form' of the object in front of him, and the beholder,
in his turn, recognizes the 'subject' of the work of art by this 'form'. This is what
might be called the traditional view of representation. Its corollary is that a work
of art will either be a faithful copy, in fact a complete replica, of the object repre-
sented, or will involve some degree of 'abstraction'. The artist, we read, abstracts
the 'form' from the object he sees. The sculptor usually abstracts the three-
dimensional form, and abstracts *from* colour; the painter abstracts contours and
colours, and *from* the third dimension. In this context one hears it said that the
draughtsman's line is a 'tremendous feat of abstraction' because it does not 'occur in
nature'. A modern sculptor of Brancusi's persuasion may be praised or blamed for

This essay was originally written as a contribution to *Aspects of Form, A Symposium on
Form in Nature and Art*, ed. L. L. Whyte, London 1951.

'carrying abstraction to its logical extreme'. Finally the label of 'abstract art' for the creation of 'pure' forms carries with it a similar implication. Yet we need only look at our hobby horse to see that the very idea of abstraction as a complicated mental act lands us in curious absurdities. There is an old music hall joke describing a drunkard who politely lifts his hat to every lamp-post he passes. Should we say that the liquor has so increased his power of abstraction that he is now able to isolate the formal quality of uprightness from both lamp-post and the human figure? Our mind, of course, works by differentiation rather than by generalization, and the child will for long call all four-footers of a certain size 'gee-gee' before it learns to distinguish breeds and 'forms'![1]

II

THEN there is that age-old problem of universals as applied to art. It has received its classical formulation in the Platonizing theories of the Academicians. 'A history-painter,' says Reynolds, 'paints man in general; a portrait-painter a particular man, and therefore a defective model.'[2] This, of course, is the theory of abstraction applied to one specific problem. The implications are that the portrait, being an exact copy of a man's 'external form' with all 'blemishes' and 'accidents', refers to the individual person exactly as does the proper name. The painter, however, who wants to 'elevate his style' disregards the particular and 'generalizes the forms'. Such a picture will no longer represent a particular man but rather the class or concept 'man'. There is a deceptive simplicity in this argument, but it makes at least one unwarranted assumption: that every image of this kind necessarily refers to something outside itself—be it individual or class. But nothing of the kind need be implied when we point to an image and say 'this is a man'. Strictly speaking that statement may be interpreted to mean that the image itself is a member of the class 'man'. Nor is that interpretation as farfetched as it may sound. In fact our hobby horse would submit to no other interpretation. By the logic of Reynolds's reasoning it would have to represent the most generalized idea of horseness. But if the child calls a stick a horse it obviously means nothing of the kind. The stick is neither a sign signifying the concept horse nor is it a portrait of an individual horse. By its capacity to serve as a 'substitute' the stick becomes a horse in its own right, it belongs in the class of 'gee-gees' and may even merit a proper name of its own.

When Pygmalion blocked out a figure from his marble he did not at first represent a 'generalized' human form, and then gradually a particular woman. For as he chipped away and made it more lifelike the block was not turned into a portrait—not even in the unlikely case that he used a live model. So when his prayers were heard and the statue came to life she was Galatea and no one else—and that

regardless of whether she had been fashioned in an archaic, idealistic, or naturalistic style. The question of reference, in fact, is totally independent of the degree of differentiation. The witch who made a 'generalized' wax dummy of an enemy may have meant it to refer to someone in particular. She would then pronounce the right spell to establish this link—much as we may write a caption under a generalized picture to do the same. But even those proverbial replicas of nature, Madame Tussaud's effigies, need the same treatment. Those in the galleries which are labelled are 'portraits of the great'. The figure on the staircase made to hoax the visitor simply represents 'an' attendant, one member of a class. It stands there as a 'substitute' for the expected guard—but it is not more 'generalized' in Reynolds's sense.

III

THE idea that art is 'creation' rather than 'imitation' is sufficiently familiar. It has been proclaimed in various forms from the time of Leonardo, who insisted that the painter is 'Lord of all Things',[3] to that of Klee, who wanted to create as Nature does.[4] But the more solemn overtones of metaphysical power disappear when we leave art for toys. The child 'makes' a train either of a few blocks or with pencil on paper. Surrounded as we are by posters and newspapers carrying illustrations of commodities or events, we find it difficult to rid ourselves of the prejudice that all images should be 'read' as referring to some imaginary or actual reality. Only the historian knows how hard it is to look at Pygmalion's work without comparing it with nature. But recently we have been made aware how thoroughly we misunderstand primitive or Egyptian art whenever we make the assumption that the artist 'distorts' his motif or that he even wants us to see in his work the record of any specific experience.[5] In many cases these images 'represent' in the sense of being substitutes. The clay horse or servant, buried in the tomb of the mighty, takes the place of the living. The idol takes the place of the god. The question whether it represents the 'external form' of the particular divinity or, for that matter, of a class of demons is quite inappropriate. The idol serves as the substitute of the God in worship and ritual—it is a man-made god in precisely the sense that the hobby horse is a man-made horse; to question it further means to court deception.[6]

There is another misunderstanding to be guarded against. We often try instinctively to save our idea of 'representation' by shifting it to another plane. Where we cannot refer the image to a motif in the outer world we take it to be a portrayal of a motif in the artist's inner world. Much critical (and uncritical) writing on both primitive and modern art betrays this assumption. But to apply the naturalistic idea of portrayal to dreams and visions—let alone to unconscious images—begs a whole number of questions.[7] The hobby horse does not portray our idea of a horse.

The fearsome monster or funny face we may doodle on our blotting pad is not projected out of our mind as paint is 'ex-pressed' out of a paint tube. Of course any image will be in some way symptomatic of its maker, but to think of it as of a photograph of a pre-existing reality is to misunderstand the whole process of image-making.

IV

CAN our substitute take us further? Perhaps, if we consider how it could become a substitute. The 'first' hobby horse (to use eighteenth-century language) was probably no image at all. Just a stick which qualified as a horse because one could ride on it (Fig. 1). The *tertium comparationis*, the common factor, was function rather than form. Or, more precisely, that formal aspect which fulfilled the minimum requirement for the performance of the function—for any 'ridable' object could serve as a horse. If that is true we may be enabled to cross a boundary which is usually regarded as closed and sealed. For in this sense 'substitutes' reach deep into biological functions that are common to man and animal. The cat runs after the ball as if it were a mouse. The baby sucks its thumb as if it were the breast. In a sense the ball 'represents' a mouse to the cat, the thumb a breast to the baby. But here too 'representation' does not depend on formal similarities, beyond the minimum requirements of function. The ball has nothing in common with the mouse except that it is chasable. The thumb nothing with the breast except that it is suckable. As 'substitutes' they fulfill certain demands of the organism. They are keys which happen to fit into biological or psychological locks, or counterfeit coins which make the machine work when dropped into the slot.

In the language of the nursery the psychological function of 'representation' is still recognized. The child will reject a perfectly naturalistic doll in favour of some monstrously 'abstract' dummy which is 'cuddly'. It may even dispose of the element of 'form' altogether and take to a blanket or an eiderdown as its favourite 'comforter'—a substitute on which to bestow its love. Later in life, as the psychoanalysts tell us, it may bestow this same love on a worthy or unworthy living substitute. A teacher may 'take the place' of the mother, a dictator or even an enemy may come to 'represent' the father. Once more the common denominator between the symbol and the thing symbolized is not the 'external form' but the function; the mother symbol would be lovable, the father-imago fearable, or whatever the case may be.

Now this psychological concept of symbolization seems to lead so very far away from the more precise meaning which the word 'representation' has acquired in the figurative arts. Can there be any gain in throwing all these meanings together? Possibly: for anything seems worth trying, to get the function of symbolizing out of its isolation.

The 'origin of art' has ceased to be a popular topic. But the origin of the hobby horse may be a permitted subject for speculation. Let us assume that the owner of the stick on which he proudly rode through the land decided in a playful or magic mood—and who could always distinguish between the two?—to fix 'real' reins and that finally he was even tempted to 'give' it two eyes near the top end. Some grass could have passed for a mane. Thus our inventor 'had a horse'. He had made one. Now there are two things about this fictitious event which have some bearing on the idea of the figurative arts. One is that, contrary to what is sometimes said, communication need not come into this process at all. He may not have wanted to show his horse to anyone. It just served as a focus for his fantasies as he galloped along—though more likely than not it fulfilled this same function for a tribe to which it 'represented' some horse-demon of fertility and power.[8] We may sum up the moral of this 'Just So Story' by saying that substitution may precede portrayal, and creation communication. It remains to be seen how such a general theory can be tested. If it can, it may really throw light on some concrete questions. Even the origin of language, that notorious problem of speculative history,[9] might be investigated from this angle. For what if the 'pow-wow' theory, which sees the root of language in imitation, and the 'pooh-pooh' theory, which sees it in emotive interjection, were to be joined by yet another? We might term it the 'niam-niam' theory postulating the primitive hunter lying awake through hungry winter nights and making the sound of eating, not for communication but as a substitute for eating—being joined, perhaps, by a ritualistic chorus trying to conjure up the phantasm of food.

V

THERE is one sphere in which the investigation of the 'representational' function of forms has made considerable progress of late, that of animal psychology. Pliny, and innumerable writers after him, have regarded it as the greatest triumph of naturalistic art for a painter to have deceived sparrows or horses. The implication of these anecdotes is that a human beholder easily recognizes a bunch of grapes in a painting because for him recognition is an intellectual act. But for the birds to fly at the painting is a sign of a complete 'objective' illusion. It is a plausible idea, but a wrong one. The merest outline of a cow seems sufficient for a tsetse trap, for somehow it sets the apparatus of attraction in motion and 'deceives' the fly. To the fly, we might say, the crude trap has the 'significant' form—biologically significant, that is. It appears that visual stimuli of this kind play an important part in the animal world. By varying the shapes of 'dummies' to which animals were seen to respond, the 'minimum image' that still sufficed to release a specific reaction has been ascertained.[10] Thus little birds will open their beak when they see the feeding

parent approaching the nest, but they will also do so when they are shown two darkish roundels of different size, the silhouette of the head and body of the bird 'represented' in its most 'generalized' form. Certain young fishes can even be deceived by two simple dots arranged horizontally, which they take to be the eyes of the mother fish, in whose mouth they are accustomed to shelter against danger. The fame of Zeuxis will have to rest on other achievements than his deception of birds.

An 'image' in this biological sense is not an imitation of an object's external form but an imitation of certain privileged or relevant aspects. It is here that a wide field of investigation would seem to open. For man is not exempt from this type of reaction.[11] The artist who goes out to represent the visible world is not simply faced with a neutral medley of forms he seeks to 'imitate'. Ours is a structured universe whose main lines of force are still bent and fashioned by our biological and psychological needs, however much they may be overlaid by cultural influences. We know that there are certain privileged motifs in our world to which we respond almost too easily. The human face may be outstanding among them. Whether by instinct or by very early training, we are certainly ever disposed to single out the expressive features of a face from the chaos of sensations that surrounds it, and to respond to its slightest variations with fear or joy. Our whole perceptual apparatus is somehow hypersensitized in this direction of physiognomic vision[12] and the merest hint suffices for us to create an expressive physiognomy that 'looks' at us with surprising intensity. In a heightened state of emotion, in the dark, or in a feverish spell, the looseness of this trigger may assume pathological forms. We may see faces in the pattern of a wallpaper, and three apples arranged on a plate may stare at us like two eyes and a clownish nose. What wonder that it is so easy to 'make' a face with two dots and a stroke even though their geometrical constellation may be greatly at variance with the 'external form' of a real head? The well-known graphic joke of the 'reversible face' might well be taken as a model for experiments which could still be made in this direction (Fig. 2). It shows to what extent the group of shapes that can be read as a physiognomy has priority over all other readings. It turns the side which is the right way up into a convincing face and disintegrates the one that is upside down into a mere jumble of forms which is accepted as a strange headgear.[13] In good pictures of this kind it needs a real effort to see both faces at the same time, and perhaps we never quite succeed. Our automatic response is stronger than our intellectual awareness.

Seen in the light of the biological examples discussed above there is nothing surprising in this observation. We may venture the guess that this type of automatic recognition is dependent on the two factors of resemblance and biological relevance, and that the two may stand in some kind of inverse ratio. The greater the biological relevance an object has for us the more will we be attuned to its recognition—and

the more tolerant will therefore be our standards of formal correspondence. In an erotically charged atmosphere the merest hint of formal similarity with sexual functions creates the desired response and the same is true of the dream symbols investigated by Freud. The hungry man will be similarly attuned to the discovery of food—he will scan the world for the slightest promise of nourishment. The starving may even project food into all sorts of dissimilar objects—as Chaplin does in *Gold Rush* when his huge companion suddenly appears to him as a chicken. Can it have been some such experience which stimulated our 'niam-niam' chanting hunters to see their longed-for prey in the patches and irregular shapes on the dark cave walls? Could they perhaps gradually have sought this experience in the deep mysterious recesses of the rocks, much as Leonardo sought out crumbling walls to aid his visual fantasies? Could they, finally, have been prompted to fill in such 'readable' outlines with coloured earth—to have at least something 'spearable' at hand which might 'represent' the eatable in some magic fashion? There is no way of testing such a theory, but if it is true that cave artists often 'exploited' the natural formations of the rocks,[14] this, together with the 'eidetic' character of their works,[15] would at least not contradict our fantasy. The great naturalism of cave paintings may after all be a very late flower. It may correspond to our late, derivative, and naturalistic hobby horse.

VI

I T needed two conditions, then, to turn a stick into our hobby horse: first, that its form made it just possible to ride on it; secondly—and perhaps decisively—that riding mattered. Fortunately it still needs no great effort of the imagination to understand how the horse could become such a focus of desires and aspirations, for our language still carries the metaphors moulded by a feudal past when to be chival-rous was to be horsy. The same stick that had to represent a horse in such a setting would have become the substitute of something else in another. It might have become a sword, sceptre, or—in the context of ancestor worship—a fetish representing a dead chieftain. Seen from the point of view of 'abstraction', such a convergence of meanings onto one shape offers considerable difficulties, but from that of psychological 'projection' of meanings it becomes more easily intelligible. After all a whole diagnostic technique has been built up on the assumption that the meanings read into identical forms by different people tell us more about the readers than about the forms. In the sphere of art it has been shown that the same triangular shape which is the favourite pattern of many adjoining American Indian tribes is given different meanings reflecting the main preoccupations of the peoples concerned.[16] To the student of styles this discovery that one basic form can be made to represent a variety of objects may still become significant. For while the idea of

realistic pictures being deliberately 'stylized' seems hard to swallow, the opposite idea of a limited vocabulary of simple shapes being used for the building up of different representations would fit much better into what we know of primitive art.

VII

ONCE we get used to the idea of 'representation' as a two-way affair rooted in psychological dispositions we may be able to refine a concept which has proved quite indispensable to the historian of art and which is nevertheless rather unsatisfactory: that of the 'conceptual image'. By this we mean the mode of representation which is more or less common to children's drawings and to various forms of primitive and primitivist art. The remoteness of this type of imagery from any visual experience has often been described.[17] The explanation of this fact which is most usually advanced is that the child (and the primitive) do not draw what they 'see' but what they 'know'. According to this idea the typical children's drawing of a manikin is really a graphic enumeration of those human features the child remembered.[18] It represents the content of the childish 'concept' of man. But to speak of 'knowledge' or 'intellectual realism' (as the French do[19]) brings us dangerously near to the fallacy of 'abstraction'. So back to our hobby horse. Is it quite correct to say that it consists of features which make up the 'concept' of a horse or that it reflects the memory image of horses seen? No—because this formulation omits one factor: the stick. If we keep in mind that representation is originally the creation of substitutes out of given material we may reach safer ground. The greater the wish to ride, the fewer may be the features that will do for a horse. But at a certain stage it must have eyes—for how else could it see? At the most primitive level, then, the conceptual image might be identified with what we have called the minimum image—that minimum, that is, which will make it fit into a psychological lock. The form of the key depends on the material out of which it is fashioned, and on the lock. It would be a dangerous mistake, however, to equate the 'conceptual image' as we find it used in the historical styles with this psychologically grounded minimum image. On the contrary. One has the impression that the presence of these schemata is always felt but that they are as much avoided as exploited.[20] We must reckon with the possibility of a 'style' being a set of conventions born out of complex tensions. The man-made image must be complete. The servant for the grave must have two hands and two feet. But he must not become a double under the artist's hands. Image-making is beset with dangers. One false stroke and the rigid mask of the face may assume an evil leer. Strict adherence to conventions alone can guard against such dangers. And thus primitive art seems often to keep on that narrow ledge that lies between the lifeless and the uncanny. If the hobby horse became too lifelike it might gallop away on its own.[21]

VIII

THE contrast between primitive art and 'naturalistic' or 'illusionist' art can easily be overdrawn.[22] All art is 'image-making' and all image-making is rooted in the creation of substitutes. Even the artist of an 'illusionist' persuasion must make the man-made, the 'conceptual' image of convention his starting point. Strange as it may seem he cannot simply 'imitate an object's external form' without having first learned how to construct such a form. If it were otherwise there would be no need for the innumerable books on 'how to draw the human figure' or 'how to draw ships'. Wölfflin once remarked that all pictures owe more to other pictures than they do to nature.[23] It is a point which is familiar to the student of pictorial traditions but which is still insufficiently understood in its psychological implications. Perhaps the reason is that, contrary to the hopeful belief of many artists, the 'innocent eye' which should see the world afresh would not see it at all. It would smart under the painful impact of a chaotic medley of forms and colours.[24] In this sense the conventional vocabulary of basic forms is still indispensable to the artist as a starting point, as a focus of organization.

How, then, should we interpret the great divide which runs through the history of art and sets off the few islands of illusionist styles, of Greece, of China, and of the Renaissance, from the vast ocean of 'conceptual' art?

One difference, undoubtedly, lies in a change of function. In a way the change is implicit in the emergence of the idea of the image as a 'representation' in our modern sense of the word. As soon as it is generally understood that an image need not exist in its own right, that it may refer to something outside itself and therefore be the record of a visual experience rather than the creation of a substitute, the basic rules of primitive art can be transgressed with impunity. No longer is there any need for that completeness of essentials which belongs to the conceptual style, no longer is there the fear of the casual which dominates the archaic conception of art. The picture of a man on a Greek vase no longer needs a hand or a foot in full view (Fig. 4). We know it is meant as a shadow, a mere record of what the artist saw or might see, and we are quite ready to join in the game and to supplement with our imagination what the real motif undoubtedly possessed. Once this idea of the picture suggesting something beyond what is really there is accepted in all its implications—and this certainly did not happen overnight—we are indeed forced to let our imagination play around it. We endow it with 'space' around its forms which is only another way of saying that we understand the reality which it evokes as three-dimensional, that the man could move and that even the aspect momentarily hidden 'was there'.[25] When medieval art broke away from that narrative conceptual symbolism into which the formulas of classical art had been frozen, Giotto made particular use of the figure seen from behind which stimulates our 'spatial' imagination by forcing us to imagine the other side (Fig. 5).

Thus the idea of the picture as a representation of a reality outside itself leads to an interesting paradox. On the one hand it compels us to refer every figure and every object shown to that imaginary reality which is 'meant'. This mental operation can only be completed if the picture allows us to infer not only the 'external form' of every object represented but also its relative size and position. It leads us to that 'rationalization of space' we call scientific perspective by which the picture plane becomes a window through which we look into the imaginary world the artist creates there for us. In theory, at least, painting is then conceived in terms of geometrical projection.[26]

The paradox of the situation is that, once the whole picture is regarded as the representation of a slice of reality, a new context is created in which the conceptual image plays a different part. For the first consequence of the 'window' idea is that we cannot conceive of any spot on the panel which is not 'significant', which does not represent something. The empty patch thus easily comes to signify light, air, and atmosphere, and the vague form is interpreted as enveloped by air. It is this confidence in the representational context which is given by the very convention of the frame, which makes the development of impressionist methods possible. The artists who tried to rid themselves of their conceptual knowledge, who conscientiously became beholders of their own work and never ceased matching their created images against their impressions by stepping back and comparing the two—these artists could only achieve their aim by shifting something of the load of creation on to the beholder. For what else does it mean if we are enjoined to step back in turn and watch the coloured patches of an impressionist landscape 'spring to life'? It means that the painter relies on our readiness to take hints, to read contexts, and to call up our conceptual image under his guidance. The blob in the painting by Manet which stands for a horse is no more an imitation of its external form than is our hobby horse (Fig. 6). But he has so cleverly contrived it that it evokes the image in us—provided, of course, we collaborate.

Here there may be another field for independent investigation. For those 'privileged' objects which play their part in the earliest layers of image-making recur—as was to be expected—in that of image-reading. The more vital the feature that is indicated by the context and yet omitted, the more intense seems to be the process that is started off. On its lowest level this method of 'suggestive veiling' is familiar to erotic art. Not, of course, to its Pygmalion phase, but to its illusionist applications. What is here a crude exploitation of an obvious biological stimulus may have its parallel, for instance, in the representation of the human face. Leonardo achieved his greatest triumphs of lifelike expression by blurring precisely the features in which the expression resides, thus compelling us to complete the act of creation. Rembrandt could dare to leave the eyes of his most moving portraits in the shade because we are thus stimulated to supplement them[27] (Fig. 7). The 'evocative'

image, like its 'conceptual' counterpart, should be studied against a wider psychological background.

IX

MY hobby horse is not art. At best it can claim the attention of iconology, that emerging branch of study which is to art criticism what linguistics is to the criticism of literature. But has not modern art experimented with the primitive image, with the 'creation' of forms, and the exploitation of deep-rooted psychological forces? It has. But whatever the nostalgic wish of their makers, the meaning of these forms can never be the same as that of their primitive models. For that strange precinct we call 'art' is like a hall of mirrors or a whispering gallery. Each form conjures up a thousand memories and after-images. No sooner is an image presented as art than, by this very act, a new frame of reference is created which it cannot escape. It becomes part of an institution as surely as does the toy in the nursery. If—as might be conceivable—a Picasso would turn from pottery to hobby horses and send the products of this whim to an exhibition, we might read them as demonstrations, as satirical symbols, as a declaration of faith in humble things or as self-irony—but one thing would be denied even to the greatest of contemporary artists: he could not make the hobby horse mean to us what it meant to its first creator. That way is barred by the angel with a flaming sword.

Visual Metaphors of Value in Art

I. *Code and Metaphor*

THIS paper is concerned with the peculiar way or ways in which artistic experiences have come for many of us to stand for, embody, or express some of the highest values, including moral values.[1]

As I shall be concerned mainly with the way colours and contours have been handled, in the historical past, to evoke a sense of these values, my subject may be described as 'visual metaphors of value'. This use of the term 'metaphor' may be in need of some preliminary justification. If we take the classical, Aristotelian, definition of metaphor, the term can apply only to a figure of speech: "When Homer says that Achilles 'Leapt on his foes like a lion' it is a simile; but when he says 'he leapt, a lion, on his foes' it is a metaphor."[2] This is a distinction which must, of necessity, disappear in the realm of the visual arts. Thus we may say that when Thorwaldsen designed his once famous memorial for the Swiss guards who were killed during the French Revolution, the 'Lion of Lucerne', he wanted to convey in visual terms 'they died like lions' or 'they died, lions'. We are used to saying in such a context that the lion is a *symbol* of courage, but there are reasons to prefer the term 'metaphor'.[3] The organizers of this Conference have asked us to leave symbols that function as pure signs out of consideration. Yet this is precisely what the word 'symbol' has frequently come to mean in art.[4] It is traditionally employed for the distinctive 'emblems' or 'attributes' by which gods, saints, or personifications are distinguished. These symbols are signs which form something like a code laid down by tradition[5]. The attributes of divinities and personifications were recorded and explained in special manuals. Most frequently such attributes are derived from the residue of an illustrative context—Jupiter carries the thunderbolt, because he is recognizable as the thunderer, St. Catherine the wheel because it is her distinctive instrument of martyrdom, and Charity children who provide a minimum opportunity for exercising her special virtue. In contrast to this use of images as labels, the lion—to remain with our example—is not a code-sign. The image of a lion can be used in different contexts, precisely as can any linguistic or visual image, to convey very different ideas. The only thing these ideas usually have in common is that they are derived from such traditional lore about the lion as is crystallized in bestiaries and fable. It is this lore which defines what may be called the area of metaphor. Which of these qualities we decide to use, however, depends largely on our wish and whim. In one context we may want to convey the idea of nobility

This paper was written for a symposium entitled *Symbols and Values*, in New York in 1952.

traditionally associated with the King of Beasts, in another its ferocity, in a third, maybe, some ludicrous aspect as illustrated in the story of the lion fearing the crowing of the cock. Each of these qualities, as the old writers on symbolism well knew, can be isolated and 'transferred' to another object: '*Leo propter aliquam similitudinem significat Christum, et diabolum*', as St. Thomas Aquinas puts it.[6] Returning to Thorwaldsen therefore, we are entitled to say: this is not a code-symbol of the type 'the lion in art means courage'. Rather should we say, 'because of its alleged courage the lion lends itself to being used as a symbol (or metaphor) for heroes'.

It seems important in our context to insist from the outset on this distinction, because the temptation to regard all symbols as codes can be overcome only by being made conscious. The belief that symbols or images can be said to 'have' a meaning (or at the most a polarity of meanings) constantly reappears in different forms.[7] Its latest version is to be found in the writings of C. G. Jung, where it is often implied that certain images are endowed with an intrinsic and constant significance. It is easy to see how this conviction might arise. Freud's discovery of dream symbolism, and the recurrence of similar symbols in folklore and myth, suggested to some interpreters that our unconscious really does use a fixed code for the transmission of its secret desires. If that were so we could speak of meanings 'belonging' to symbols. Once unriddled in any context we would have, as it were, a dictionary meaning, valid for any other context. But the evidence also bears a different interpretation.[8] When anthropologists say 'upright poles are phallic symbols', they may be regarded as using a shorthand label for the longer but more nearly accurate formulation, 'upright poles lend themselves so well to use as phallic symbols that their use for this (conscious or unconscious) purpose is exceedingly widespread'.

In what follows, then, I shall not be concerned with the fixed or conventional visual code-symbols of value, such as they exist in religious ritual, but with visual qualities that lend themselves to symbolic use. A simple example of what I shall call a visual metaphor is the use of the colour red in certain cultural contexts. Red, being the colour of flames and of blood, offers itself as a metaphor for anything that is strident or violent. It is no accident, therefore, that it was selected as the code sign for 'stop' in our traffic code and as a label of revolutionary parties in politics. But though both these applications are grounded on simple biological facts, the colour red itself has no fixed 'meaning'. A future historian or anthropologist, for instance, who wanted to interpret the significance of the label 'red' in politics would get no guidance from his knowledge of our traffic code. Should the colour that denotes 'stop' not stand for the 'conservatives' and green for the go-ahead progressives? And how should he interpret the meaning of the red hat of the cardinal or the Red Cross?

B

II. *Metaphor and Substitution*

THE possibility of metaphor springs from the infinite elasticity of the human mind; it testifies to its capacity to perceive and assimilate new experiences as modifications of earlier ones, of finding equivalences in the most disparate phenomena and of substituting one for another. Without this constant process of substitution neither language nor art, nor indeed civilized life would be possible. Psychoanalysis has made us familiar with the wide range of substitution which enables man to find gratification in goals far removed from his original biological needs. It has shown us, for instance, how the child's attitude toward its mother may be applied and reapplied in changing circumstances to new objects of love. The term 'transference', used by psychoanalysts to describe this process, happens to mean exactly the same as the Greek word '*metapherein*'. In a recent paper[9] I have attempted to show that even an apparently rational artistic process such as visual representation may have its roots in such 'transference' of attitudes from objects of desire to suitable substitutes. The hobby horse is the equivalent of the 'real' horse because it can (metaphorically) be ridden.

It is against this background that we must see our present problem of how, in art, a visual quality may be experienced as the equivalent of a moral value. The metaphors of daily speech may provide a convenient starting point for the study of these equivalences, particularly those which 'transfer' qualities from one sensory experience to another. These so-called synaesthetic metaphors[10] which make us speak of a 'velvet tone', a 'black bass', a 'loud colour', etc., are specially interesting for us, because here no conscious transfer takes place. Somehow in the centre of our minds the qualities of blackness and of a bass voice converge and meet. Similarly, we speak of a loud colour not because we consciously relate a quality of sounds to a visual impression, but because the colour 'strikes us that way', as another vivid metaphor puts it. Now this convergence is inseparable from the experience of values; in fact, biological values constantly lend themselves as ready metaphors for other values. Warmth, sweetness, and light provide us with early and intense experience of gratification, and so we speak of a warm friendship, a sweet child, a shining deed. But other experiences also come into play. Economic value provides the metaphor for 'value' in general. This may be why we start our letters 'Dear Sir'. Social values of the past have faded into metaphors that make us speak of a 'noble' gesture. Values impressed by early education get transferred and applied in figures of speech, such as a 'clean fight', and so on. In all these instances we again have something like synaesthesia. The friendship is *experienced* as 'warm', it 'warms our heart'. If this unity of experience is not merely a matter of words,[11] it allows us to draw two rather useful conclusions. One concerns the 'diagnostic' value of aesthetic vocabulary. As long as criticism has existed, critics have used metaphors to express their

approval or disapproval. They have branded colour combinations as 'vulgar' or exalted forms as 'dignified', have praised the 'honesty' of one artist's palette and rejected the 'meretricious' effects of others. Perhaps these terms in their aggregate tell us more about the aesthetic experience than is usually allowed? For this is the other conclusion that may suggest itself—writers on aesthetics have been at work so long telling us what art is *not*, they have been so anxious to rid art of any heteronomous values, that they have created a rather forbidding void in the centre. The synesthesia of values crystallized in our linguistic habits shows, I believe, that this void is artificial. The vexed question, whether or not aesthetic values may be said to exist 'independently', need not concern us here. What matters is that in our living experience they always find resonance in other areas of value. There was once a historical reason for protesting against a confusion of values in criticism, most of all against a facile confusion of art and morality, but now when this danger no longer exists we should again acknowledge the fact that there are few people who never experience great art in terms of moral values. It will be the principal aim of this paper to suggest the direction in which we should look for an explanation of this fact.

III. *Gold as a Symbol*

THE love of light, surely, reaches deep into our biological nature, and so does the attraction of glitter. What wonder that this elementary reaction provided mankind with its basic symbol of value? For what else is gold but the glittering, sunlike metal that never ages or fades? Or what else are jewels but gaily sparkling stones which do not break? There was a time—and it is not so very far back—when riches, economic wealth, could thus feast the eye, when the miser could enjoy the sparkle of his hoard, instead of having to admire balance sheets. The fact that wealth can no longer be seen, that it no longer provides direct visual gratification, belongs with the many dissociations of value from immediate experience which are the price we pay for our complex civilization. There are many documents from the past which testify to the appeal of what might be called mutually reinforcing metaphors of value, sparkle and costliness, and one such document introduces us into the heart of our problem.

In the twelfth century, Abbot Suger of St. Denis wrote a famous account of his renovation of the Church of his Abbey (the first Gothic building) and of the treasures he dedicated to it. In a famous passage of this record he describes how the sight of a precious reliquary studded with gems 'carries his mind from the material to the spiritual world', *anagogico more*. The philosophical background of this passage has been fully elucidated by Suger's latest editor, Professor Erwin Panofsky.[12] He has shown how Suger regards his treasure in terms of the mysticism of light

ascribed to the Neoplatonist Dionysius the Areopagite, whose memory was specially cultivated in Suger's Abbey. It was here that Suger could find a developed doctrine of religious symbolism which makes light the visible manifestation of the divine. Panofsky suggests, moreover, that the sight of the gleaming gems induced in the Abbot something like a religious trance; but in our context it is relevant that this trance could never have been induced by tinsel. Only because the Abbot had been overawed in his devotions by the awareness of the tremendous values here embodied, and only because his philosophy sanctioned an apprehension of the supernatural in terms of sensuous symbols, could the glitter do its work as a metaphor for the realm of light. Here, as always, seeing cannot be separated from knowing.

Suger's account is exceptional only through the clarity of his analysis. The use of the precious and the gleaming as a metaphor for the divine is, of course, almost universal in religious art.[13]

In his book *Symbolism and Belief*, Professor E. Bevan has enumerated some of these basic metaphors which have served mankind for the visualization of the 'higher' powers. Height itself is one of them, and indeed the author makes the point that we cannot escape this spatial metaphor whether we use the words 'superior value', 'exalted', 'excellent', 'transcendent', or countless others.[14] In art, as in life, the co-ordinates of light–dark, high–low, are frequently joined by physical beauty *versus* ugliness, using the terms not in any abstruse sense, but simply denoting desirable health and vigour as opposed to deformity and decay. The power of these metaphors is exemplified in countless elaborate allegorical pictures in which a host of beautiful personifications hurl crowds of ugly symbolic monsters from exalted regions of radiant light into an abyss of darkness. These pictures exemplify the most universal and unsophisticated type of visual metaphor of value in which the fair stands for the good, the healthy for the friendly, the radiant for the holy. Though the philosophy of Plato has given some kind of metaphysical sanction to this idea of the equivalence of the beautiful with the divine, this symbolism is really rather too obvious to be particularly interesting. In fact, art has long since conquered regions of metaphor far beyond such simple identification.

IV. *Noble Simplicity*

WHEN in the fifteenth century, Leone Battista Alberti discussed the decoration suitable for places of worship, he considered the use of gold only to reject it. Quoting the authority of Plato and of Cicero he advocated the use of plain white, as he was convinced that the divine powers loved purity best in life and art.[15] At first sight it might seem as if Alberti had only exchanged one visual metaphor, that of sparkle, for another, that of 'purity'. But if we study his advice in the context of humanist culture, we see that there is an important difference between Suger's

immediate experience of divine radiance in the splendour of his reliquaries and Alberti's love of purity. The difference lies precisely in the fact that Alberti rejects the gratification of outward splendour in favour of something more 'dignified'. He values the white wall not only for what it is, but for what it is *not*. The terms 'pure' and 'unadorned' themselves imply this element of negation. Art now stands in a cultural context in which an expectation aroused and denied can by itself become expressive of values.

Of course this negation is only meaningful when it demonstrates a renunciation in favour of 'higher' values. In the non-conformist meeting house the rejection of glitter and colour is done in the name of a pure religion, and the aesthetic factor is pushed to the very fringe of experience. The austere simplicity of a shack may sometimes impress us, but it is not what Alberti had in mind; for the Renaissance was confident that such renunciation could be directed to higher values *within* the realm of art. This marks the beginning of a thorough process of sophistication that, for good or ill, has divorced the art of Western civilization from a simple appeal to the senses. Not that Renaissance writers despised gold, but that they were everywhere anxious to prove that art itself creates a value that can 'trump' gold. Alberti elsewhere tries to make this clear to his readers by explaining that a leaden statue by Phidias would be worth more than its weight in gold.[16] And it was the pride of the Renaissance artist that his art created higher values than the mere surface attractions of sparkle.

A strange historical misunderstanding has created the prejudice that the art of the Renaissance glorified the splendours of visual gratification against the austere spiritualism of the Middle Ages. The contemporaries of this great revolution saw it in very different terms. The very first appraisal of the import of Giotto's 'revival' of art, contained in Boccaccio's *Decamerone* less than a generation after the master's death, is quite unambiguous on this score. Boccaccio celebrates Giotto as the painter who

had brought back to light that art that had been buried for centuries under the errors of those *who painted rather to delight the eyes of the ignorant than to please the intellect of the wise.*[17]

This contrast between a low kind of art that appeals to the eyes of the simple-minded and a 'higher' form that can be appreciated only by the cultured, becomes a commonplace of criticism in the sixteenth and seventeenth centuries. It is amusingly illustrated in Vasari's *Lives of the Painters*[18] where we read the anecdote of Sixtus IV, who promised a special prize to the artist who would acquit himself best out of the team of four employed in the Sistine Chapel. While the true masters, Botticelli, Perugino, and Ghirlandajo, gave of their best, the fourth, Cosimo Rosselli, knew that he was 'poor in invention and weak in design'. Much to the amusement of his colleagues he plastered his fresco with gaudy colours, ultramarine

and gold, to cover up its shortcomings. In the end the laugh was his, for the Pope, who knew nothing about art, not only awarded the tyro the prize, but even insisted on the others giving their frescoes a generous sprinkling of gold.

The taste that is here ridiculed is the 'vulgar' taste of the Philistine, and it only adds spice to Vasari's story that this Philistine is the Pope himself, who thus proves himself inferior in culture to the artists he employs. There is no need to add further examples. For in the strict hierarchic society of the sixteenth and seventeenth centuries the contrast between the 'vulgar' and the 'noble' becomes one of the principal preoccupations of the critics. Not that they recognized this contrast for a metaphor. On the contrary. Their belief was that certain forms or modes are 'really' vulgar, because they please the low, while others are inherently noble, because only a developed taste can appreciate them. Their examples of what constitutes 'decorum' always point in the same direction. There is always a strong negative element in what constitutes 'good taste'. It presupposes a mind not easily swayed by the appeal of immediate gratification which would be a lure to the 'vulgar'. Thus loud colours, provocative dress, expletive speech, are all a 'breach of decorum' and 'in bad taste'.

This equation between 'taste' and 'manners' is of course deeply rooted in the traditions of our culture. In his fascinating book on the process of civilization, Norbert Elias[19] has demonstrated in some detail how the gratification of our appetites becomes subject to increasing social restraints which can be traced in the varying social codes. In this sphere we have no difficulty in understanding why the values of taste and manners were equated with the pyramid of hierarchical power, the 'noble' at the top and the 'vulgar' at the base. It is an historical fact that social taboos usually spread from the top downward. The nobleman ate daintily while the villain still gulped his food. Though, in point of fact, the aristocracy—like Vasari's Pope—did not always show a similar sophistication in matters of art, the metaphor of the noble was derived from this basic stratification. Of course ideally the restraint of the 'noble' is not only one of behaviour. Whatever the reality may have been like, it is first and foremost conceived as a moral restraint, a control of the passions, a domination of impulse. This applies to Roman '*gravitas*' no less than to knightly '*mesure*' or '*courtoisie*'—and when Nietzsche, in his hysterical praise of the 'noble', singles out 'the slow gesture, the slow glance'[20] as a physiognomic characteristic of his admired aristocrat, he still characterizes the person of strong self-control who is not impelled by spontaneous appetites to look or move.

If this analysis of a critical metaphor is correct, we gain, perhaps, a first glimpse into the process by which art itself can become to us a symbol of moral value. In the co-ordinate system erected by our culture, renunciation of gratification, nobility, and the Good converge and become one. To test this impression gained from historical material, the historian can do no better than to resort to introspection.[21]

V. *Clean Lines*

THE conditions for such an introspective test are not too inauspicious. For in the past few decades we have gone through a revolution of 'taste' which has much in common with the process of 'sophistication' characterized in the preceding section. If the Renaissance (to put it schematically) rejected glitter for 'nobility', the twentieth century has rejected ornament for the sake of 'clean outlines'. Everybody familiar with the catchwords under which this battle was and is still being waged will recognize that here, too, social and moral issues seem inextricably intertwined with questions of aesthetic value. Perhaps, however, we have now acquired sufficient distance to see the contending parties with some detachment. Why did the Victorians revel in ornament? The quickest schematic answer would be to say that ornament had come to 'stand for' Art. In the complex give and take of our aesthetic reactions this is hardly a surprising development. In the Renaissance art had acquired an 'autonomous' value, divorced (as we have seen) from preciousness and brightness. What is more natural than that this value, in its turn, became an 'area of metaphor'? To praise a landscape the eighteenth century called it 'picturesque'— associated with things seen in pictures.[22] To make a pair of scissors praiseworthy the Victorian designer shaped it on the pattern of Gothic tracery, to let it partake of the aura of value that surrounded the relics of the 'Age of Faith'. In itself this use of ornament is not new in the nineteenth century. All fashion in ornament—and who could draw the line between style and fashion?—rests on such associations. The Florentine burgher of the Renaissance who adorned his house with a porch '*all'* *antica*', wanted thereby to transform it into a likeness of an ancient temple, to proclaim his allegiance to the values of the noble Romans. In the dim distant past, of course, ornament had had a more direct power.[23] To the primitive artist who turned the handle of a vessel into a snake, or its spout into a beak, the handle became a snake and the spout a beak, partaking, thereby, of the magic force inherent in them. Even here, we might say, metaphor is at work: the table 'legs' end in protective claws and thus the table is made 'one' with the guardian animal. But, however that may be, by the time we reach the Victorians, ornament has become the metaphor of Art, and of Art as the symbol or visible token of wealth. The Victorian interior with its aspidistras and tigerskins, its velvet curtains and 'ornaments' on the mantlepiece, its furniture covered with ornamental allusions to the art of all respected ages, is really shaped in the likeness of an aristocratic museum in which the spoils of centuries display the owner's 'connoisseurship'. Suddenly all this is victimized by sophistication and falls under the taboo of 'tasteless ostentation'. We were asked to tear down the heavy curtains and enlarge the windows to let light and air into the 'stuffy' rooms, to sweep away the knick-knack which only 'collects dust', to knock down the 'false' stucco ornament, and to remove the useless excrescences

from our furniture in favour of 'clean', functional lines. There may have been some rational impulse behind this revolution. Possibly Pasteur's discovery of germs and the dangers lurking in unsweepable corners had something to do with its beginnings. But whatever it may have been that set the ball rolling, introspection shows, I submit, that concern for hygiene is really not the whole story. Much of modern design which we instinctively prefer is not so much more 'hygienic' in an objective sense as *suggestive* of cleanliness and rational living. If the Victorians took their visual metaphors from the museum, we take ours from the operating theatre and the factory. If primitive man turned his table into a metaphor of a protecting animal and the Renaissance burgher his palace into a metaphor of a Roman temple, we are asked to see our house as a 'machine to live in'. The machine itself, of course, or rather the world of engineering, has become an area of metaphor on which we constantly draw. The 'streamline' contour is employed metaphorically where no rapid airstream will ever cause friction, to suggest or 'express' efficiency. Similarly, hygiene, cleanliness, purity, have become areas of metaphor that cause us to wrap our wares in cellophane and turn our rooms into chromium-plated offices. And, just as with the change to 'decorum' in the Renaissance, the revolution is felt to have strong social overtones. The main objection against the Victorian interior is that it is 'vulgar', by which is meant that it allows a too easy, childish gratification in the gaudy and 'cheap'. Books on 'good' and 'bad' design hint openly that to prefer one lampstand to another is a sign of social inferiority. Meanwhile, of course, the tide has already turned. In the sphere of art the 'organic' forms of a Henry Moore appeal more to the really 'advanced' groups than the 'constructivist' purity of Mondrian or Pevsner. In design Victorian 'atrocities' have acquired the distinction of being 'amusing'—which must be taken to mean that they have receded far enough into the background no longer to be dangerous.

For this, above all, introspection seems to show—that our rejection of Victorian ornament and all that went with it, was not just a matter of aesthetic preference What strikes us as 'vulgar' in art or design does not merely leave us indifferent, it gives us positive displeasure to the point of making us 'feel sick'. Our creation of new visual metaphors for the 'chaste and pure' finds its necessary counterpart in a strong aversion to such forms as strike us as meretricious and indecent. The very disgust we feel at the 'cheap', the 'gaudy', the 'sloppy', proves our strong emotional involvement. Nor is the nature of this involvement hard to guess. We react as if we resisted seduction, and this is suggested too by the metaphors we use. We speak of a painting as 'pretty-pretty', to imply that such primitive gratification as it offers is not for the grown-up mind. We call it 'chocolate boxy' to describe its inartistic invitation to self-indulgence. Everywhere our reaction suggests that we have come to equate such indulgence with other childish gratifications we have learned to control. We find the 'cheap' work 'too sweet', 'cloying', 'mushy', and 'bulgy', with an

obvious erotic overtone. There is some evidence that it is only works that have more recently fallen under the taboo of sophistication which have this effect on us. Forms of the more distant past may strike us sometimes as poor but rarely as 'vile'. The use of gold which so shocked Renaissance writers as a sign of childish vulgarity now impresses us as pleasantly naive. We feel we can afford some indulgence in this simple pleasure. We are close to a sophistication of the second degree which welcomes the 'primitive' as a value, providing a metaphor for all that is strong, direct, forthright, and 'unsophisticated'. The art of the past has often had to lend itself to this symbolic use.[24]

If the results of this brief excursion into introspection can be generalized, our attitude to certain elements of artistic expression follows indeed a curve similar to that of our attitude to other forms of gratification. The findings of Elias would seem to apply here no less than in other fields of 'good behaviour'.[25] The process of civilization advances what he calls *die Peinlichkeitsgrenze*, the threshold of what is felt to be embarrassing, but frees other areas which are felt to be completely under control. The reaction of the 'Philistines' to the sophisticated regressions of modern art suggests that these, too, are experienced as a threat against which the mind must mobilize its defences. Both the 'highbrow' and the 'lowbrow' experiences moral worth in some works of art and rejects others as 'indecent'—and both may have more subjective right to their attitudes than we are sometimes inclined to concede.

VI. *Impulse and Restraint*

THE result of the two preceding sections might be summarized by saying that in the context of our culture art not only embodies those natural metaphors which have so frequently attracted the attention of aestheticians—violent colours for violent emotions—but also their negation, and that it is very often through such negation, restraint, or renunciation, that art creates new metaphors of 'higher' values. But before we proceed to generalize on these findings certain difficulties have to be overcome. One concerns the relation of 'art' to 'taste'. Not that the two can ever be quite neatly separated, or that it would be a fruitful undertaking to 'define' their limits. But even without committing ourselves to a verbal definition, we all know what is meant when we say that 'good taste' is often satisfied by rather poor art, provided that it remains on its best behaviour. We may even feel intuitively (if we are romantically inclined), that 'taste' may, at times, stand in opposition to art and suffocate its vitality. These dangers of the ideal of 'noble simplicity' were well brought out at the very time of its greatest vogue during the 'Age of Taste' by none other than Sir Joshua Reynolds, P.R.A., in a passage that deserves full quotation:

When simplicity, instead of being a corrector, seems to set up for herself; that is, when an artist seems to value himself solely upon this quality; such an ostentatious display of

simplicity becomes then as disagreeable and nauseous as any other kind of affectation. He is, however, in this case, likely enough to sit down contented with his own work; for though he finds the world looks at it with indifference or dislike, as being destitute of every quality that can recreate or give pleasure to the mind, yet he consoles himself that it has simplicity, a beauty too pure and chaste to be relished by vulgar minds.

It is in art as in morals; no character would inspire us with an enthusiastic admiration of his virtue, if that virtue consisted only in an absence of vice. . . .[26]

We might elaborate the moral simile, offered us by Reynolds himself, and suggest that conformity is not virtue; that where there are no passions to be controlled restraint is not experienced as a value. Something analogous is no doubt experienced in the face of those artistic negations or renunciations that are the present object of our attention. Not that it must always be possible to distinguish the 'noble simplicity' of the true work of art from its less noble isotope, the 'work of taste'. In architecture, for instance, opinions on this point are apt to vary considerably—witness the diverse estimate of the stature of the Renaissance architect, L. B. Alberti, the very master we selected for his doctrine of the 'purity' of white unadorned walls. But by and large we have the feeling that we are able to distinguish mere absence of emotion from control of emotion, and that the great work of art is marked by an intensity of impulse, matched and dominated by an even greater intensity of discipline.

We are here touching upon a problem of physiognomic understanding that was the lifelong preoccupation of Ludwig Klages, who, unfortunately, marred the value of his intuitive insights by his Bergsonian irrationalism and his hatred of rational argument. Klages's starting point was graphology. He was anxious to show that the same trait or absence of traits in the handwriting of individuals acquired a different meaning if we experienced them as due to the weakness of drives or the strength of resistance. He introduced the idea of the '*Formniveau*', the intuitively perceived level of performance that allows us to sense that presence of 'life' that may pulse through the most disciplined of scripts.[27] The type of duality he apparently had in mind is expressed in less metaphysical form, in terms of 'heart' and 'head', in the following description by a performing musician of a great fellow musician at work:

We in the orchestra are on closer terms with the conductor than anyone else, and are in an unassailable position to judge whether he is making music from his heart or from his head. Let it be well and truly understood that in Toscanini the two are in perfect balance. All his music-making springs from his inmost being, though his mind directs his heart, as every member of the orchestra is made aware in the first five minutes of his rehearsal. He is completely caught up in the music, and every line of his face shows the depth and intensity of his feeling. And it pours forth from him. The fact that he is master of his power does not mean that he is dishonest with himself, but that all power on earth, to be effective, has to be in control. Look at him in the act of building up a climax. He asks more and more until the orchestra's breath and strength are almost used up, and then from his reserves he

gives forth still more of himself, until the most vital point of all is reached. He never allows his forces to expand themselves to waste, nor does he ever overpaint a phrase.

His crowning glory is the presentation of a work with such divine simplicity that it suddenly appears in a new and fresh light—yet, incredibly, only as the composer left it.[28]

The phenomenon here characterized in such pleasantly untechnical language would probably be called 'ego control' by the psycho-analyst. It is a quality that is particularly well exemplified in the art of the musical performer with its temptations and the possibility of rational checks. When we are told, for instance, that Toscanini 'never overpaints a phrase' we understand that he never yields to the allurement of a moment, as minor performers do, that he renounces the 'cheap effects' that may provide immediate gratification but disrupt the architecture of the whole, and that the gain from this austerity in the presence of intense emotion is that 'divine simplicity' that becomes a musical metaphor of highest values.

Perhaps a little more can even be extracted from this example. For the performer stands half way between the creator and the public and somehow partakes of the problem of both. Only recently Paul Hindemith has stressed his belief in the Augustinian doctrine of music as an image of moral order which is attained by the listener through his active collaboration in the act of musical creation.[29] Again he describes an appeal to ego-control *versus* a mere indulgence in the pleasures of sound, the passive surrender he attributes to Boethius's theory of music. We here gain a hint of the hierarchy of values within music which has its parallel in the other arts. The design of the whole dominates over the surface attractions of the parts, just because it presupposes a higher degree of control on the part of the creator and the beholder or listener. The noble renunciation in art is renunciation of part effects for the sake of submission to the larger structure. But not every withholding of gratification is experienced as a metaphor of nobility. There is something like a depraved sophistication, a playing with the '*raffinement*' of colour or sound, that teases and surprises but seems to use negation as a spice rather than as a sacrifice to higher values. Only the sternest moralist would deny these effects their place in art, but ancient academic doctrine which relegated them to a lower plane may have had some psychological justification behind it.

VII. *Is Beauty Truth?*

THERE is no more famous and no more moving record of what we have called the 'confluence of values' than Keats's 'Ode On a Grecian Urn'. It was this (real or imagined) work of art, of course, that inspired the much quoted and much abused utterance, 'Beauty is truth, truth beauty'. Are we to see more in this than a mere exclamation of ecstatic enjoyment? If we read the poem with our present preoccupations in mind, we may be struck by its imagery of gratification withheld, of passion unfulfilled. The very first line introduces this motif:

> Thou still unravish'd bride of quietness,

and the poem soon rises to that paean of renunciation

> Heard melodies are sweet, but those unheard
> Are sweeter; . . .
>
> Bold Lover, never, never canst thou kiss,
> Though winning near the goal—. . .
>
> More happy love! more happy, happy love!
> For ever warm and still to be enjoy'd
> For ever panting, and for ever young;
> All breathing human passion far above,
> That leaves a heart high-sorrowful and cloy'd, . . .

Is it because it is a '*cold*' pastoral, stilled and remote, that the urn acquires the dignity of a universal symbol? One may be tempted to think so. For beyond the general neo-platonic faith in the truth of the artist's vision such as it is expressed in Keats's letters,[30] the idea that the realm of beauty can be entered by man only at the price of renunciation plays an important part in eighteenth-century aesthetics. Thus Schiller's speculations turned upon the contrast between the enslavement of our animal nature and the freedom of aesthetic contemplation.

> *Wollt ihr schon auf Erden Göttern gleichen,*
> *Frei sein in des Todes Reichen*
> *Brechet nicht von seines Gartens Frucht !*[31]

But whatever the exact roots and implications of Keats's exclamation there remains the fact that great art has given to many the feeling that they are in the presence of 'truth'. Usually discussions of that point turn on the conviction that all great art is 'truthful' because it is 'sincere' and 'honest'—just as bad art is often branded as the opposite. No investigation of the moral aspects of art can shirk this important issue. What we want to know is how we should interpret this intuition that the great work of art is 'sincere'.

In this section I shall try to explain why this favourite term of the critics should no less be considered a metaphor than the terms of 'nobility' or 'purity'—and, conversely, as in the previous examples, why this metaphor still describes some kind of psychological reality. The temptation to take the metaphor literally is even greater here than in previous instances. We are assured that the artist is sincere and truthful if and only if he expresses what he 'really feels'. But the difficulties in the way of this naive version of expressionism have often been pointed out. Nobody would seriously maintain that a musician who writes a sonata must wait for a sad mood to write the adagio and has to postpone the writing of the 'scherzo' till he feels gay.[32] And even if he did, who would ever know and thank him for it? What right have we to inquire after an artist's private feelings? And how can we know that what strikes us as 'false sentiment' did not express an actual experience of a truly sentimental soul?

Obviously we have here a confusion of various meanings of the term 'expression'. In everyday usage the term 'expression' refers most frequently to the manifestation of feelings through gesture, inflection, or facial expression. But even here we must be wary of confusion. Blushing is a sign of embarrassment, frowning is a sign of anger. Both indicate the presence of certain emotions much as the proverbial smoke indicates the presence of fire. But there is a difference between these forms of 'expression'. Blushing is a symptom of embarrassment—and as such largely outside our control. A blush, therefore, cannot, be dishonest. Frowning is a symptom of anger, but it so happens that we can also frown intentionally. We can frown at will to communicate the fact that we are angry. The frown as an 'expression' of anger can become the equivalent of a verbal communication. It becomes a shorthand formula which the teacher or actor can use for the statement (true of false), 'Now I am annoyed'. When we speak of 'expression' in daily life, we lump symbol and symptom together. We have our reasons for doing so. For the living expression of social intercourse is made up of both types of sign. Convention has taught us to control and canalize the symptoms of our emotions, to let them conform to certain symbolic standards.[33] It is only in extreme situations that the average grown-up allows genuine symptoms to overwhelm his conscious control or that he feels driven to employ symbols of feelings which are in no way symptomatic of his state of mind.

When critics of the pre-Romantic age spoke of 'expression' in art, it was always the 'symbolic' sense they had in mind. They discussed the expression of figures *in* the picture, the anguish of Laocoon, the fury of Herod, they analysed the means a poet or musician has at his disposal to 'paint the affects'—as the eighteenth century put it—and noted the vocabulary which the various arts have developed for this purpose. Translated into the terminology of this essay they would say that the major key lends itself to the musician as a symbol or metaphor of gaiety, that a stormy sky in the background of a massacre can be used as a metaphor of passionate grief. To them, in other words, art was not 'expression' but made use of 'expressions', developed and held in readiness by tradition or 'style'.

As long as the term 'expression' was thus confined to the symbols used by the artist, the question of his own 'sincerity' did not arise. It was only with the advent of Romanticism that this term became one of the favourite epithets of critics, and this shift of emphasis is connected with the increasing belief in the function of art as communication of emotions. The work of art as such, in other words, was valued as a symptom of the artist's state of mind, as an 'expression of personality', and this, at once, raised the issue of the genuine *versus* the false expression.

But have we really a right to equate artistic truth with truthful communication? Does the idea that the morality of great art rests on a coincidence of symbol and symptom not rather hide than reveal the complex relationship between the artist and his work?[34] It is true that Horace advises the poet 'You must feel pain yourself if

you want me to cry', but such advice no less than Wordsworth's contrasting recollection 'in tranquillity' should be considered technical hints rather than moral injunctions. The artist's private feelings at the moment of production clearly do not enter here, and as to his personality—we have long learned to see the immense complexity that shields behind this simple word. We could hardly ever recognize an artist whom we knew only through his work. So how far is his personality 'expressed' in it?

And yet the feeling of 'sincerity' we have in the face of certain masterpieces cannot be disputed, any more than of 'nobility', 'purity', or 'discipline'. The suspicion arises that they are all metaphors pointing to a similar centre. When we find a teacher's frown 'expressive', we are not concerned (unless we are the pupils) whether his rage is 'real' or only 'put on'. We rather mean that it is convincing, because it is not merely a symbol in isolation (that would strike us as false), but that it is co-ordinated with other symbols of anger, a scornful voice, a tight lip, and set in the proper curve of rising anger. It is possible that most people will perform more convincingly if they talk themselves into real anger, but surely it is not this that would make it more moral. And so we are led to the conclusion that once more it is the submission of the part to the whole, the element of control, of bridled emotion rather than of disconnected symptoms, that is responsible for this intuition of 'honesty', and that may make art analogous to a moral experience.

This suspicion that the feeling of 'truth' or 'sincerity' in art is due to the synesthesia of values, is strengthened if we look into the reasons why certain types of paintings are so often charged with the corresponding sin of 'insincerity' and 'false sentiment'. A scrutiny of critical literature would probably reveal that such charges refer more often than not to what we called symbols rather than symptoms; to the swooning saints of Bolognese seventeenth-century painters, the coquettish maidens of Greuze, or the theatrical pathos of Doré. In our present context we are no-concerned with the question whether these works ought to be valued or not—they are anyhow coming into their own among the sophisticated—but simply how we should interpret this charge of dishonesty. It could be substantiated only if it could be maintained that Reni wanted to claim the Saint's emotion as his own. But there can be no question of that. Reni did not want to 'express' piety, he wanted to use 'an expression of piety', as he understood it, for a picture of a saint, and so the criterion of honesty *versus* dishonesty really does not apply.

It is not hard to guess, on the other hand, why so many people feel compelled to use this handy metaphor of opprobrium against such pictures. They are the victims of the same 'process of civilization' which imposed its taboo on gold and ornament. The scope of emotion we are permitted to show in society has much contracted even since Victorian days. We have tried to reduce both symptom and symbol to the minimum needed to secure contact among really sensitized people. Works of art

which display symbols running counter to these taboos 'get under our skin', they 'make us sick'. We suspect them of wanting to seduce us to a forbidden form of exhibitionism and we evade them by throwing doubt on their sincerity. As we do not want to cry, we turn the dictum of Horace against them and maintain that they never felt pain—as if they had claimed that they did. Here, too, the aversion to expressive symbols (which Romanticism led them to confuse with symptoms) has driven the taste of the sophisticated continuously backward in time to more primitive and archaic art which did not assail their nerves with easily interpretable expression. The primitives could not offend by an unseemly display of obvious emotions. Their admirers tried to run away from expression and landed ever deeper in expressionism. Perhaps it tickled their pride to fancy themselves able to penetrate through the impenetrable mask of an Aztec idol and to detect expression where the 'vulgar' would see only ugliness and rigour. Perhaps in trying to gauge the expressive value not of faces and gestures but of lines, colours, and patterns, they felt permitted to indulge in the experience of emotion without trespassing on the taboo of 'false sentiment'. There is, of course, a valuable side to this revolution of taste. It lies in the recognition that art yields emotional satisfaction only at the price of renunciation. But unless the critic gains some insight into the mechanisms here at work, the metaphors he uses can also do harm, and a good deal of such harm, I submit, has in fact been done by the identification of art with symptomatic expression.

VIII. *Hopes and Dangers*

THE symbol has been recognized as a force of social control and cohesion ever since Carlyle, in the turbulent pages of the *Sartor Resartus*, spoke of the 'Poet and inspired Maker; who, Prometheus-like, can shape new Symbols, and bring new fire from Heaven to fix it there', and execrated the 'tatters and rags of superannuated worn-out symbols . . . dropping off everywhere, to hoodwink, to halter, to tether you . . .'[35] It is not long ago that A. N. Whitehead elaborated his words, reminding us that 'Those societies which cannot combine reverence for their symbols with freedom of revision, must ultimately decay either from anarchy, or from the slow atrophy of a life stifled by useless shadows.'[36]

As we move away from the hierarchical society of the past, problems of symbols and values become, in fact, more acute. We have seen how strongly this type of society imprinted its frame of reference on the terms in which art was conceived. The 'noble' and the 'vulgar', the 'high' and the 'low', the 'dignified' and the 'common', are today not much more than pale, fading metaphors for what were once tangible realities. We need not mourn their passing away in order to realize that here an area of metaphor is passing out of our consciousness which, for centuries if not longer, gave man a symbol of value, however crude. It did even more—it provided

a bait or reward for the 'process of civilization' itself. Ever since the Renaissance, perhaps indeed since the Courts of Love, 'courtoisie', culture, urbanity, were rewarded by a rise in the social scale. The development of a taste ready to forego immediate gratification for 'higher' satisfactions was among the accomplishments so rewarded. We are used to looking down on snobbery, the pretence of culture for the sake of social advancement,[37] but what begins as pretence often becomes genuine—at least in a second generation. Snobbery in this wider sense may have been one of the most powerful engines in keeping culture going. It provided the social pressure that induced people to learn the stock of symbols or common images called 'general culture'; it put a price on self-restraint. When Molière's M. Jourdain wants to leave his bourgeois state behind to become a *gentilhomme*, he calls in the Masters of Music, of Dancing, of Fencing, and of 'Philosophy'. We may laugh with Molière or we may feel somewhat embarrassed at his snobbery, but the fact remains that hierarchical society exacted a high entrance fee—a remodelling of the whole person to certain standards. Today these mechanisms are still at work, but they are relaxing their grip. Specialization threatens the community of areas of metaphor, liberalization of society the unquestioning community of standards. What are the chances that art may provide the symbols of value which society seems in danger of losing?

If our analysis has been correct, such chances exist, but there is little room for easy optimism. For art is not the 'universal language' that could link classes and civilizations. The reason is that it does not rely on a universal area of metaphor common to all mankind. Even where it does not make use of a 'code', even where it does not allude to specific lore, it relies for its effect on the complex interplay of attraction *and* repulsion, gratification and renunciation for the sake of 'higher' values. If we have come a little nearer to understanding how this balance can serve for those who are attuned to its particular kind of equilibrium, as a metaphor of the 'good' in all its converging forms, we have also learned how much of this response depends upon factors beyond easy control. It is regulated from the centre of our being; it is intimately linked with the degree of our emotional maturity and the level of our culture. In psycho-analytic terminology these are matters which largely depend upon the strength of our ego and the state of its defences and are thus not easily adjusted by courses on 'art appreciation' alone.

There are tendencies discernible in our modern world which seem to hold out hope. The means of mass communication, so often execrated as spreaders of vulgarity, seem to have 'conditioned' a much wider audience than ever before to the true understanding of music: partly no doubt, as their sponsors claim, by familiarizing many listeners with classical masterpieces, but partly also, one may suspect, by providing such a cloying surfeit of easy gratification contained in popular 'hits', that the values of subtler harmonies became desirable and understandable to an

increasing number of listeners. Perhaps the gaudy colours of advertisements may help in a similar way to create a response to the restraint of great art.

Against these positive factors, however, we must set the negative conclusions that might be drawn from some of our observations. The Beauty of the 'Grecian Urn' becomes Truth because of what may be called its 'plenitude of values' held in miraculous equilibrium—passion and denial, 'hot pursuit' in the 'cold pastoral'. The danger from the emergence of new values, that constantly threatens art, is precisely the danger to this equilibrium. It is a danger well illustrated in the satirical remark on 'simplicity' quoted above from Reynolds,[38] and it is a danger that constantly increases with what I have called the process of sophistication. This process implies, as I have tried to show, that a work of art comes to stand in a context where it is valued as much for what it rejects and negates as for what it is. In modern art these negations and negations of negations have reached a bewildering complexity and the social taboo of the 'cheap' and 'vulgar' falls with capricious speed on one aspect of art after the other—releasing areas only just condemned to be patronized or enjoyed. Of course these negations and releases have their genuine function, they correspond to a real shift in balance experienced by the artists and their friends. But the danger is that an increasing emphasis on the negative aspects—the *absence* of illustration, representation, imitation, sentiment, contrivance—may push the work of art ever closer to the work of taste; which is clearly the opposite effect of the one desired. It is a danger still increased by the catchwords of our time, in which the static social values of 'noble' *versus* 'vulgar' are replaced by the 'dynamic' values of 'progressive' *versus* 'backward'. In this battle of ideologies the poorest work can do service as a badge to proclaim the value of 'progress' or 'traditionalism'—in fact, the poor work can perhaps proclaim this value louder because it need not concern itself with that equilibrium of values which alone makes art into a worthy symbol of our highest values.

The critic who would attempt to prescribe to the artist what to do, or leave undone, in order to create symbols of value, would invite ridicule. The abortive art of Nazi Germany and of Soviet Russia stands as a warning against such presumption. Yet the critic has his share of responsibility in these matters. Art is not just 'the expression of the age'[39]: it is the work of people who have to find approval if they want to live. The catchwords of value which the critic discerns in the drift of social trends and to which he, in turn, gives currency, ring in the ear of the creative artist and often guide his preferences or impose taboos. It is all the more important for him to be aware that his metaphors *are* metaphors, but that they spring from that living centre where the 'good', the 'clean', the 'noble', the 'true', the 'healthy', the 'natural', the 'sincere', the 'decent', are but the facets of one untranslatable experience of a plenitude of values that speaks to the whole man—as great art has always done.

Psycho-Analysis and the History of Art

W HEN I was honoured by the invitation to give this year's Ernest Jones Lecture I felt, of course, the usual mixture of trepidation and pride; trepidation at the thought of having to address an audience of specialists in a field where I am only a trespasser—an audience, moreover, accustomed to listen with the 'third ear'; pride in being allowed thus to pay a public tribute to a great scientist and scholar. I was particularly glad that this should happen in a year in which Ernest Jones has yet again added to the debt of gratitude we owe him by turning historian and biographer in his exciting Life of Sigmund Freud. But what I did not know when I accepted, and what may perhaps also be a surprise to you and to him, is that I would find in Ernest Jones a dangerous rival in my own proper field—the history of art. I once tried to tell the whole story of art in a mere 450 pages. Imagine my mortification when I found that Ernest Jones had performed the same feat in exactly half a page, and that, perhaps, unconsciously! I must read this rival product to you, because I shall have to come back to it more than once in the course of this lecture. It occurs in Ernest Jones' classic paper on 'The Theory of Symbolism',[1] very near the beginning:

'if the word "symbolism" is taken in its widest sense'—he writes—'the subject is seen to comprise almost the whole development of civilization. For what is this other than a never-ending series of evolutionary substitutions, a ceaseless replacement of one idea, interest, capacity or tendency by another? The progress of the human mind, when considered genetically, is seen to consist, not—as is commonly thought—merely of a number of accretions, added from without, but of the following two processes: on the one hand the extension or transference of interest and understanding from earlier, simpler, and more primitive ideas etc., to more difficult and complex ones, which in a certain sense are continuations of and symbolize the former; and on the other hand the constant unmasking of previous symbolisms, the recognition that these, though previously thought to be literally true, were really only aspects or representations of the truth, the only ones of which our minds were—for either affective or intellectual reasons—at the time capable. One has only to reflect on the development of religion or science, for example'—ends Dr. Jones—'to perceive the truth of this description.'

You see how I was saved by a hair's breadth from being put out of business. 'Religion or science, for example', says Dr. Jones—and leaves it to me to add art. But psycho-analysis does not believe in accidents of this kind, and maybe it was no complete accident that art was not mentioned in the article that was written in 1916. For in these earlier years of psycho-analysis the aspect of art that attracted most attention was not so much the historical progress of modes of representation,

The Ernest Jones Lecture, read before the British Psycho-Analytical Society in November, 1953.

which is so admirably summed up in this paragraph, as its expressive significance. In most psycho-analytic discussions of art the analogy between the work of art and the dream stands in the foreground of interest. I think it cannot be denied that this approach has proved more rewarding in the field of literature than of painting. True, there are paintings such as some by Goya, Blake, or Fuseli which are dream-like;[2] but if you follow me in your mind on a lightning excursion to the National Gallery, with its Madonnas and landscapes, still lifes and portraits, you will realize that the traditional conventional elements often outweigh the personal ones in many, even of the great masterpieces of the past. Now I would not be here, of course, if I were inclined to deny that a personal determinant must always exist and have always existed; that if you had analysed Hobbema you might have found out why he preferred to make capital of Ruysdael's watermills rather than of Koninck's panoramas or how it came that Wouverman delighted in painting white horses and Paulus Potter cattle.

But does it matter all that much? This may at first seem a very heretical question to ask, yet on its answer depends the whole relationship between psycho-analysis and the history of art. For try as we may, we historians just cannot raise the dead and put them on your couch. It is a commonplace that there is no substitute for the psycho-analytic interview. Such attempts as have been made, therefore, to tiptoe across the chasm of centuries on a fragile rope made of stray information can never be more than a *jeu d'esprit*, even if the performance is as dazzling as Freud's *Leonardo*.[3] We historians could always prove to you that the information you need is not to be had, and you could retort that without such essential information we might just as well pack up and go home. And so I repeat the question whether it really matters all that much if we know what the work of art meant to the artist. It clearly matters on one assumption and on one assumption only: that this private, personal, psychological meaning of the picture is alone the real, the true meaning—the meaning, therefore, which it also conveys if not to the conscious at least to the unconscious mind of the beholder. I know that this assumption underlies a good deal of writing on modern art,[4] but I doubt if it is sound analytical doctrine. I need hardly remind this audience of the letter Freud wrote to André Breton when that leader of Surrealism asked him for a contribution to an anthology of dreams: 'a mere collection of dreams without the dreamer's associations, without knowledge of the circumstances in which they occurred, tells me nothing and I can hardly imagine what it could tell anyone'.[5] If the work of art has the character of a shared dream, it becomes urgent to specify more clearly what it is that is being shared. This is the problem to which I should like to direct your attention.

In order to escape from generalities I should like to pose this problem in as concrete a form as possible. I show you here one of Picasso's most popular works—

popular at least on the other side of the iron curtain: his so-called Peace Dove (Fig. 8). What I may call its manifest social or public meaning is quite clear. The dove is an old conventional symbol for peace and it owes this meaning to the conviction that it is a very meek bird. Perhaps it is not without significance that Konrad Lorenz has told us that actually doves or pigeons are most savagely aggressive. The psycho-analyst will then want to go beyond this surface meaning. He will ask what other qualities may have contributed to the success of the dove as a symbol. Ernest Jones has drawn attention, in a somewhat different context, to the qualities through which it lends itself as a phallic symbol.[6] Perhaps this meaning is indeed present to reinforce the appeal of the poster as a poster—but this would also be true if a hack rather than Picasso had drawn it.

Now we happen to be able to guess a little at least of the personal meanings that the dove, or rather the pigeon, must have for Picasso. His friend and companion Sabartés, living in an age made avid for such memories through the influence of psycho-analysis, has recorded episodes from the artist's childhood that centre round the pigeons his father used to paint.[7] Picasso's father, Don Pepe Ruiz, was an artist and keeper of the local museum in Majorca, and he used to paint salon pictures of dovecots which Picasso still likes to glamorize. These pictures Don Pepe painted from stuffed pigeons which he carried to his office and back home. Now Picasso remembers having been paralysed with fear when left alone at school, and tells how he used to cling to his father and how he kept his father's walking stick, his paint brushes, and most of all his stuffed pigeon as hostages to make quite sure his father would come back and fetch him. Before this audience I need hardly enlarge further on the symbolic meaning of all these implements of his father's trade. Nor, I suppose, would you consider it far-fetched to imagine that this frantic fear of losing the father screens an obvious oedipal wish. Small wonder, you may say, that the boy took eagerly to helping his father paint pigeons, that he advertised for these birds in a children's newspaper that happens to be extant, and that his identification led him to excel as an infant prodigy in drawing and earn a prize for academic exercises as a boy of twelve. Less wonder even, that it was this same boy who, as he grew up, eliminated his father's name Ruiz from his signature, called himself Picasso after his mother, and proceeded to kill his father's academic standards not only in himself but the world over. So far the story looks neat enough.[8] But the aesthetic question is still unanswered. Does this private meaning really glow in the work before you? Could you surmise it from this poster if Sabartés had not obliged us accidentally with this telling episode? Frankly I doubt it. Though the pigeon must be charged and overcharged with meanings and memories for Picasso, though he cannot but have enjoyed this opportunity of doing a pigeon, as his father did, but one that would fly over half the world, I see no evidence that this private meaning reverberates in the particular work, that it is communicated.

Here, of course, would be a field where psycho-analysis could help immensely in clearing up the tangle in which the theory of art as communication has landed us. For if the idea that the private unconscious meaning of a work communicates itself to the unconscious of the public is more than a misunderstanding of psycho-analytic doctrine, then it should be easy to test. All you have to do is to compare the reactions. in analysis, of some of your patients to the same work of art. If, by a happy chance, the artist himself were also in analysis it would be even better, but it is not a necessary condition. Because if the theory of unconscious communication makes sense, it could be tested through the recipients alone—if their reports tally there was an intersubjective meaning—like a code for which there is a standard key.

But I think one need only formulate this theory in such a crude manner to appreciate its shortcomings. The relation between an artist and the world at large—between private and public meaning—are obviously much more complex. Perhaps we can grope our way a little nearer to the true state of affairs if we contrast Picasso's peace dove with an earlier work that helped to make his reputation. I mean the *Demoiselles d'Avignon* of 1907 (Fig.9). Here, too, we are reasonably well-informed about some of its private significance, its manifest content to the artist. We know at any rate that the title I quoted was given to it by an art dealer. What it really represents is a brothel in the Calle de Avignon near Picasso's home in Barcelona.' Of course this specific significance would also be hidden from us if we did not happen to have this information. But here we have a work of art which, whether we like it or not, met with a tremendous response. It became the starting-point of Cubism, and thus the origin of much that we call Modern Art. How was this possible?

You need only ask this question to see that if it can be answered at all it cannot be answered in terms of Picasso's personal history alone. It acquired this meaning within a different context: the context of the institution we call art. Now for the psychological history of this institution I must refer you back to Ernest Jones' clandestine history of art which I communicated to you at the beginning of this lecture. It is a history, as you remember, not of external accretions, but of a constant extension and modifications of symbols. This is particularly true of what we call representation in art. You know how slowly that skill is acquired in history—how it proceeds from the so-called conceptual symbols of child art or primitive art to a slow approximation to what we call appearances. Indeed, all the mechanisms described by Ernest Jones in his paper on the 'Theory of Symbolism' could be illustrated from this history of our peripheral field of study. The pleasure principle that favours repetition, the recognition of similarities rather than of differences, is exemplified in the representational and ornamental stereotypes of many primitive cultures; the reality principle, which proceeds by assimilation of the unknown to

the known, in the countless instances in which tradition colours perception or expression. Thus it is a familiar fact that the eighteenth-century artist who went out to record the beauty of the English countryside was as likely as not to return from his expedition to the Lakelands with a version of Claude Lorrain's Roman Campagna, just sufficiently modified to pass as a faithful vista of a beauty spot. It is perhaps less familiar but equally true that many a young artist who sets out to record his unconscious images returns from this *descensus ad inferos* with a version of Picasso's penultimate invention just sufficiently modified to pass as self-expression. What matters to us, of course, is not that so much of art or pseudo-art is derivative, but that up to a point all art must be, if Ernest Jones' description applies. It is this fact, I believe, which explains that art has a history, a style, in contrast to perception and to dreaming which have not.[10] And so the fact, for instance, that all eighteenth-century landscapes or twentieth-century dream-paintings have enough in common to allow us art historians to tell, on the whole, where and when they were made, is not due to some mysterious fluid or collective spirit that governs the modes of perception or the images of dreams but rather to the observable fact that symbols developed from a common stock will tend to have a certain family likeness. But I see the *Demoiselles d'Avignon* staring at me fiercely and reproachfully—how did they come to be modified into such a shape? If the genetic approach is right the attempt to answer such a question will always threaten to land us in an infinite regress, or—what is much worse—in an infinite lecture.

I would really have to take you back to Pygmalion, the mythical artist who fashioned the figure of a woman—or rather not a figure, but a woman. For you know from Ernest Jones that in these dim beginnings of art a symbol is not experienced as a symbol. The child's baby doll is not an image of a baby so much as a member of the class 'babies'; provided, that is, that you can do with it what babies are for—hug it, bathe it, and throw it on the floor. Pygmalion's statue, we may surmise, was a woman in the sense in which the doll is a baby—it had sufficient characteristics of her sex to be classifiable as a woman.[11] At least when we enter the light of history we can see that the symbol of a woman is not created by closely imitating the appearance of the female body, but more or less by the process historians have called conceptual representation. In this case it is the representational formula for man which is just sufficiently modified to be acceptable as the symbol for woman. The reason may be that artists both in archaic Greece and in the Middle Ages (which saw a repetition of this process) were men, and that what Schilder calls the body image, the awareness of the artist's own body, is always a strong compelling force in early attempts at representation. At any rate you can see in such thirteenth-century figures as the Adam and Eve of Bamberg Cathedral that Eve is just distinguished by an addition of two small symbolic breasts (Figs. 10–11). Even when Botticelli painted his Venus he had not yet quite mastered the anatomical

problem. One can see from his corrections, his *pentimenti* (Fig. 12) which remain visible on the canvas, how he shifted the breast about, and how unsure he was of the relative position of arm, shoulder, and breast. One generation later a Raphael, who had absorbed the representational symbols of classical art, had no such difficulties in the painting of his Galatea (Fig. 13). He can and does visualize the body in the round and represent it in the most complex posture. Now it is well to remember that such a complex image is not only more difficult to paint but also more difficult to read than the more primitive representation of Botticelli.[12] Up to a point we have to work from clues and repeat in our mind the imaginative effort of the artist if we are to build up the figure for ourselves. We have to become Pygmalions to this Galatea. It is true that the artist helps us to find these clues. The very symphony of symmetries he builds up helps us in the process of assimilation, for we need not always start afresh; we are being trained while looking, and we cannot but enjoy these correspondences, these visual rhymes which lead our eye around and make it build and re-build the picture. In front of such a painting we may remember the passage from Dr. Jones about the constant unmasking of previous symbolisms. Looking back from here, Botticelli's Venus must have appeared a mere symbol rather than the truth. And yet the same would probably happen to anyone who looked back to Raphael's *Galatea* from a later generation that had already seen Titian's *Europa* (Fig. 14), which is so obviously a challenge to the earlier work. To people who saw the truth revealed by Titian's painting (now at the Gardner Museum in Boston), the play of light, the rush of movement, the tangible body, Raphael's nymph may well have seemed contrived. At the same time you see how Titian can rely on a public ready to make even more difficult adjustments. No longer need he rely on overt symmetries. Or look at the arm with its shadow across the foreshortened face. What demands it makes on our imagination! The degree to which Titian can rely on suggestion—on the trained connoisseur meeting him half-way—is particularly revealed in the miraculous landscape of the background with its cloudy forms into which we must—and can—project the figures of Europa's companions rushing to the beach (Fig. 15).

Let me pause for a moment to recapitulate what we have observed. In the eighty years between Botticelli and Titian there is clearly an enormous increase in skill; in skill not only of representation but in making sense of representational symbols. This duality, this interplay between the artist and the beholder, is a factor which is often overlooked. We owe its theoretical formulation from the point of view of psycho-analysis to Ernst Kris, who is my guide and mentor in these things. It was Kris who first emphasized that the emergence of what might be called the aesthetic attitude to painting—as distinct, that is, from the ritualistic attitude—brings about a new type of reaction, or, as he puts it, of discharge. The connoisseur wants to identify himself with the artist; he must be drawn into the charmed circle and

share in his secret. He, too, must become creative under the artist's guidance.[13]

To us historians this psycho-analytic insight is so valuable because without it such rapid developments as the one I described would be inexplicable. Here, as often, a somewhat deeper psychological analysis of what actually takes place has shattered more facile generalizations. The development of style, of modes of representation, is too often treated as the result of organic growth, of real evolution. At the very time that Titian painted, Vasari thought he had discovered the secret of the history of art. Art grew up like a human being, there was an organic development from childish beginnings to mastery. The conclusion that art, in its turn, was just another symptom of a general process of maturation—that people who drew like children had a more childish mind—looked only too plausible. We now see, perhaps, why this plausible view is so superficial. Mature art can only grow within the 'institution', as I call it—within the social context of the aesthetic attitude. Where this breaks down, representation must soon revert to the more primitive, more readable conceptual image. We can test this theory not only through an analysis of the decline of western art in late antiquity, but more strikingly perhaps, by comparing the Venice of Titian with the London of Shakespeare. Nobody would seriously contend, I believe, that the mind of Shakespeare's audience was necessarily more primitive than that of Titian's public. In fact, Shakespeare even provides the proof that the thrills of visual projection were familiar to his audience; think of Hamlet and Polonius talking about the cloud that is shaped like a camel, or of the majestic image of the changing shape of clouds in *Antony and Cleopatra*. But through lack of opportunity Elizabethans could not paint such complex pictures (could they even have read them?). Compared with the miracles of Titian, their portraits look like stuffed dummies.

It cannot have escaped you that within the sphere of painting the aesthetic relationship brings about a greater freedom. This Europa, painted for Philip II of Spain, is of course more frankly erotic than anything that went before. But the erotic content is neither concealed nor obtruded. It is absorbed, as it were, in that aesthetic process of re-creation, of give and take. We can guess that an increase in such active participation, in projective activity, may be accompanied by an easing of conventional taboos. Even the pious King of Spain could look at such a masterpiece of the brush without guilt feelings, for who could deny that here was art at its highest?

This observation of the compensatory nature of aesthetic satisfaction was also suggested to me by the work on the history of caricature I was privileged to undertake with Ernst Kris.[14] For this, in a nutshell, is really the result at which we arrived by more circuitous paths: portrait caricature appeared so late in the history of art because of the aggressive component that underlies the distortion of a physiognomy. It seems as though it could become acceptable as an art by virtue of the premium of

the aesthetic achievement, the sophisticated game of creating an intentionally dissimilar likeness. This game, in turn, presupposes the trained response of the connoisseur, who repeats the artist's imaginative performance in his own mind. Basically we have, of course, the same mechanism as the one Freud discovered in wit. But visual wit is apparently harder to learn and to appreciate than the verbal joke. And so it needed not the evolution of mankind but the development of visual evocation in Italian art to come to fruition.

These examples suggest that there is something like a necessary balance between what one might call aesthetic activity and regressive pleasure. If this is so it would have important consequences for the interpretation of stylistic changes. For if this theory is right the absence of such balance will result in aesthetic discomfort. I must apologize if I proceed to test this theory on you, but I see no other way of bringing home to you the truth of this psychological observation. This is a nineteenth-century treatment of our theme of Venus rising from the sea—by that most successful of masters of French nineteenth-century *Art Officiel*, Bouguereau (Fig. 16). Let us admit right away that Bouguereau has made further progress in the direction of representational accuracy—beyond Raphael, whom he exploits, and beyond Titian. Aided by the successive conquests of appearance made during two centuries and by the mechanical device of photography, he places before us a most convincing image of a nude model. Why, then, does it make us rather sick? I think the reason is obvious. This is a pin-up girl rather than a work of art. By this we mean that the erotic appeal is on the surface—is not compensated for by this sharing in the artist's imaginative process. The image is painfully easy to read, and we resent being taken for such simpletons. We feel somewhat insulted that we are expected to fall for such cheap bait—good enough, perhaps, to attract the vulgar, but not such sophisticated sharers in the artist's secrets as we pride ourselves on being. But this resentment, I submit, only screens a deeper disturbance; we could hardly feel so ill at ease if we did not have to put up a certain amount of resistance against the methods of seduction practised on us. And so it is small wonder that works of this kind coincided with a retrograde movement of taste; the sophisticated looked out for more difficult gratifications and found them in the cult of the primitive. For the refined connoisseurs of Bouguereau's age it is Botticelli's Venus which becomes the haunting image of chaste and childlike appeal. Its very awkwardness in construction endeared it to the art lover, who wanted to make his own discoveries, his own conquests, rather than to yield to seduction.[15]

Perhaps this is the moment to remind you of another of Ernest Jones' papers on art: I mean the essay he published exactly forty years ago about 'The Influence of Andrea del Sarto's Wife on his Art'.[16] It is not the historical problem that concerns me. I do not want to yield to the temptation of writing a 'del Sarto Resartus' and of risking the name of a Teufelsdröckh. If the biographical facts Vasari tells us

c

about the artist are correct—and that is always a big 'if'*—Dr. Jones' diagnosis of a
case of suppressed homosexuality will certainly stand, and the passivity it implies
is obviously suggestive in our context. But what attracted Dr. Jones in his essay was
the problem of the artist whose very virtuosity seems something of a handicap.
Again I resist the temptation of discussing whether we still see Andrea in that light.
For what matters to us is that such a reaction was not only possible but widespread
among the nineteenth-century critics whose verdict forms the starting point for
Dr. Jones' study. I believe it was Robert Browning above all who reinterpreted
Vasari's estimate and created the moving image of Andrea del Sarto, called the
faultless painter—the artist who suffers from too much facility.

> At any rate, 'tis easy, all of it!
> No sketches first, no studies, that's long past!
> I do what many dream of, all their lives,
> —Dream? strive to do, and agonize to do,
> And fail in doing . . .
> Well, less is more, Lucrezia . . .

And then comes the moment when he takes the charcoal to show that he could
easily correct a mis-drawn arm of Raphael's; but still, with all its faults—or should
I say because of its faults?—Raphael's is the greater work. This, I dare say, is an
idea that could never have entered the mind of Vasari or, for that matter, of the
historical Andrea. The fault of faultlessness is a discovery of the nineteenth
century.[17] And I think that the question it raises—the question What is wrong with
perfection?—has a greater chance of being answered by psycho-analytic thought
than the question of what is right with perfection, which in the nature of things can
only produce the sonorous tautologies of much academic aesthetics. Why do we really
abuse the masterpieces of Bouguereau and his school as slick and perhaps revolting?
I suspect that when we call such pictures as his soulful *Elder Sister* (Fig. 17) in-
sincere, for instance, or untruthful, we are talking nonsense. We screen behind a
moral judgement which is quite inapplicable. After all, there *are* pretty children in
the world, and even if there weren't the charge would not apply to painting. But this
does not mean that our own reaction is not genuine. We do tend to find such things

*Dr. Jones was, of course, aware of the fact that Andrea's near-contemporary biographer is not
always a reliable witness, but it is only in the last few decades that we have learned to see the purpose
and degree of Vasari's distortions. Briefly, his book must be read as a series of inspiring examples
and cautionary tales for young artists. Within this moralizing context Andrea is cast for the role of
the hen-pecked weakling who does not get anywhere despite his undoubted gifts. He must have
had character-traits that lent themselves to such interpretation, but it is likely that Vasari fastened
on them for two reasons: first, because he knew Andrea to have left the service of the French king,
quite an unforgivable act in the eyes of the courtier Vasari; and secondly, because of his unwilling-
ness to jump on the bandwaggon of Michelangelo's followers, an equally serious blunder to his
archmannerist biographer. If we add to this that Vasari may well have been bossed by del Sarto's
wife (as apprentices were apt to be bossed in those days) when he stayed in the master's house as a
poor and rootless beginner, the personal motives which guided his literary revenge become only too
apparent. How far this account, in its turn, then prejudiced an objective appreciation of del Sarto's
art this is hardly the place to discuss.

syrupy, saccharined, cloying. With these terms of abuse we are on firmer ground. They describe by synaesthetic metaphor our reaction to a surfeit of oral gratifications.

Now it is my conviction, which I should like to submit to you, that the importance of oral gratification as a genetic model for aesthetic pleasure is a subject that would reward closer investigation. After all, food is the first thing on which we train our critical faculties from the moment of birth. The very word taste which we use to describe a person's aesthetic responses suggests this model. But so strong is the Platonic prejudice in favour of the spiritual senses, the eye and the ear, that a blanket of social disapproval seems still to cover such animal gratification as eating and drinking. Psycho-analysis cannot be accused of that prejudice, but here the insistence on art as communication and on the model of the dream seems to have worked as a deterrent to investigators. I do not know whether a good cook communicates something through the sauce he makes or invents, but I do think that such an invention need not be all that far removed from aesthetic creativity as we are sometimes told. The French, who know most about such things, call an artist's manipulation of paint his 'cuisine', and indeed certain paintings afe really meant for the dining room—a feast for the eye. I hope you need not be reassured that I do not think that that is all there is to painting. Botticelli's Venus, or a self-portrait by Rembrandt, clearly have other dimensions of meaning and embody different values[18]—but when we speak of the problem of correct balance between too much and too little we do well to remember cookery. For it is here that we learn first that too much of a good thing is repellent. Too much fat, too much sweetness, too much softness—all the qualities, that is, that have an immediate biological appeal—also produce these counter-reactions which originally serve as a warning signal to the human animal not to over-indulge. Perhaps it could be shown that this warning signal shifts from a biological to a psychological plane. I mean that we also develop it as a defence mechanism against attempts to seduce us. We find repellent what offers too obvious, too childish, gratification. It invites regression and we do not feel secure enough to yield.

I am afraid I cannot cite much evidence, for if there is psycho-analytical literature about this particular aspect I have failed to spot it; but my impression is that such reaction increases with increasing age and civilization. The child is proverbially fond of sweets and toffees, and so is the primitive, with his Turkish delight and an amount of fat meat that turns a European stomach. We prefer something less obvious, less yielding. My guess is, for instance, that small children and unsophisticated grown-ups will be likely to enjoy a soft milk chocolate, while townified highbrows will find it cloying and seek escape in the more bitter tang or in an admixture of coffee or, preferably, of crunchy nuts.

Now for the wider psychological interpretation of this distinction between the

soft and the crunchy I can quote psycho-analytic authority. Edward Glover, in his study 'The Significance of the Mouth in Psycho-Analysis',[19] describes in a masterly fashion how these types of gratification penetrate, as he says,

'every nook and corner of our daily life. All gratifications'—he says—'are capable of distinction in accordance with the satisfaction of active or passive aims. They stamp respectively the biter or the sucker. Study the mouthpiece of pipes, the stub ends of pencils, offer your friends chocolate caramels, ask them if they like new bread or stale . . . observe the degree of partial incorporation of the soup spoon, the preference . . . for cutlet and sauté or sausages and mashed potatoes, and in a few minutes you will be able to hazard a guess as to the instinct modifications after birth which may require the deepest analysis to bring home to the individual . . .'.

As you see, Dr. Glover is here concerned with the diagnostic value of taste, not with its aesthetic dynamics. And yet his analysis has an important bearing on our argument. It links up the idea of the soft and yielding with passivity, of the hard and crunchy with activity. And what makes us sick in art is perhaps an insinuation of passivity which is increasingly resented the higher the brow. For in a way the highbrow, the sophisticate, the critic, is a frustrated artist, and if he cannot satisfy his standards by creating, he wants at least to project; this is a craving, it seems, that easily increases with its satisfaction. How much of it is due to narcissism, the need to be able to enjoy what is inscrutable to the rest, it would be interesting to know. But one thing is important here. The enjoyment itself is not merely pretended. It is as genuine as the revulsion from the cheap and vulgar. I should ask your permission to support this contention with another little experiment *ad hominem*. Again I must beg your forgiveness for inflicting yet another work of *Art Officiel* on you. This atrocity is a painting of the *Three Graces* by Bonnencontre (Fig. 18).[20] I will spare you an analysis of all that makes it odious. Let us rather see whether we can perhaps improve the sloppy mush by adding a few crunchy breadcrumbs. This is the photograph of the same picture seen through a wobbly glass (Fig. 19). You will agree that it looks a little more respectable. We have to become a little more active in reconstituting the image, and we are less disgusted. This second image (Fig. 20) shows the same painting seen at a greater distance through the same glass. By now, I think, it deserves the epithet 'interesting'. Our own effort to reintegrate what has been wrenched apart makes us project a certain vigour into the image which makes it quite crunchy. I'd like to patent that invention, for it has great economic potentialities. In future, when you find a picture in your attic of 'The Monarch of the Glen' or of 'Innocence in Danger', you need not throw it away or give it to the charwoman. You can put it behind a wobbly glass and make it respectable.[21]

For you must have noticed that this artificial blurring repeats in a rather surprising way the course that painting actually took when the wave of revolt from the Bouguereau phase spread through the art world. Let me just remind you of this mount-

ing crescendo in a few pictures. This Renoir (Fig. 21) reminds us of the blurring achieved by Impressionism which demands the well-known trained response—you are expected to step back and to see the dabs and patches fall into their place. And then Cézanne with whom activity is stimulated to even greater efforts, as we are called upon to repeat the artist's strivings to reconcile the demands of representation with obedience to an overriding pattern. It is just because this reconciliation is never complete—because we are constantly brought up against tensions and barbs, as it were, which prevent our eyes from running along smooth lines—that to us Cézanne can never be boring (Figs. 22, 23).

But let us not, in pursuance of this one line, forget our formula. The increase in activity permits regression elsewhere. Something like this process of compensation must also find its place in our oral model. The biter who finds the pleasures of passivity barred to him finds his compensation in the indulgence of aggressive impulses. Such a compensation, a redistribution of psychological gratifications, must also take place during the post-Bouguereau period. In a way, I was really over-simplifying when I said that the crudities of *Art Officiel* demand no activity from the beholder. They appeal to him to complete the anecdote, to dream up what happened before and what will come after, as in this painting by Kaulbach called *Before the Catastrophe* (Fig. 24). I'd like to know why this simple pleasure has also become taboo to the highbrow; why his aesthetic super-ego pulls him up not to be childish and to attend to the form—to turn, as it were, from a thematic apperception test to a Rorschach. One could learn a lot in studying such prohibitions. At any rate, Impressionism succeeded in excluding literary association and in confining the give and take to the reading of the scrambled colour-patches. But in return for this effort of shared activity, it yields a wonderful premium of regressive pleasure. For the first time in several centuries the public were allowed to see real splashes of loud, bright, luminous colours which had been banned as too crude and primitive by Academic convention. When we speak of the derision encountered by the first Impressionist pictures, do not let us forget how quickly the method triumphed and made all earlier paintings look like 'mere symbols'.[22] Impressionism stands on the watershed between two modes of satisfaction. It can be seen as the summit of the process that leads the pictorial symbol to be matched ever more closely with appearances, and as the beginning of an openly regressive art, of primitivism. Within the complexities of Cézanne, standards of representational accuracy that had been the norm for centuries could be relaxed; van Gogh and Gauguin forsook them altogether for the sake of an imagery crudely and aggressively regressive. And so at last we are back at the situation within which alone Picasso's *Demoiselles d'Avignon* can be understood.

You remember that Picasso was an infant prodigy, and remained a virtuoso of the easy hand who could outdo his father any time. By 1905 he had developed a

distinctive manner of his own, in which he combined a note of social compassion with a predilection for wan, somewhat pre-Raphaelite figures (Fig. 25). There is a touch of *fin de siécle* in these tender mothers and strolling acrobats who so appealed to the imagination of Rilke. And yet one can imagine that the ease with which these insinuating figures came to him must have made the young artist feel a little like Browning's or Ernest Jones' Andrea del Sarto. Imagine the impact on such a nature, first of the exhibition of the Fauves in 1905, and then of the great show of Cézanne arranged in 1907 after the master's death.[23] Like Browning's Andrea, who observes the fault in Raphael's arm, it must have brought home to him that 'less is more', that the striving and agonizing of Cézanne stood higher than his own somewhat fatal ease. What would a gifted and ambitious artist do ? He would apply the wobbly glass, but go even further in that direction than Cézanne or the Fauves had ever done. Somewhat like this (Fig. 20)—or rather like this (Fig. 9).

Now psychologically the interesting thing is not that he did what was more or less in the logic of the situation,[24] but how hard he had to struggle to get away from skill and sentiment and meet the demand for more activity and more regression. There is evidence in the sketches that when he first planned the brothel picture it was to have fallen into the category of that compassionate genre Picasso had developed. The artist says at any rate some 30 years later that the man who enters what an American catalogue calls 'a scene of carnal pleasure' was to have carried a skull.[25] Picasso had doodled erotica before,[26] and maybe his decision to choose such a subject for a monumental canvas was part of his desire for stronger meat—but he still sought contact with tradition. For the moralizing accent reminds us of the Temptation of St. Anthony, which Cézanne had painted several times and which Picasso may have known.[27] The early sketches for the individual women fit this interpretation (Fig. 26-27). To Picasso, as to many writers of the time, the prostitute symbolized the victim of society, and he endows her with a wistful beauty. It is dramatic to see how he struggles against this pull to paint one more image of graceful outcasts; how he eliminates all trace of the anecdote and sets out to create something more passionate, more savage. And it is important to note that these symbols do not rise spontaneously from his own mind, but can only become articulate through contact with things seen. Sophisticated taste among the Fauves had discovered the enigmatic force of primitive art as seen through Western eyes. And so it is to Negro masks (Fig. 28) and African fetishes (Fig. 29) that he turns. But even in this guise there was still some sentiment. If I am right in my interpretation, it is not before he abandons for a time his own medium, which had become so fatally easy for him, not before he takes to carving, where he can exploit his lack of skill (Fig. 28), that he can find the way to the regressive forms from which all trace of Bouguereau had been expelled and which therefore made such an impression on his time.[28]

And now he pours into these regressive forms all the aggression and savagery that was pent up in him. The great smashing begins. He invents the game of Cubism, the art of representing Humpty Dumpty after the fall. In these pictures primitive representational cues turn up, but only to tease and misdirect us—we try to integrate the guitar (Fig. 30) as we integrated Galatea or Europa, but find that we are everywhere brought up against a contradiction, till our mind is set in motion like a squirrel in a cage. But look at the premium of regression that is offered us if we let ourselves be whirled by the merry-go-round. In the dizzy chase after Humpty Dumpty the primary process comes into full play—anything is possible in this crazy world—is not this guitar with its curves and its hollow body (Fig. 31) also a symbol of the female body? And this primitive picture of a bottle beside another guitar (Fig. 32)—is it not also a phallus? Perhaps. Though I readily confess that I put this suggestion to you rather as a premium for all the activity to which I have compelled you. For now, of course, I have nearly done. If I am right, the point about such paintings is not that their creator, like all of us, has an unconscious in which these archaic modes of symbolization live on; nor even that like all of us he partakes in his mind of the qualities of Oedipus, Pygmalion, and perhaps of Bluebeard. The point is that he found himself in a situation in which his private conflicts acquired artistic relevance. Without the social factors, what we may term the attitudes of the audience, the style or the trend, the private needs could not be transmuted into art. In this transmutation the private meaning is all but swallowed up.[29]

I am afraid I cannot yet quite leave off without showing at least that I do not want to run away from the question that must have obtruded itself on you. If we refuse Bonnencontre our resonance because his paintings are too mushy, does this imply that a Cubist picture that appeals to us for being gritty is therefore good art? I am sure things are not as simple as that. In a way every taste and style can become the instrument of a great artist—though some may be better instruments than others. But while I think that taste may be accessible to psychological analysis, art is possibly not. I am conscious of having oversimplified those shifting urges, the psychological pulls and counterpulls that result in changes of taste and style within the context of civilization;[30] but though a fuller analysis would certainly have to take account of more elements, I do think that such redistributions in the balance of gratification are neither quite so complex nor quite so significant as stylistic movements are sometimes made out to be. For when all is said and done they concern acquired taste. This is the most malleable part of human nature, the one most easily affected by social pressures and not, as it is sometimes claimed, the inmost soul of what is called 'an age'. But though I am convinced that the artist can only become articulate through the symbols presented to him by the age, the real work of art clearly achieves more than the satisfaction of a few analysable cravings. Instead of a fairly simple parallelogram of psychological forces we are here

confronted with the highest type of organization. Here we must assume countless pulls and counterpulls on a hierarchy of levels that would baffle analysis even if we had greater insight into the kind of elements used. Every square inch of any painting in any style may testify to a yielding to regressive impulses in the colour employed and to a domination of such impulse in the disciplined brushwork that husbands its force for the climax.

> 'There is a dark
> Inscrutable workmanship that reconciles
> Discordant elements, makes them cling together
> In one society . . .'

Psycho-analytic terminology allows us perhaps at least to discuss these elements, and to indicate the centre of what Wordsworth more beautifully describes as 'a dark, inscrutable workmanship'. It is the ego that acquires the capacity to transmute and canalize the impulses from the id, and to unite them in these multiform crystals of miraculous complexity which we call works of art. They are symbols, not symptoms, of such control. It is *our* ego which, in resonance, receives from these configurations the certainty that the resolution of conflict, the achievement of freedom without threat to our inner security, is not wholly beyond the grasp of the aspiring human mind. But, when I come to think of it, I'd like to shirk the question after all, whether the picture on the screen holds all its elements in such a miraculous and reassuring balance. For to answer this question—let it be said in all humility— Psycho-analysis is not really competent; but neither is the History of Art.

On Physiognomic Perception

A N apology is needed for introducing a discussion in 'The Visual Arts Today' with extracts from a lighthearted skit published by the Goettingen physicist, Georg Christoph Lichtenberg, in 1783.[1] If the reader glances at the illustrations, the general direction of the argument should become apparent: they come as near as the eighteenth century ever did to experiments with 'abstract' shapes. It is true that they are intended as representations depicting various forms of tails, tails of dogs and of pigs, and 'pigtails' of men, but they are shown for their physiognomic, or as we should say today, for their 'expressive' qualities. The target of the satire was the method of Johann Caspar Lavater, who had started a vogue for reading people's characters from their portrait silhouettes.[2] What provoked Lichtenberg was not only the matter but also the manner of Lavater's effusions, his pretentious and exaggerated language, his rapturous intuitionism—a style, by the way, that betrays the influence of art criticism, of the famous purple passages in which Winckelmann tried to convey his admiration for the masterpieces of Greek sculpture.[3] A few samples from Lichtenberg's parody must suffice to establish my point that there is still something to be learned from his implicit criticism of this 'physiognomic' approach to shapes and forms.

B

With a warm heart embracing the whole of nature and with pious awe contemplating every one of her creations, dearest reader, beloved friend of my soul, behold this tail of a dog and declare if Alexander, had he wished to sport a tail, need have been ashamed of such a one. There is nothing namby-pamby ladyship's-pet-lap-doggie sweetie mousie nibbling tiny creature here. All is manliness, forward urge, a high sublime sweep and a thrust, calm, pensive, charged with dynamic power, as far removed from servile slinking between the legs as from that of the pointer's, game-scenting, worried and horizontally in-decisive. Were man to perish, in truth the

A Dog's Tail

sceptre of this earth would go to tails like this. Who does not feel a sublime caninity bordering on humanity in the curve near a.? In position, how near to the earth, in significance, how close to the heavens! Beloved Nature, darling of my heart, if ever you may desire to grace your masterpiece with a tail, listen to the fervent prayers of your doting servant and bestow on him such a one as B.

This paper was written as a contribution to *The Visual Arts Today*, ed. G. Kepes, Cambridge, Mass., 1960.

This tail belonged to the favourite dog of King Henry VIII. Caesar he was called and Caesar he was. On his collar one read the motto: *aut Caesar, aut nihil* in golden letters and more clearly yet, and more fierily his eyes declared the same. His death was caused by a fight with a lion; but the lion died five minutes before Caesar. When they called out to him 'Marx, the lion is dead' he wagged this eternalised tail three times, and died, a hero avenged. . . .

*Eight silhouettes of students' pigtails as an exercise:**

1. Almost the ideal pigtail. The shaft teutonic, steel-like, the flag noble, the rose of aggressively loving tenderness. It snarls death to the philistine and to the unpaid bill. Certainly more power than prudence.

2. Here everywhere more prudence than power. Timidly straight, nothing highminded, no surges of temper, neither a Newton nor a Jack the Ripper. A sweet dandyish whip of a pigtail, not for discipline but for decoration, a tender marzipan heart lacking the pulse of fire. Its highest flight a little song, its boldest wish a little kiss.

3. Dammed-up dynamism. A powderkeg forgotten under a brazier, if it explodes it fills the world. Oh noble, excellent pigtail. *Angli et angeli.* A pity only that you depend on a mere mortal neck; if you flew through the heavens the comets would say: which of us could vie with you ? Studies medicine.

[4 and 5 omitted]

6. Assuredly either a young tomcat or a young tiger, a hairsbreadth closer to the latter.

7. An abomination. Fie, fie, indeed! How can you have sat on a head consecrated to the Muses. Maybe you were once torn in a drunken brawl from the wig of a barber's apprentice or a strolling musician, and tied as a trophy to the student's hair. Wretched botchery, not nature's work, but a ropemaker's. Hemp thou art and hemp should rather have strung up the neck of thy tasteless possessor to the gallows.

* Another apology to historians of costume for the inaccuracy of my terminology.

8. Hail to thee and eternal sunshine to the blessed head that wears thee. If ever reward accorded with merit it is thou who wouldst be the head, thou excellent pigtail, and thou the appendage, blessed head. What kindliness in the silky tender slope, effective without any masking hemp-hiding ribbon, and yet smiling bliss like plaited sunbeams. Soaring as far above even crowned heads as a saint's halo over a nightcap. . . .

Questions for further exercise:
 Which is the most powerful?
 Which is most charged with creative energy?
 Which is the lawyer, the medical student, the theologian?
 Who is most in love?
 Who has a scholarship?
 Which of them might have been worn by Goethe?
 Which of them would Homer select were he to return to earth?

There is no surer way of killing a joke than explaining it. I shall certainly leave it to the reader to draw the parallel between Lichtenberg's butt and those effusions of modern critics that may come to his mind. My purpose is not so much to attack nonsense as to discuss the validity and the limits of the physiognomic approach. For clearly there is some residue of sense in his commentaries. They could not be swapped round among the illustrations without losing in conviction. And this conviction is not only strong but lasting. To me the dog's tail has become 'charged' with that expression of heroic poise that Lichtenberg manages so brilliantly to read into it.

For there is indeed such a thing as 'physiognomic perception' which carries strong and immediate conviction. We all experience this immediacy when we look into a human face. We see its cheerfulness or gloom, its kindliness or harshness, without being aware of reading 'signs'. Psychologists such as Heinz Werner[4] have emphasized that this type of 'global' and immediate reaction to expression is not confined to the reading of human faces or gestures. We all know how easily a similar response is evoked by other creatures, how the penguin will strike us as grave, the camel as supercilious or the bloodhound as sad—needless to say, without warrant from the 'behavioral sciences'. Moreover, the metaphors of our speech testify to the ease with which we carry this physiognomic perception into fields even further removed from their rational application; we speak of cheerful colours or melancholy sounds. Any poem, good or bad, will furnish examples of this extension of physiognomic perception, also known as the pathetic fallacy, telling of smiling skies and menacing clouds, the caress of the wind and the soothing murmur of the brook. These reactions testify to the constant scrutiny with which we scan our environment with the one vital question: are you friendly or hostile, a 'good thing' or a 'bad thing'? It may be argued that the answer to this question is as basic to the survival of any organism as are the answers to the questions of other perceptual probings, such questions as "What is it?", "Where am I now?", "How do I

get from here to there without bumping into things?" Indeed if we follow Bruner[5] and others in regarding perception as a process of categorizing, we may argue that the application of physiognomic categories of 'smiling' or 'menacing' are among our earliest and most basic responses.

What speaks in favour of this view is the 'regressive' character of these experiences. There is something basic and compulsive, as Lorenz has shown,[6] in our reading of animal physiognomies, which suggests the proximity of unlearned layers. Even the poet's metaphor of the smiling sky suggests, as do all metaphors, a looser network of categories than do the tighter meshes of literal and rational language: the poet lives in a world where all things can still be divided into those that smile and those that frown, he has preserved the child's capacity to probe and question anything in nature—and anything in nature will answer him clearly enough to allow him to 'sort' the world into these 'physiognomic' categories.

From this point of view, metaphors are not primarily 'transferred' meanings, linkages established, as the classical theory of metaphorical expression has it. They are indicators of linkages not yet broken, of pigeonholes sufficiently wide to encompass both the blueness of a spring sky and a mother's smile.[7] It adds to the interest of these categories that they are so often intrasensory: the smile belongs to the category of warm, bright, sweet experiences; the frown is cold, dark, and bitter in this primeval world where all things hostile or unpleasant strike us as similar or at least equivalent.

How far are these reactions subjective or culturally conditioned? Not entirely, it seems. Even though language and cultural habits may contribute much to the currency of individual metaphors and poetic clichés, we still do not expect any people to call their sweethearts 'bitter' or to sing of the cold and dark smile of a mother fondling her baby. Osgood's experiments in his much discussed book, the *Measurement of Meaning*,[8] seem to point in a similar direction: his team asked subjects to classify a number of random words in terms of apparently irrelevant qualities, e.g., are fathers more heavy than light, are boulders more serious than gay? Whatever criticism of Osgood's methodology may be possible, one thing emerges from these curious questionnaires: we are ready to categorize any notion in terms of such contrasting qualities, and our response, so it seems, will not be entirely random. Boulders, it may be, belong to the world of potential obstacles, and so, by the way, do fathers, if compared to feathers. What wonder that they are both found on the harsher side?

It is obvious that not only poetry but all the arts rely on these responses for some of their effects. What we call the 'expressive' character of sounds, colours or shapes, is after all nothing else but this capacity to evoke 'physiognomic' reactions. There is no theory of art, old or new, which ignores this element altogether. The ancient theory of music, for instance, elaborated the 'expressive' character of modes and

keys, orators discussed the physiognomy of words, rhythms, and sounds, and architects had something to say about the physiognomy of the various 'orders' in architecture. Even in the visual arts, the expressive possibilities of shapes and forms as such were by no means neglected by the writers of the academic tradition.[9] It was only with the rise of Expressionism, however, that the artist's and critic's attention was almost exclusively focused on this elementary effect. The first thing that teachers of art and art appreciation try to impress on their students nowadays is to look out for the expressive character of shapes, textures, and colours. This shift of emphasis may well be a necessary reaction to the increased demands by our technological civilization on the rational faculties. To those who fear that the rush of mechanized living deadens our immediate response to the voice of things and kills the child within us, it is a source of comfort that artists and critics remind us of these pristine layers of experience. There is thus a good deal to be said for exploring and developing these sensitivities, but only on one condition: we must not confuse response with understanding, expression with communication.

It was this confusion, I contend, that Lichtenberg found in Lavater. Not that he denied the possibility of understanding and interpreting physiognomic expression. He was himself the author of the most detailed commentary on Hogarth's satirical sequences ever to appear. But here, he would have argued, the context of the story, together with all the emblematic allusions introduced by the artist, guided the interpreter and controlled his flights of fancy. The reason why Lavater's method of physiognomic intuition results in nonsense is not that he explores his own response, but that he treats it like an infallible oracle that is in no need of corroboration.

The scientist Lichtenberg, on the other hand, knew that the intensity of a personal intuition is no measure of its correctness. He had experimented with physiognomic impressions and found them wanting. He had tried, for instance, to picture to himself the face of the night watchman from the way he heard him call the hours during his nightly round, and then he sought him out to sketch his portrait. There was no similarity.

Popular wisdom, of course, has always warned us against relying on 'first impressions'. Why, then, are we so rarely aware of the extent of their fallibility? All cognitive processes, I believe, demand above all a flexibility and elasticity of mind. There is no advantage in our remembering the early stages of our probings that have been superseded by a better fit. Unless we fix them deliberately, as Lichtenberg did, they are conveniently discarded and forgotten. It is a worthwhile and humbling exercise to follow his example and (in the absence of night watchmen) to listen to a conversation behind you on a bus, trying to figure out the appearance and social status of the speakers before turning round and checking your intuitions, or consciously to anticipate the voice of a person who is just being introduced to you. Only by such introspective experiments can we learn how we actually build

up the image of a person in real life. We always try to make as much sense as we can on the basis of such clues as are given us. But we are flexible enough to amend this guess as other clues become available.

The person with a gloomy face will alert us to the possibility of other gloomy symptoms; but as soon as his voice or his smile refutes this expectation we forget or ignore our first impression and adjust the category in which we place him. We may see his handwriting, and if we are responsive to those signs, we may enter its surprising boldness on our image of the man. Should we then hear of other traits, his heroic war record or his fondness for Verdi, we always add the information to rectify our former image (which we quickly forget). Each time we instinctively conceive it as our task to fit the mosaic stones into one unified impression, a picture of the man as we form it through our efforts to 'make sense' of all his traits.[10] It would need a very severe jolt for us to abandon this basic physiognomic hypothesis of a unified character behind all the manifestations we register. The 'split personality' is something we may be able to grasp intellectually, but hardly emotionally.

What should emerge from this discussion is both the value and the fallibility of physiognomic intuition. Without its initial response we could never arrive at a hypothesis which we could subsequently modify and adjust to the evidence provided by life or by history. But we destroy the value of this instrument if we overrate that initial groping, our first move in the effort to make sense.

The role of such initial probings for any act of understanding, any hypothesis, has been stressed with particular force in K. R. Popper's epistemology.[11] We could not find our way through the world if we did not use the stream of incoming stimuli to answer specific questions that help us to decide between given alternatives. Where we lack all other clues, we must venture on a random guess that subsequent observations will have to confirm or refute.

I believe that the physiognomic reactions that Osgood and others have investigated are of a similar character. In normal conditions we would not operate with them any longer than necessary to perform the first unstable act of categorization which serves as a starting point for subsequent probes. Lichtenberg's 'further questions for exercise' illustrate the same effect of a choice situation when we are asked to decide which of the hairstyles might have been Goethe's.

No one has more reason to interest himself in this type of situation than the historian, who tries to build up a picture of the past by asking it questions of a similar kind. There is a charming sketch by Max Beerbohm which happens to take us into the same milieu as did Lichtenberg's skit. It is entitled 'A Clergyman', and it deals with a scene reported in Boswell's *Life of Samuel Johnson*.[12] A simple question interjected by an anonymous clergyman provoked one of the Doctor's characteristic outbursts. Beerbohm fills in the details of the scene from his imagination, he convinces us that the interjection must have been made in a high-pitched

voice, and he gradually builds up the image, and indeed the whole melancholy life-story, of the unfortunate vicar whose fate it was to be crushed by the great bear.

In a sense, Beerbohm provides a model of how every historian should and does react to the stray pieces of evidence that reach him from the past. But remembering the warnings of the satirist, he will always be ready to abandon or modify his imaginative reaction as soon as more clues become available. Who knows? He may after all be able to identify the clergyman present at Mrs. Thrale's party, and even to find his portrait or description. The very intensity of his vision will spur him on to test it against fresh evidence. His training has made him aware of the subtle difference between the ability to make sense and the possibility of understanding.

Here, at last, we come back to the problems of art and understanding which are the real concern of this essay. I have drawn attention in a different context to what I have called the 'physiognomic fallacy' in the history of art.[13] It is first exemplified by Winckelmann, who professed to divine the 'noble simplicity and quiet grandeur' of the Greek soul behind the impassive marble front of classical statues. The misleading character of such impressions has been commented on by critics as diverse as Meyer Schapiro[14] and André Malraux.[15] And yet the illusion of a 'spirit of the age' persists. We may now understand a little more clearly how this illusion of unity arises and what its function may be in the historian's work.

Whenever an ancient cult image, the pattern on a brooch, a broken column or a painted potsherd asks to be interpreted, any historian worth his salt will try to make sense of it in such terms as his creative imagination suggests. But a critical mind will not rest content with this vision. He will watch for further evidence to fit it into the image of the lost culture. Usually, of course, such further evidence is available in one form or another, and the historian's task is precisely to fit it all together into a context that 'makes sense'. And so intensely does his imagination become engaged that he begins to people the past with the men who might have created those very brooches and done those very deeds of which the sources tell us. There is much to be admired in this effort of the imaginative historian to 'wake the dead' and to un-riddle the mute language of the monuments. But he should never conceal from himself that his method is circular. The physiognomic unity of past ages which he reads from their various manifestations is precisely the unity to which the rules of his game have committed him. It was he who unified the clues in order to make sense of them.

There is a natural transition between these techniques and compulsions of the historian to make sense of the unintelligible, and the problems confronting the critic of contemporary art. Much of this art demands to be interpreted in historical terms: it is said to represent the spirit of this age (except, of course, where it expresses that of the future!). No wonder that art criticism has largely been replaced by what theologians used to call 'apologetics', the teacher or preacher expounding the

esoteric mysteries of the oracle *in partibus infidelium.* Whenever the public fails to understand, this must be due to its incapacity to respond, and so he demonstrates that it is possible to 'make sense' of those bewildering configurations on the museum walls or the lecturer's screen.

But, I fear, no more is needed for this demonstration than that skill of verbalizing our physiognomic responses that is so successfully parodied by Lichtenberg. We can all train ourselves to do a Lichtenberg for almost any lump or blot. By virtue of their mere existence they must have a physiognomy, some kind of expressive character, if only we dig deep enough into the layers of our mind that respond to the voice of things. The only trouble is, that the way of regression is not the way of understanding. In the unified physiognomic world of the child no differentiation has yet occurred between the inanimate and the animate, let alone between things and symbols. Can we be surprised that art, having embarked on the road of systematic regression, seems also on the way to abolishing these distinctions and to exploring the expressive voice of accidental shapes and random movements? If we train the public to share in this game, Burri's framed piece of old sacking can soon be trumped by any old sack. In one way, of course, art has always had this function of teaching regression. It is the poet and the landscape painter who have kept alive the voice of nature for an urbanized civilization. But regression alone is not art. Where it reigns supreme, everything becomes charged with meaning, as in a dream, and there can be no difference between sense and nonsense. The physiognomic approach may lead to the suicide of criticism.

I believe that this sad event will be the outcome of a real moral dilemma which does honour to our age. We have learned that *tout comprendre c'est tout pardonner,* but we tend to forget that this admirable maxim befits the psychiatrist in his consulting room rather than the critic. True, the critic too must widen his sympathies and cultivate his capacity to respond, but he must still keep his will to understand sufficiently under control to distinguish between Goethe's pigtail and Goethe's *Faust.*

I have no ready solution to this dilemma. But I would contend that the first step will be made when the critic again regards it as his duty to respond *and* to criticize. He need not surrender his new tolerance to do so. He need not even criticize the shapes and configurations offered for his response any more than he would criticize the shapes of the mountains in Switzerland. You cannot argue with shapes, but you can argue with painters and those philosophies of art that have resulted in a situation that is as torturing to the artist[16] as it is stultifying to the critic. What we need above all, I believe, is a fresh analysis of fundamentals. Having seen where the identification of art with expression leads us, we must claim the right to examine its credentials.

In conclusion, therefore, I should like to glance at one characteristic passage in

Dewey's *Art as Experience* which illustrates, to my mind, the weaknesses of this approach.[16] It is all the more interesting, as Dewey here argues against Roger Fry's rejection of all content in painting.

> A person with a knack can easily jot down lines that suggest fear, rage, amusement, and so on. He indicates elation by lines curved in one direction, sorrow by curves in the opposite direction. But the result is not an object of *perception*. What is seen passes at once over into the thing suggested. . . . The meaning of an expressive object, on the contrary, is individualized. The diagrammatic drawing that suggests grief does not convey the grief of an individual person. . . . The esthetic portrayal of grief manifests the grief of a particular individual in connection with a particular event. It is *that* state of sorrow which is depicted, not depression unattached. It has a *local* habitation.

One feels that there is some force behind Dewey's strictures, but their formulation is open to doubt. We remember that the meaning of his contrasting lines will indeed be obvious, but only on one condition, the condition of Osgood's experiment: if we ask any beholder which of the lines are more sad than gay, the answer will be not only easy but trivial. Without some such context it will not only be hard but impossible to find their 'meaning'. Not only might the same pair of lines be sed to suggest the contrast between youth and age, dark and light, earth and air,[17] but if we encountered them among geological diagrams or statistical graphs, their expressive character would cease altogether to be perceived. If, on the other hand, we were determined to individualize their expression, there would be nothing to stop us, as Lichtenberg's skit proves. Why should we not ask those 'diagrammatic lines' if they represent the grief of a man or a woman? if of a woman, whether that of an old or a young woman? if of a young woman, whether she is fair or dark? What can prevent us, in the end, from charging those lines with as much meaning as Lichtenberg projected into the tail of his dog Caesar? Is it not precisely the point that we can always give any utterance a local habitation if there is nothing to contradict our projections?

No line as such, whether drawn by an artist or merely by a 'person with a knack', can alone and unaided 'convey the grief of an individual person'. Communication, as engineers have been reminding us in the last few years, always presupposes a selection between possible alternatives, a tuned receiver ready to be switched from one state to another by some impulse travelling along a channel.

Those who subscribe to the theory of art as communication have not helped their case by calling any mark the artist makes on the canvas a 'statement'. They forget (if they ever knew) that this description should be reserved for propositions that can be true or false. A patch of red is no more a statement than the word 'fire'. True, we may use either of the two for a communication, but only on condition that the context makes it clear how it is being used, and that there is the assumption shared by those communicating that there are possible alternative utterances. The red

light will serve as a traffic signal, because it is neither green nor yellow. The word 'fire' will serve the platoon commander because his soldiers are set for this message. If we twiddle the knob of our radio and hear only a shout of 'fire', we cannot know whether it was part of a message to the police, part of a battle scene, a conductor imploring his orchestra to play with more verve, or an angry boss demanding the dismissal of a stupid employee. Here, as always, we can narrow down our guesses by sampling the broadcast again, but such efforts at making sense should not be confused with understanding the meaning of the statement that a fire has broken out at a given place and time, a message which the fire brigade may find true or false.

It is the problem of the artist that he must, in the nature of things, know the meaning the red patch has for him within the physiognomic context of his private world. The idea that all he need do is to transform his emotion into an 'expressive' configuration and send it across to the sensitive beholder, who will unwrap the parcel and take out the emotion, is responsible for much confusion in these matters. If the rise and fashion of information theory has done any good, it is to have disposed of this primitive 'parcel post' model.

I am by no means sure that art can be wholly described as 'communication' in this or any other sense. But I am convinced that those who desire it to communicate anything must narrow down the vagueness of that first physiognomic guess, which is too often identified with the aesthetic response. Here is the reason why every contextual aid is of so much value—the captions provided by Klee, for instance, or the traditions of certain forms. Here, I believe, is also the reason why we find it so much easier nowadays to cope with paintings by artists we know personally or who, at least, have long been familiar to us through their work. Without some framework against which to test and modify our first impressions, we are left to the tender mercies of our initial projections.

Dewey may be right when he implies in the context of his passage quoted that the content of the picture will often provide the additional dimension needed to question the line for its 'expressive' meaning. This was the traditional solution that certainly proved its worth in the theories of the past. It demanded that the various elements of a work of art be harmonized so as to form a 'whole': the tune of the song had to be fitted to the mood and meaning of its words, the character of a landscape background to the import of the scene represented. To continue with Dewey's example, the grief of the Madonna would be accompanied by lines different from those that might fit the grief of a jilted girl.

I do not wish to imply that Dewey's argument disposes of all attempts to build up an art of expressive forms alone. Instrumental music is always there to remind us of the possibility of such an art, but music does not rely on the physiognomic impact of one intuitive response. The opening chords of Beethoven's *Eroica* are certainly expressive, they put us in a frame of mind, but they alone are not the symphony.

The symphony, it seems to me, takes shape precisely as we follow the anticipations of these chords and find them modified, confirmed and transformed by the subsequent development. Understanding the *Eroica*, in other words, may have some features in common with those other processes of understanding that I have described before. To be sure, it needs that state of responsiveness that goes with regression, but it also needs that willingness to revise, that alertness to further clues, that we associate with other faculties.[18] Only the future can show whether similar modes of apprehension can also be developed for combinations of pure shapes and colours in painting and sculpture. Given certain standards and traditions, this might still happen. But if we do not want to kill these arts with kindness, we must help the artist to find a valid theory of articulation that does justice not only to the expressive character of his elements but also to the mystery of ordered form.

Expression and Communication

THE Romantic idea that art is the language of the emotions has a long and complex history reaching back to the belief in spells and incantations. Frequently attacked and questioned, particularly by the upholders of formalist aesthetics, it still maintains its hold; indeed, it may be more firmly entrenched to-day than in earlier periods. The purpose of this paper is to ask how a language of the emotions might be conceived to function and where the main misconceptions may lie that have laid this theory open to justified attack.

I believe that these misconceptions are conveniently exemplified in the following passage from a lecture by Roger Fry:[1]

'If we take an analogy from the wireless—the artist is the transmitter, the work of art the medium and the spectator the receiver . . . for the message to come through, the receiver must be more or less in tune with the transmitter . . . herein lies the difficulty, for the message of a work of art is generally immensely complex, summarising as I believe a whole mass of experience hidden in the artist's subconsciousness. And this complexity renders it probable that each receiver only picks up a part of the total message . . . many people possess only very imperfect receiving instruments, instruments that can only respond to extremely violent emissions of a crude and elementary kind.

It is never fair to take an analogy literally and there are passages in the same lecture which show that Roger Fry did not want quite to sustain this comparison. If anybody had a right, moreover, to think of his mind as of a sensitive instrument it was this great critic. But Fry's strength lay in the intensity and subtlety of his response rather than in the clarity of his analysis, and the champion of the idea of 'significant form' certainly held some theory of natural resonance. For this is what the analogy from wireless transmissions would seem to imply. It suggests that the artist broadcasts his message in the hope of reaching a mind that will vibrate in unison with his own, and that his medium (the work of art) is only the means to achieve this end. Any failure on our part to respond must ultimately be due to an incapacity for picking up the vibrations that reach us through the medium.

The idea that art effects some kind of emotional contagion has been at the basis of all expressionist aesthetics ever since Horace wrote his famous line:

si vis me flere, dolendum est primum ipsi tibi (*Ad Pisones*, 103/4).

But whatever the value of such injunctions as a technical device for the poet, it is clear, as Susanne Langer has been at pains to point out, that no theory of art could be built on the assumption that, writing a symphony, a composer would have to wait for a gay moment to put down the *Scherzo* and for a melancholy

This paper was written as the opening contribution to a symposium with Professor Ruth Saw on *Art and Language of the Emotions* at the Joint Session of the Aristotelian Society and Mind Association in 1962.

experience to invent the *Adagio*. Susanne Langer, however, holds fast to the expressionist assumption that forms or tones are analogues of feelings and will therefore convey a specific emotional experience.[2] The transmitter can be operated by an engineer who wants to 'present' a 'pattern of sentience', but the beholder is still a mere receiver who will undergo the same 'progress of excitation' if he tunes in and responds as well as the mechanism of his mind allows.

Indeed, if I understand the assumption of the expressionist theory correctly, it is that expression is somehow rooted in the nature of our minds, and that it therefore stands in no need of conventional signs. The following table may make this pretended opposition clear.

Expression	Communication
Emotion	Information
Symptom	Code
Natural	Conventional

The expression of emotion works through symptoms (such as blushing or laughter) which are natural and unlearned, the communication of information through signs or codes (such as language or writing) which rest on conventions. It is clear from the outset that both sides of this table represent extremes, while most means of communication and expression in our daily lives lie somewhere on a spectrum between these poles. Our speech makes use of conventional symbols which have to be learned, but the tone of voice and speed of utterance serve as an outlet for some symptoms of emotions which can even be picked up by small children or animals. On the other side of the scale, our gestures and expressions which we believe to be 'natural' are still filtered through the conventions of our culture; the smile of the hostess is less a symptom of joy than a conventional sign of welcome and, reading Victorian novels, one may suspect that even the maiden's blush can be somewhat stylized.

If we want to look at art from the point of view of communication and expression, we must also first place it somewhere between these extremes. The traditional symbols and emblems we find in religious painting would belong to one aspect, the symptoms of emotion we believe to detect in the painter's brush strokes to the other. It is true that expressionists tend to regard the conventional aspect as less essential, less artistic than the other. Be that as it may, I should like to argue here that we are certainly more likely to make progress in the discussion of this whole area if we analyse the two extremes in artificial isolation before we look at their possible interdependence.

It is clear that the 'resonance' theory can only apply, if at all, to the extremes of 'natural' symbols. Yawns may produce yawns and symptoms of panic may be contagious in an excited crowd. But not even the most extreme expressionist would want to confine the effects of art to such biological reactions. His case has

always rested on the belief that there are such things as natural responses beyond those immediate symptoms of emotions. He points to the 'effects' of forms, tones and colours on man and beast which suggest that the colour red is exciting and slow music soothing. The baby, he would rightly say, does not have to learn the meaning of the lullaby in order to fall asleep and the young child need not be told that bright colours are more cheerful than drab ones.

There are some, I know, who worry about the exact meaning of the statement that a colour is gloomy or a tune sad. I shall assume that we know what is meant. Doubters are recommended to study those cruel anecdotes in which a stammerer, overcome by excitement, is asked to sing his message and blurts out a tale of woe and disaster to the tune of some cheerful 'hit'. We know very well why such a performance makes us laugh. There *is* such a thing as a gay melody and a cheerful colour.

I have discussed this natural equivalence between emotional states and sounds, colours and shapes in various contexts, and have drawn attention, in this connexion, to the experimental tool which C. E. Osgood has developed for their exploration. In Osgood's investigations,[3] the subject is confronted with the question whether, say, black is more sad than gay, more heavy than light, more powerful than weak or more old than young. However irrational these alternatives may sound, answers would appear not to be random. There is some inborn disposition in all of us to equate certain sensations with certain feeling tones.[4] Osgood has arranged these scales in three dimensions to plot what he calls our 'semantic space'. Though this method may well involve an oversimplification, I propose to simplify it in turn and present it for the sake of my argument in a two dimensional form:

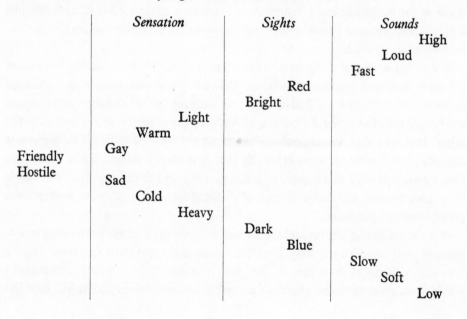

What this diagram suggests is a natural code of equivalences that represents, I think, the core of the expressionist argument. Every colour, sound or shape has a natural feeling tone just as every feeling has an equivalence in the world of sight and sound.

Imagining our basic reactions to be grounded in the biological urge for survival you may say that what is experienced as hostile will make us sad, what strikes us as friendly is gay in mood. Further out on the scale of sensory experiences, we come to the body feeling of change of temperature, where friendliness is experienced as warm and warmth as friendly, hostility as cold and cold as hostile. Along the line of visual sensations, darkness is gloomy and hostile, light warm and friendly. Among colours, red, being brighter than blue, will easily be experienced as the equivalent of warmth and cheerfulness, blue of cold and sadness. And so we come to the gamut of sounds, ranged according to pitch, speed and volume, where the slow, low and soft is more suitable for the funeral march and the fast, tinkling and loud for the triumphal dance.

I am aware of the extreme crudity of this model and would not dream of saddling anyone with the theory in this form. It is clear for instance, that our Western music has other dimensions than those entered into the diagram, the most important being that between tension and resolution based on the distance from the tonic.[5] But refinements of this kind, however interesting, would not upset my basic contention: they would only add another gamut, this time the gamut of intervals or chords, from the 'warm' and relaxed to the 'cold' and tense ones—an attempt which has actually been made by Deryck Cooke in his recent book *The Language of Music*.[6] The same could be shown for gamuts of lines or shapes, where angular configurations would go to the cold and tense end of the spectrum, round and undulating ones to the friendly and warm pole.

If this doctrine of equivalence contained the truth and nothing but the truth, it would allow us to account for the theory of natural resonance. A painter would be a person naturally disposed to project his feelings on to the gamut of sights, a musician would do the same with scales of sound. Feeling sad in a hostile world, either would select from his medium the exactly equivalent shade and the recipient of his message would experience the identical emotion, since he would share the artist's natural code of equivalence. But it is precisely because this theory has proved so persuasive that we must probe its weakness. From the critic's point of view, surely, its principal weakness lies in its total inability to account for structure. It is no wonder, in fact, that its popularity led to an abandonment of structure and to the increasing cult of the spontaneous 'natural' symptom in abstract expressionism and, beyond, to the uniformly blue canvas that expresses the artist's 'blues'.

Roger Fry would have been the last to be satisfied with this state of affairs.

We remember that he criticized people who 'only react to extremely violent emissions of a crude and elementary kind', and he would not have excluded artists from this stricture. But is not this crudeness inherent in the theory? The artist with his blue canvas forgets that whatever message unstructured blue may convey to the applauding critic is not inherent in the blue paint like a fluid or essence, but derives its meaning from its shock effect, its unexpectedness. His very longing to be 'unconventional' draws attention to the importance of convention in this process. We are forced, in other words, to switch our attention to the other side of the diagram, that of communication through conventional signs. And here, of course, the resonance theory lets us down immediately.

I confess that I have selected Roger Fry's formulation of this theory precisely because the analogy from wireless makes it especially easy to show up this weakness. For the conditions of wireless transmissions have been analysed together with other devices of telecommunication by communication engineers who have developed the mathematical theory of information.[7] What this theory has taught us unmathematical laymen to see with greater clarity is the process of interpretation that is bound up with the reception of any signal. It is human beings who communicate, not channels. Hence it is by no means the case that it needs a very sensitive instrument to pick up a complex message. Any channel that can be 'off' and 'on' can transmit a series of messages interpretable as instructions to select one of two alternatives, and this can be done sequentially much as in the game 'Twenty Questions'.

Technicians, I know, look with some misgivings at the uncritical use which is sometimes being made of their concepts outside the area for which they were intended. Intellectual fashions always carry such dangers. We certainly should not take a method of description for a new aesthetic prescription. One of the most interesting devices of information theory, for instance, is the possibility of measuring the information content of any message as inverse in ratio to the prior probability of its occurrence. The entirely anticipated obviously brings no fresh information; it is the unexpected that is news. This way of looking at signals in terms of their expectedness or unexpectedness has proved fruitful in the analysis of style in music and language.[8,9] But it may also have its share in the present cult of the 'random' in art and music which considers creativity entirely in the trivial terms of the invention of the unexpected.

The use I propose to make of the analysis of communication is a much more modest and, I hope, a safer one. It is not to explain art, but to criticize certain assumptions about art. For just as I think that the critic can learn from Osgood's psychological method of questionnaires, despite the fact that art is more than an exploration of 'semantic space', so I shall try to show that the new approach of the engineer has yielded some helpful tools for the probing of the 'language of the

emotions'. In my present context the most important reminder is perhaps the obvious fact that (in the words of Professor Colin Cherry):

'signals do not convey information as railway trucks carry coal. Rather we should say: signals have an information content by virtue of *their potential for making selections*. Signals operate upon the alternatives forming the recipient's doubt. They give power to discriminate amongst or select from these alternatives'.

It is not my intention to apply this technical passage to a discussion of *Hamlet* or of Rembrandt's *Night Watch*. I should rather show its bearing on our problem with a famous story from antiquity which is closer to communication than it is to art. When Theseus' father, Aegeus, scanned the sea for the returning expedition against the Minotaur, he thought of the pre-arranged code according to which a white sail would mean success, a black one defeat. Theseus having lost Ariadne on Naxos, forgot to hoist the white sail and his father drowned himself. Of course, the code could have been enriched to include other possibilities, but nothing Theseus could have done at that distance could have conveyed to his father his state of mind which was indeed plunged in gloom, but for entirely unforeseen reasons. The sail could only function as a signal 'operating on the alternatives forming the recipient's doubt.'

The example is not quite uninstructive in our context because here, too, we have a case where a conventional code interacts with something felt to be 'natural'. Surely it was no accident that black rather than white was the sign agreed upon for failure. Black seems to us a more 'natural' sign for grief, and white for a 'brighter' mood: and even though we know that cultural conventions also play their part (and that black is not everywhere the colour of mourning), the correlation makes sense in terms of expressiveness. But clearly, black is infinitely more likely to be thus interpreted as an expression of gloom where we know, as we know in this case, that there is a choice between alternatives, one of which is to be taken as expressive of gloom. There are plenty of contexts where we are not aware of any possible alternatives and where black, therefore, is of no expressive significance: for instance, ordinary printer's ink ordinarily used.

It may be a little easier now to show up the theoretical fallacies of our hypothetical blue canvas 'charged', as the jargon has it, with the artist's blues; for we are certainly forced to reconsider the Expressionist diagram of synaesthetic equivalences in the light of the theory of communication. If there is anything in this doctrine of natural signs, it only applies to the relationship of alternatives. Where there is a choice between red and blue, the move towards blue is more likely to be felt as equivalent to a move towards the sad end of the spectrum. I need not labour this point, for I have made it in the chapter on 'Expression' in my book on *Art and Illusion*, where I tried to show that all kinds of relationships or transitions can be equated in our half-dreaming mind with the transition from 'ping 'to 'pong'.

D

There may be a layer deep down in our mind (if I may speak in metaphors) for which these sensory categories are only different aspects of the same experience. But maybe it is precisely because they all converge in one point that even the directions seems extraordinarily unstable. That same scale from low pitch to high pitch that looks, in one aspect, equivalent to that from sadness to gaiety, can also be seen as going from warm to cool. Often it is a mere matter of nuance that effects a complete reversal. Tinkling is gay, but a shrill sound is like a shriek and chills you to the marrow. Our culture and our education, moreover, have effectively interfered with our primitive reactions. That all-important contrast between relaxation and tension can also become the opposition between indulgence and restraint; and in contrast with tension, restraint is surely a value, equated in aesthetics with the heroic, the chaste and the pure. These acquired scales turn out to be especially unstable. The sign of indulgence that moves one person to tears may disgust another—not because he has failed 'to pick up the message' but because he understands it all too well. One of the weakest points in the theory of natural resonance is this tendency to equate any failure to respond with a failure to understand.

For those of us who reject the resonance theory, understanding the language of the emotions is much more like any other understanding. It presupposes a knowledge of the language and therefore a grasp of alternatives open to the artist, but it also presupposes what the Romantic would describe as natural sympathy. Without acquaintance with the potentialities of the artist's medium and the tradition within which he works those natural equivalences which interest the expressionist could not come into play. What strikes us as a dissonance in Haydn might pass unnoticed in a post-Wagnerian context and even the *fortissimo* of a string quartet may have fewer decibels than the *pianissimo* of a large symphony orchestra. Our ability to interpret the emotional impact of one or the other depends on our understanding that this is the most dissonant or the loudest end of the scale within which the composer operated.

This is one of the reasons why concentration on the physiognomic properties of sights and sounds will never yield a theory of artistic expression unless it is coupled with a clear awareness of the structural conditions of communication. Granted that colours, shapes or harmonies can be experienced as expressive, the artist can only use these qualities with some confidence within a limited choice situation. The critics who worry how a chord can possibly be described as 'sad' are justified in one respect: it is not the chord, but the choice of the chord within an organized medium to which we so respond. The artist who wants to express or convey an emotion does not simply find its God-given natural equivalent in terms of tones or shapes. Rather, he proceeds as he proceeds in the portrayal of reality—he will select from his palette the pigment from among those available that

to his mind is most like the emotion he wishes to represent. The more we know of his palette, the more likely we are to appreciate his choice.

It is clear from this point of view that the traditional media of art may have come into existence by accident. In theory, there is no reason why other media or gamuts should not be created which serve a similar function. The experiments of contemporary painters with textures are a case in point. I have little doubt that it is possible to build up a response to such novel scales. What I doubt, here and in all similar cases, is only that this response can be an immediate resonance. We would again have to learn, first of all, to regard the degree of smoothness or roughness as part of the message and become familiar with the scale within which the artist operates.

As soon as we look at the artist's ideal public less in terms of minds mysteriously attuned to one another than in terms of people ready to appreciate each other's choice of alternatives, we can ask once more how far such decisions can be interpreted as communicating emotions.

Returning to our highly simplified model, it might be worth examining how far the simplest form of equiprobable alternatives might still take us. In the arts that unfold in time, this principle is easily found; for here we have the example of the engineer's methods. All we would need is to adopt some convention according to which every message presents a binary choice articulated by a subsequent message. If we are sick of 'ping' and 'pong', we can take the contrast between bright and dark (b and non-b). The first message would tell us to look at the brighter side of the scale, the subsequent, if it happened to be non-b, on the darker half of that brighter side and the next, perhaps, on the brighter eighth. Since the original dimensions of the scale are indeterminate, the process would lack a quantitative precision, but as a relational progression it could be imagined to move to increasingly finer distinctions. Let us go back to our example of Theseus: a white sail was to announce success, a black failure. Had he foreseen the possibility of failure in success, he could first have hoisted the white sail and only then the black to indicate that he was victorious but sad, or better still, he could have retained the white sail but modified its message by a black pennant. Crude as the example may be, it may still illustrate the possibility of more subtle methods of articulation which must play their part in the arts of time, such as the rich language of Western music. What else is modulation but the modification in progression of the tonality first established? Of course, in music the black pennant that modifies the white sail can by a sort of magic become itself the principal message when the key relations change. The language of music would certainly not permit any mechanical application of the principle of progressive subdivision and modification, *ad infinitum*.

But then, neither music nor any other art ever worked with one binary code. Western music, as we have seen, combines the gamuts of rhythm, pitch and volume

with those of tension (to recapitulate, only those we have mentioned already): Western painting makes use of shapes, colours, texture—not to speak of subject matter. Even if we imagined for argument's sake that each of these allowed only of one choice of alternatives, the number of possible combinations and permutations would rapidly increase. Given the many gamuts at our disposal, the complexity that can be achieved with this simple vocabulary is quite respectable. For each of these parallel gamuts can be used to support or, if necessary, enforce or enfeeble the message sent on the other channel. Even the painter of our monochrome canvas, after all, which he feels to be 'pong', can reinforce the effect by using the expressive effect of a heavy, downward brushstroke as a further symptom of his blues or, alternatively, he can dab the paint on with such a light 'ping' touch that he counteracts the impression of melancholy.

Much of traditional aesthetics is concerned with the doctrine of mutual reinforcement of various sense modalities and scales, often treated under the rather misleading name of 'decorum' (or fittingness):

"Whatever the general character of the story is, the picture must discover it throughout, whether it be joyous, melancholy, grave, terrible, etc. The nativity, resurrection, and ascension ought to have the general colouring, the ornaments, back-ground, and everything in them riant and joyous, and the contrary in a crucifixion, interment, or *pietà*", says Jonathan Richardson[10] in the eighteenth century. Criticism often consists in pointing out the observance or non-observance of these rules of 'mutual reinforcement'—how the vowels of a poem or its rhythms vary in tune with its mood,[11] or how a composer enhances a text by the choice of harmonies, dynamics and even orchestration. In the chilling language of engineers, such duplication of messages would probably fall under the heading of 'redundancies'.[7] Even engineers, however, know of the importance of redundancies to defeat what they call 'noise'. Their practice of repeating important messages is only the simplest instance. Our speech, as is well known, uses the device of redundancy freely to aid our interpretations, useful where we have failed to attend to every part of a message. It seems to me quite possible that what we call form in art, symmetries and simplicities of structure, might well be connected with the ease and pleasure of apprehension that goes with well-placed redundancies.

The psychological instability of our individual gamuts must make this possibility of mutual reinforcement and anchorage of obvious importance for our model. But given such anchorage, the opposite possibility of mutual modification is even more interesting. A glance at the spectra of sound may illustrate my point. It suggests that the dimensions of louder, of faster and of higher may tend to be experienced as parallel. There are memorable passages in music, such as the climax of Beethoven's *Leonora* No. 3 in which these dimensions are used to reinforce each other and volume, speed and pitch rise to tremendous tension. Practising musicians

know that these three dimensions do indeed tend to fuse, that there is a natural temptation for the 'expressive' player to turn a *crescendo* also into an *accelerando* and to press on a high note. But music would not be the subtle instrument of expression it has become in the hands of our masters if this link were, in fact, always observed. The *crescendo* that remains disciplined within the tempo of the movement is often the more impressive because of its sense of control. No artist is worth his salt who cannot keep the various dimensions of his language apart and use them for different articulations. After all, if an increase along all these dimensions is the 'expected' and the 'obvious' thing, his discipline will earn him the reward of doing the improbable and all the more convincing. We can catch a glimpse here of the direction in which our model could easily be enriched if we abandoned the primitive ping-pong structure and allowed for differences in probability. However, such an attempt would soon take us out of the possibilities that can be sketched out in words. Nor do I think we have as yet exhausted the potentialities even of our crude binary model.

Even in this model such possibilities of mutual modification would increase the artist's range and subtlety considerably. Let us imagine, for argument's sake, that our 'ping' 'pong' is played in print with two types of lettering, normal and **bold.** According to the theory of 'decorum', **'pong'** would obviously have to be printed in heavy type and 'ping' normal, but our modulator would be free to inverse the order to achieve a 'pong' modified by lighter print and a **'ping'** charged with some heaviness. We are free, if we like, to add other possibilities such as 𝔤𝔬𝔱𝔥𝔦𝔠 and latin script. Again, our tendency might be to use a bold gothic for '𝖕𝖔𝖓𝖌', but it is precisely for this reason that a normal gothic '𝔭𝔬𝔫𝔤' might strike you as unexpected and subtle. Perhaps the effect of such mutual modification is no more predictable than it is in cookery, but its possibilities must increase enormously with every new dimension added to the artists' gamuts.

But it is also clear, at least intuitively, that an increase in gamuts or media will not necessarily be a gain for this kind of 'language'. There must come a moment when the message is muffled because of the many signals that we are supposed to attend to. We no longer know which of them is intended to modify what, and thus ambiguity and obscurity increase. The only way out of this impasse would be the establishment of some hierarchy comparable to the temporal hierarchy of subsequent messages. If we knew which was the dominant scale, as it were, and which the subsequent modifications, we could still attend to them one by one in their intended rank. In our example of Theseus, the first message with the sail might be called the classifier, indicating the class of message to which we now shall have to attend, while the pennant might be described as the modifier. Clearly, in larger hierarchies these would become relational terms, every modifier could be a classifier for a subsequent modification.

I realize that this proposal sounds abstruse, but I believe that it really matters a good deal which of two distinctions is seen as the dominant one. That this is so with the distinctions of speech is easily shown. Take the momentous question which Tovey asked, whether good bad music was better or worse than bad good music. Looking at the example, we see that the English language makes sure of this distinction by making the adjective nearer the noun the dominant classifier, the one further removed the subordinate modifier. It is not uninstructive to look for similar examples, such as the difference between a left-wing Right-wing politician and his right-wing Left-wing rival, or, more simply, that between a reddish blue and a bluish red.

Perplexing as these distinctions are, the psychology of perception suggests that in the field of vision, at least, we are all marvellously adept at playing the game of 'classifiers and modifiers'. Our ability to separate what is called the local colour of things from the colour of illumination is based on this skill. We easily recognize the difference between a white wall in the shade and a grey wall in sunlight; more than that, even where the light reaching our retinas from both may be identical the two will 'look' quite different to our interpreting mind. And so with all sense modalities. The same scent or taste is known to affect us very differently according to our interpretation of its source. It is not a question so much of how a dish tastes as what dish is modified by this particular flavour. Plutarch remarks somewhere that that fish looks and tastes best that appears to be meat, and that meat that looks and tastes like fish. I have not tested this idea, nor would I like to. But everybody has experienced how closely related the 'what' and the 'how' are to our minds. The '*haut goût*' of venison would repel us in beef.

The point of this digression was to give one more reason for the importance of context and structure in our interpretation of expression. For if hierarchies could be shown to play their part in the language of the emotions, they would allow us to distinguish between degrees of understanding and misunderstanding. It is an experience common to all of us that great works of art are inexhaustible. Contrary to our crude models, their texture of relationships is so rich that we can never get tired of exploring them. But there is a difference, I would contend, between this feeling of understanding a work better and better, without changing one's basic interpretation, and another, more disconcerting experience when we discover, or believe we discover, that we have misunderstood it altogether and have to start from scratch because we had got the hierarchies of meaning upside down. To give a simple example: *Don Quixote* is (probably) rightly understood as a comic novel with tragic overtones which of course, have their comic aspects and so on, *ad infinitum*. To take it the other way round and read it as a tragic work with comic touches is the kind of misunderstanding I would distinguish from incomplete understanding. It may be more intense, but it is also more wrong-headed than a superficial reading that only takes in the crude first pointers.

We have thus come a little closer, after all, to the traditional problems posed by *Hamlet* or Rembrandt's *Night Watch*. We can see why it makes a difference whether *Hamlet* is primarily to be understood as a tragedy of revenge or as a study of neurotic indecision, or whether the *Night Watch* is primarily a group portrait or a history piece.

Dilemmas of this kind only throw into relief the firm guidance which tradition and experience usually give us. In traditional art forms, the category or *genre* provides the first pointer. The grim *scherzo*, the melancholy waltz, even the senseless shaggy dog story, could not deliver their 'message' without this firm context. In painting, of course, the traditions of subject matter used to establish the dominant classifier even where they were modified beyond recognition. Courbet's *Stonebreakers* presented the public with a figure from 'low life' on a heroic scale. Turner's late landscapes modified the traditional Academy picture in the direction of the sketch. Each of these achieved some of their 'expressive' force by what, in a strictly technical sense, should be called a breach of decorum. If the history of an art is of any relevance to aesthetics, it is precisely because it will help us in these first rough and ready classifications on which all our subsequent understanding may hinge. Granted that a great work of art is so rich in structure that it remains potent even when misunderstood: if we are really out to receive its 'message', we cannot do without all the contextual aids the historian can unearth.

One example must suffice here. Its bearing on our argument is all the greater as it concerns a work by an Expressionist painter which has recently been used with much success to elucidate the expressionist theory of art. In his Charlton Lecture on Kandinsky's painting *At Rest* ('Ruhe') (Fig. 34), Professor Ettlinger has shown convincingly[12] how Kandinsky used unstructured colours and geometrical shapes in the belief that these were inherently charged with emotive power. The artist's theoretical writings testify to his interest in all ideas of spiritual resonance, from those of the Romantics to those of Theosophists and Anthroposophists. He also appears to have interpreted the investigations of Gestalt psychology in the light of these preoccupations. Professor Ettlinger makes it clear that Kandinsky wanted the shapes themselves to suggest and convey the feeling of calm or repose. He mentions the similarity of the configuration with a 'harbour with sailing boats and a steamer', but he is convinced, in the light of Kandinsky's declared aims, that such an interpretation is as wide of the mark as are the notorious diagrams transposing Raphael's paintings into systems of triangles and squares. In the terminology of this paper, we could say that Raphael may have painted Madonnas modified into triangles but Kandinsky, at most, triangles modified into a harbour scene. Professor Ettlinger makes no secret of his opinion that Kandinsky's experiment did not quite come off. I certainly doubt that even the most sensitive beholder would feel 'at rest' in front of this picture.

It so happens, however, that we can restore a clear expressive meaning to Kandinsky's composition by placing it in its historical context. During the 'twenties, the artist worked side by side with Paul Klee at the *Bauhaus*, and the two were friends. In a humorous snapshot of 1929 they posed together as the famous twin monument to Goethe and Schiller.[13] Now, in 1927 Klee, who never shunned representation, had experimented with the suggestion of movement in ships, first in a drawing of slightly swaying sailing boats and then in a larger harbour scene which he called 'Activity of the Port' (*Aktivität der Seestadt*) (Fig. 33). It is a witty experiment in conveying the bustle and restlessness of the harbour by novel graphic means. What is relevant to our context is only how much Kandinsky's work, painted a year later, gains in intelligibility when placed side by side with Klee's. Suddenly the massive rectangular forms acquire indeed the dimensions of heaviness and calm, they are the 'pong' to Klee's 'ping'. The artist may well have thought all the same that his picture speaks for itself. Whether we are writers, critics or painters, we are all apt to forget that not everyone shares our knowledge and our past experience. But without such sharing, messages will die on the way from transmitter to receiver, not because we fail to be 'attuned', but simply because there is nothing to relate them to. Neither communication nor expression can function in a void.

But this refutation of the resonance theory would hardly have warranted our effort if the results only applied to the receiving end of the transmission. I believe that the examples studied must also have their bearing on the understanding of the rôle of language of emotions for the artist himself. Surely Kandinsky's starting point can hardly have been a feeling of calm which he wanted to 'code' in terms of shapes. Whether he knew it or not, his imagination was kindled by Klee's experiments. The discovery of how much could be conveyed by lines and shapes must have stimulated him to explore how far such means could be simplified and still be used for varying expressions. It was the challenge of modifying an existing configuration. In playing these games, the artist becomes his own public, as it were. He is fascinated by the possibilities of choice and of variation within a restricted medium not only, as the formalists would have it, because of the fascination of structure as such, but also as we have seen, because it is this restriction alone which enables him to equate his choice with the 'ping' and 'pong' of feeling tones. No emotion, however strong or however complex, can be transposed into an unstructured medium. Both the transmitter and the receiver need the right degree of guidance by an array of alternatives within which the choice can become expressive.

Having been so much concerned with games and models, I should like to conclude with a suggestion of how to replace Roger Fry's analogy while remaining in the area of communication. Instead of his simile of transmitters, let us think of

a correspondent who regularly writes letters overseas at the present postage rate of sixpence. One day, in a receptive state of mind, he is struck by the prosy purple colour of the sixpenny stamp and, being in a playful mood, he casts around for other combinations that would express his feelings more adequately. Needless to say, the recipient might never notice this deviation from the norm if he were not told of the birth of a new art form. But once the stage is set, our players could start the game. Their medium consists of ten denominations of stamps —$\frac{1}{2}$d., orange; 1d., blue; $1\frac{1}{2}$d., green; 2d., brown; $2\frac{1}{2}$d., red; 3d., purple; 4d., light blue; $4\frac{1}{2}$d., light red; 5d., light brown; 6d., light purple. Both financial prudence and a sense of form impose the rule of affixing the right amount. Even within this limiting rule, however, there are no less than six choices of uniform colours (12 orange, 6 blue, 4 green, 3 brown, 2 purple, 1 light purple) which may reflect quite a variety of moods—'reflect', that is, for the partner who would appreciate the message of three brown stamps as about the drabbest that could be selected. Given such a partner, he would surely and rightly expect a splendid piece of news when he saw the envelope decorated with the maximum of variety, one orange, say, one blue, one red, one green, then another orange, keeping the contrasts throughout at the widest. Combine the two oranges and go thence to red and then from blue to green, and the tension has subsided although the mood is still very bright. Of course, the two can also agree on the direction of reading, making the left-hand stamp the 'classifier' that stands for the dominant mood, while the others articulate it in succession. Perhaps great anger and some sadness would lead to two red, and one blue stamp. Only a fit of reckless fury, however, would break through the rules altogether and affix three red stamps at the gratuitous expense of $1\frac{1}{2}$d. But in such a fit of extreme expressionist abandon, our correspondent would be in danger of spoiling his medium for good. Once the rule is broken, there is no valid reason why he should not plaster the whole envelope with colours. Moreover, going back to the rules will be increasingly difficult, for it would now imply that his emotions have cooled more than he would like to indicate. As a true artist, therefore, our correspondent will not yield to this temptation of 'breaking the form', at least till he has exhausted all its possibilities. What challenges his imagination is rather the game itself, the wealth of combinations adding up to sixpence which the reader is invited to explore. Perhaps those who get really absorbed in the game will try to fit their moods to interesting combinations rather than make the message fit the mood. Only those who do, I believe, may have the true artistic temperament— but that is a different story.

Achievement in Mediaeval Art

EVERYONE who still has faith in the future of art history as a discipline must be grateful to Garger for posing, with extreme precision, a problem which self-respecting scholars have thought themselves obliged, for the sake of scientific objectivity, to avoid.

The problem is one of aesthetics—a term which we need to learn to accept again. Garger asks whether it is at all possible to make a value judgement about a work produced within a style and tradition which belongs to the past. The discussion of any general question of this kind requires some general assumptions within which to work. The assumptions made by Garger raise, however, certain difficulties, and it is with these that the following paper is concerned. In saying this I should not be taken as launching a polemic against Garger's vivid and absorbing paper, but simply as attempting to examine the problems with which he deals from a sufficient distance to let the details dissolve and the main outlines become clearer.

II

FIRST of all, Garger's conception of artistic achievement appears to oversimplify the situation, for he asks with regard to any particular work of art: what was intended here and what was achieved. Surprising as it may seem, even behind these simple questions there is an assumption which needs examination. This division between intending and achieving, if taken strictly, presupposes a conception of artistic production which can be described, schematically, as Platonic.[1] 'An artist' according to Dürer 'is one who is inwardly full of images' and can realize his conceptions in his material. The work of art, therefore, is nothing but the projection of an inner picture; even where it appears incomplete, 'it is really complete if the artist has achieved his aim' (Rembrandt). On this view, artistic ability has two parts, having ideas and being able to execute them. Artistic achievement involves a passage from the eye to the hand, from the mind to the canvas. But must this notion of achievement serve for all conceptions of art?*

* A genuine elucidation of this concept would pre-suppose a psychology of the creative process by which the image in art was generated, something one could scarcely improvise. G. A. S. Snijder's *Kretische Kunst* (Berlin 1936) brings it home to us how many-sided the problem is. The next step would have to be a clarification of the concept of projection in its application to different types of art. It surely matters in our evaluation of a work of art whether we regard the picture before us as actually produced by tracing round a vivid mental image, conceived as projected onto the drawing surface, or as proceeding from the pre-conscious. The latter type of case may, in turn, vary in the degree to which the mark already down contributes to the further development of the drawing, or the painting already done has an effect on how the painting develops. It looks as though the artist could take the same attitude to the unfinished or unsuccessful parts of his work as he might to an accidental configuration, letting himself be led by its suggestions. The doodler can re-interpret his own marks as he interprets an ink blot. The unlikely rhyme may stimulate the poet to a bold image. Who in such cases could evaluate the achievement from the point of view of fulfilling some pre-conceived design? Before we know where we are the question has become one of the level of inventiveness, in the sense in which this might appear in a Rorschach test score.

This paper was first published in German under the title 'Wertprobleme und mittelalterliche Kunst' in *Kritische Berichte*, 1937. The paper of Ernst von Garger which it discusses was 'Über Wertungsschwierigkeiten bei mittelalterlicher Kunst', published in the same journal for 1932–33. The translation is by Michael Podro.

It must be emphasized that the supposed division between intention and result, aim and effect, is only appropriate in its rigorous form for the art which emerged after the idea of inspiration had become current. A Leonardo may linger and hesitate over how to complete his image of Christ, but the artist of an earlier period entertained only ideas which he knew how to realize. He did not struggle with his medium nor search for a new method of expression, but thought and formulated with already known elements. He did not follow an inner voice, but an external commission which laid down that the projected work be firmly based upon the patterns already established for works of that kind.

The work therefore, which the mediaeval artist set out to produce did not exist in his mind's eye, for, as we know from Schlosser's work on the subject, the whole procedure was of a quite different kind. What he had before him was not a mental picture but a real model (*simile*). He knew, on the whole, what his finished product had to be like. Both the visual motifs and the subject matter were given. His first problem was achieving what Garger has termed the required degree of recognizability. With regard to the 'work of art', the precise nuance of colour and expressive tone, perhaps it was not the artist's habit to worry too much until he had his pencil or chisel in his hand. Garger's question of when the artist would have thrown his brush away in despair (having failed to realize his mental image) may not, therefore, be quite appropriate.

For this kind of experience belongs to our contemporaries who grope for a subject which would embody a certain emotive quality, and who struggle from the beginning to the end of their creative process for precise shades of brightness or gloom, delicacy or restraint. The mediaeval artist may very well simply have accepted the emotional overtones—including the facial expressions—as they happened to emerge. But we may go further and ask, whether, for instance, a Carolingian illuminator would have understood Garger if the latter had asked him which aspects of his work had come out as intended and which were botched. His education may have taught him that that which had perfect technical finish was precisely that which was good—and that doubly so in a world in which finished craftsmanship was what was prized in a work of art.* Here we certainly have a perfectly clear concept of skill in execution, but this sense of skill is scarcely problematic and is relatively easy to judge. Particularly in the art we term 'applied' (a term which would be redundant in the context of the middle ages) there are few points of dispute. Manual skill, at least, has well defined levels. **In the seventeenth century the aged Rembrandt may have lacked recognition while a Metsu was prized

*'And it was finished, the agonizing work. Perhaps it was not good, but at least it was finished, and as soon as it was finished, there it was, and it was good.' (Thomas Mann: *Schwere Stunde*).

** The question of the door of San Zeno in Verona should perhaps be re-considered in the light of this. There are parts of the older panels of the doors (for instance the Dance of Salome) where surely the finished product did not correspond to the model from which it was cast. (Fig. 37)

but I suppose that it is inconceivable that one of the supreme craftsmen of the Middle Ages, a goldsmith such as Nicholas of Verdun was an unappreciated genius.

But if we take Garger's question about intention and achievement in this way, we trivialize it quite inadmissibly. For treated in this way the fundamental questions about the criteria of aesthetic value, about the nature of aesthetic achievement, are simply ignored. But where are we to seek such criteria? It seems that we should inquire into the kind of possibility of achievement which exists within any given system or style before asking about the achievement of the particular work. After all, what we mean by a skill is the ability to perform a given type of task, and so we should ask what kinds of tasks the mediaeval artist was set. On what was not demanded of him there has been general agreement. Copying nature, certainly a concrete task, was not his aim, but rather the re-employment of a stock of forms, the characters of a pictographic system, derived from classical antiquity. Thus his task became, above all, a matter of mastering the use of these signs; the copyist has to do justice to the significance of his exemplar. But one ought not really to speak of copy and exemplar, for our mediaeval artist's product should rather be thought of in the way that we today think of the performance of musicians and actors. The text is there, the manner of presentation—the charging of that text with meaning—is what constitutes the aesthetic achievement. The mindless interpreter is just as little an artist as one who arbitrarily mangles his text.

The analogy is not complete, but perhaps it throws some light on the possibility of achievement within an art where what counts is neither a fresh mastery of natural appearances nor the creation of new formal structures. Certain types of Far Eastern art follow more completely the pattern suggested by this analogy; for there the work of art may be a performance re-creating another which already exists. The analogy holds much less well in the case of mediaeval art which is far less homogeneous. For here the objective closeness of a work to some classical prototype can no more be a criterion of value within mediaeval art than closeness to the copybook reveals the distinction of someone's handwriting.

III

THE analogy with handwriting, however, may also be misleading. Quite enough has been written by interpreters of mediaeval art about expressive lines, giving, that is, a graphological interpretation. But if, in taking this approach, one has no standard of comparison, no norm to which to refer the particular example, one will go awry. Conventional signs respond much more readily to expressive impulses than do images forming part of a naturalistic idiom. If Van Gogh's excitement transforms the character of cypress trees into a mass of agitated flamelike lines, the graphic expression breaks through the norm of natural appearances. An image from the

middle ages which at first sight looks similar, demands, however, a different inter-pretation. The excitement which turns a traditional symbol into a flourish is differ-ent in degree and kind from that which impinges in representation. In the former a system (or set of forms) is seen as disrupted, in the latter it is simply altered. Nevertheless, it must be admitted that, where there are established symbols and conventions, the additional graphological element can have its effect: that is, one is justified in regarding them not only for their intended and conventional meaning (like the letters of an alphabet), but also as the symptoms of an emotional state (like a gesture).

Even someone quite unmusical can see something 'appassionato' in the manus-cript of Beethoven's *Appassionata*. The written notation is charged with expression, but this happens to be extrinsic to the music. In the visual arts of the West, however, this factor oftens enters into the work itself, revitalizing the sign with fresh meaning. The middle ages also knew the possibility of this kind of effect. One can imagine that the prototype of the *Evangelist* in the Schatzkammer in Vienna might have been executed in the style of the Ébon Evangelist, or rather, that these works indicate two basic possibilities of mediaeval art (Fig. 35–36). But such an aprioristic con-struction of the actual aesthetic possibilities gives an account of only one side of the historical situation of mediaeval art, and that not the most important. Furthermore, the picture of mediaeval artists as freely interpreting traditional forms is one quite unauthenticated by the historical evidence. Certainly as we move from one work to another we find, wherever we go, variations on the same motifs, but what one wants to know in this context is just how far it was a matter of the artist being allowed freedom to make transformations.

IV

GARGER, in the first instance, may want to make the incompetence of the copyists responsible for change. There may be cases in which this is so, but they are surely untypical. The classic example of extreme transformation is that afforded by Irish and Anglo-Saxon illumination. What occurs there in so marked a way may be found to a certain extent in large areas of mediaeval art. Ought one to go on using Garger's conception of ability in these cases ?

The straightforward dexterity of the artist who illuminated the Book of Kells is as beyond dispute as the direction of his transformations is clear. If one raises the question of achievement here, it becomes necessary to distinguish, much more clearly than Garger does, between ineptitude and primitiveness. This one can only do if one admits the relevance of some concept of evolution.

This question about primitiveness is not new, but perhaps it had to recede into the background for some time in order to be asked again with renewed point. An

earlier generation of scholars, concerned with tracing the common characteristics of all types of primitive style, drew certain consequences from these similarities. We owe to them the notion of the 'conceptual image' which dominates child art as well as primitive art.[2] Its prevalence in Egyptian art was explored by Schaeffer, and its re-emergence in mediaeval art was emphasized by Schlosser. Thus it seems that the intellectual tools already exist for taking up the discussion again.[3]

In fact we now know a little more about the characteristics of primitive image making: we can draw on research into the ornament of primitive peoples,[4] the imagery of the blind and the insane.[5] Many common factors are beginning to emerge, so that the question as to the respects in which mediaeval art belongs to what we broadly term 'primitive image making' does not appear senseless.

V

ONE day it may be possible to describe the development toward the primitive in late antique art as one of dissolution, but not one of unqualified decline. For the return to the primitive may have brought out aesthetic virtues which would not otherwise have emerged. Garger himself elaborated on this notion elsewhere,[6] but in the way he has recently posed the question about achievement in mediaeval art, he has left it somewhat obscure. The return to 'picture writing' which went with the pre-occupation with content, was a joint condition of the dominance of the 'conceptual image'. This furthermore facilitated the emancipation of formal values. There is only an apparent paradox here. For in as far as the recognizability of symbols is not compromised and the sign remains a sign, primitive predilections may be allowed free rein. This applies to the pure use of precious colours in mediaeval illumination as much as to that ornamental elaboration of the whole work which leads to such a high decorative achievement.[7]

Where developed cultures, like the antique or the modern, demand from works of art the discovery of credible representations or compositions, both correct and beautiful at the same time, mediaeval art achieved a sense of order and beauty of colour which was, as it were, purer and more striking. But it also did so more easily because the other demand was not felt. Indeed, colour and the elaboration of schematic shapes was allowed to transform and almost totally disrupt earlier representations of nature.

It should be noted that the 'level of recognizability', which limits in mediaeval art the extent to which a sign may be elaborated with ornament, is not usually like that of really primitive art. Only in extreme cases, for instance, is an isolated sign made to stand for the whole complicated appearance of something. One reason which may be advanced for this is that illustration of a unified scene—one of the tasks of mediaeval art—demands a higher measure of verisimilitude to be intelligible.

Mediaeval art, however, soon had another task more important than all others, which belonged to it alone, and led to a new sense of order.[8] It had to represent abstract relations outside the scope of a systematically representational art. The whole system of mediaeval thought, which is one that so completely involves levels of subordination, is made intuitable and manifest through ordered schematic images.[9]

But this development and the primitive mode of image making are not mutually exclusive. For one may characterize many forms in primitive art by saying that each form also carries a meaning and that none can be understood considered merely as form. The study of the development of ornament occasionally suggests such an interpretation. I am thinking of those styles where not only scrolls and palmettes but even letters and sacred symbols are transformed into zoomorphic shapes by the addition of eyes, beaks and claws. It looks as if the *horror vacui* of these styles extended from the crowding of motifs to the superimposition of ever fresh meanings.

VI

IT may seem idle to make such assumptions without substantiating them by reference to particular examples. But it seems necessary to indicate the direction in which inquiry into the problem of evaluation should be directed in order to establish a basis for discussion of many of the issues which Garger raises. His treatment does not appear free from the assumption of a kind of knowledge by instinct, to which he is overtly opposed. In the final instance he interprets physiognomically the move away from naturalism in mediaeval art. From the constraint of forms made to adhere to the schematic shapes, he infers feelings of constraint on the part of the artist in his relation to the world. This line of thought is really only a refined form of the widely held assumption according to which the withdrawal from realism represents a withdrawal from the world, or a transcendence of nature, or that the so-called transcendentalism of mediaeval art is a direct reflection of transcendental metaphysics.

What needs to be questioned here is not the assumption that there was such an attitude in the mental life of the middle ages, but the facility of the correlation, the unreflecting assumption that one can make an inference from one to the other. This may be subtler but it is no more valid than Taine's belief that he could elucidate the gloominess of mediaeval art by reference to the depressing condition of the epoch.[10] In such judgements the style as a whole expressive system is set over against a hypostasized collective personality—either of a people or a period—of which it is held to be the expression. Popular psychology may infer from the rough sound of a language to the rough character of those who use it. A scientific appraisal of expression, however, can be concerned only with judgements based upon the understanding

of the language and the discrimination and elucidation of the individual expressive features within it. Certainly the kind of language a people possesses is not a matter of mere accident. The style employed by the artists of a period is no accident either. But to see it as a super-work of art made by a super-artist is the residue of a romantic philosophy of history, and one should only subscribe to this if one knows what one is doing.

To insist upon this is to forego a source of strong and subjectively very genuine enjoyment. The social success of art history today, its receptivity to the art of all times and all peoples, rests all too often perhaps on just such a view of the past. It is not the individual work of art which is enjoyed, rather, the language in which it is formulated is treated as if it were itself a work of art. It would be superfluous to cite examples, one ought rather first to look for those who have resisted this temptation to do this—indeed it is more than a temptation, it is virtually a compulsion*.

For what we experience as the understanding of expression is not a matter of reading separate features, it becomes the simultaneous grasp of the overall form. And we experience the expressive force of this overall form even when we know that it corresponds to nothing inward. Even to a behaviouristic animal psychologist the marabu is bound to look wise and ceremonious, and even to a critical art-historian, primitive masks appear expressive, although he knows that some of their lines are not intended as part of a facial expression. It was first Münz's work on the sculpture of the blind which showed quite clearly how inescapably we see the characteristics of objects as expressive even when they have these characteristics for some quite different reason. In this direction there are many more distinctions to be drawn than Garger has done in discussing expression in late antique art. One obscurity derives from an ambiguity in the use of the word expression itself. Clearly, any conceivable aspect of any civilization can be seen, among other things, as the symptom of a mental climate or an intellectual situation. This goes for the success of a book no less than for a code of criminal law. But the terminology for a scientific study of culture would distinguish between a theory of crime deterrence as a symptom and a clenched fist as an expression. The word *threat* may cover both, as it has connotations which range from individual responses to social institutions, but in the study of societies we have to distinguish between such senses.

Similarly, the return in late antiquity to the primitive conceptual image, which enlarges those features of the subject which are more important, is a cultural symptom and moving as such. When someone who once spoke with perfect fluency breaks down and babbles incoherently we may be profoundly moved. But in itself, inarticulateness is more 'primitive' than fluent discourse. And that throws some

* It is noteworthy that the visual arts above all others are subject to the danger and provide the source of such pleasures, and even the visual arts have done this only in the last hundred and fifty years. There is no 'historicism of world literature' which is comparable to the historicism of expressionist art history.

light on the undifferentiated character of the expression in late antique art which Garger quite correctly emphasizes. What we experience as expression in late antique art is mostly its primitiveness with all the associations which this has for us in the context of that period.

VII

OF quite a different kind is Garger's second hypothesis regarding the distinctive value of mediaeval art. He presents for discussion a conception of images which should be seen as having numerous meanings simultaneously, meanings which are combined to make linguistic metaphors intuitable. If this interesting suggestion could be supported it would be a crucial part of the explanation of the working of mediaeval art as an expressive system and greatly enhance our grasp of it. However, it does not seem to me probable that sufficiently good evidence of particular cases of this kind could be found. We know one area where Garger's description fits detail by detail. That is caricature. Here the artist represents the man whom he wants to call an ox by an ox. He lets the judge in his robes become a giant ink-well if this is the analogy he wants. This free play with the symbolic function of the form presupposes an overall freedom in image making and representation, for which the examples of mediaeval art which have come down to us are striking counter-evidence. *Someone who, as Garger himself emphasizes, has trouble in representing an object so that it is recognizable, would hesitate at the idea of representing two objects in one image. For a game of that kind is indeed a symptom of the freedom which we do not find in mediaeval art.[11]

We seem to have come far from the problem of evaluation, but not, surely, too far. For here we are confronted with a genuine problem of historical development to which we must return on another occasion. Whether one considers this development from primitive constraint to freedom as valuable, is not something to be scientifically decided. Science has no competence for dealing with such questions; on the other hand it is appropriately engaged in indicating which works relate to which ideals of art.

*There is at least one such case in the later middle ages. The fire-screen in the background of the Master of Flémalle picture of the Virgin (National Gallery, London) has, as it were, the effect of a halo as well. It is precisely the break with mediaeval treatment, however, which appears to have made possible, or brought about, this kind of half way house. The traditional sign for holiness has been rationalized and thus reality as such has been invested with a certain sanctity.

André Malraux and the Crisis of Expressionism

THE Voices of Silence[1] is a revised version, in one heavy volume, of André Malraux's three previous books of *The Psychology of Art*.[2] The smaller format, and the reduction of illustrations in size and (of colour plates) in number, inevitably focuses attention more on the text than was the case with the earlier splendid picture-books. For this text astounding claims are made by the publisher's 'blurb'. A passage from Edmund Wilson, the distinguished critic, is quoted, in which Malraux's work is mentioned in one breath with the *chefs d'œuvre* of Gibbon, Marx, and Tolstoy. No service is done to Malraux by such comparisons. Leaving all other considerations aside, *Decline and Fall, Das Kapital*, and *War and Peace* are masterpieces properly so called. They represent not only intuitions but a tremendous amount of disciplined labour. Malraux's text, against such a background, looks like a mere string of accumulated *aperçus*, sometimes brilliant, sometimes vacuous, but nowhere imbued with that sense of responsibility that makes the scholar or the artist. There is no evidence that Malraux has done a day's consecutive reading in a library or that he has even tried to hunt up a new fact. To do Malraux justice, however, he shows himself quite aware of the fact that his outlook and purpose differ fundamentally from those of the historian or the scholar:

> For a very small number of men, keenly interested in history, the past is a complex of riddles asking to be solved, whose progressive elucidation is a series of victories over chaos. For the vast majority it comes back to life only when it is presented as a romantic saga, invested with a legendary glamour . . . it is art whose forms suggest those of a history which, though not the true one, yet is the one men take to their hearts (p. 619).

There is no more concise way of describing what Malraux's book is about, than to say that it is about the 'romantic saga' suggested by art. At times he succumbs to its spell and relates it as though it were fact, at times he holds himself in check and probes into the forces that gave rise to it, but in his style and presentation he never renounces the 'legendary glamour' which this saga can lend to rhapsodies about art. The company to which Malraux would aspire, therefore, is not that of Gibbon, Marx, or Tolstoy, but perhaps that of Winckelmann, Ruskin, or some other of those great 'backward-looking prophets' who drew, from the interpretation of the art of the past, an inspiration and a message for their contemporaries. Malraux tries to do for the anti-classical styles of Europe and Asia what Winckelmann did for the ancient Greeks and Ruskin for the Age of Faith. But even here there is a fundamental difference in stature. These giants created the myths which they propagated; they were the founders of an aesthetic religion. Malraux is, at best, an apostle. His message is derived from that of the expressionist critics most

This article was written as a review of *The Voices of Silence* (English edition, London 1954) in *The Burlington Magazine*, 1954.

en vogue in Central Europe in the 1920s. Moreover, he rather gives the impression of an apostle who wrestles with the very faith he preaches. While Winckelmann and Ruskin passionately believed in their visions of the past, Malraux recognizes such visions for what they are—projections of our own preoccupations and desires. But he would rather have faith in an illusion than no faith at all and so we find him extolling that notion which has proved so fateful and fatal to our time—the Myth.

Perhaps the sophistications and involutions of this attitude of mind can only be understood against the background of the crisis which shook the art world in the first post-war period. Those of us who still remember the afterglow of expressionism know of the fascination which its new vision exerted. Had our fathers and grandfathers been blind? How could they have failed to respond to the tremendous intensity with which the very art they had dismissed as 'primitive' was now seen to be charged? How could they have measured it by such external and 'materialist' standards as representational accuracy, technical skill, or sensuous beauty? Once those prejudices were removed, the art of all times and periods seemed no longer mute. Describing this feeling with some detachment, Hans Tietze wrote, in 1925, of the great revision of art history that had occurred since 1910, of the 'daily discoveries of new worlds, the hourly transvaluations of all values'. Even the once familiar took on a new intensity: 'Classical Antiquity, Gothic and Baroque suddenly entered our lives with an undreamed-of immediacy, and the works of Far Eastern and Negro artists breathed a complete humanity that stirred the very depths of our being.'[3] It was clear to all that more was here at stake than a mere shift in taste. When Max Dvořák gave his historic lecture on 'Greco and Mannerism' in 1920, he wound up with a profession of faith which looks curiously moving in retrospect: 'In the perennial struggle between matter and spirit the scales are now inclining to the side of the spirit—if we have recognised in Greco a great artist and a prophetic soul we owe it to this momentous change.'[4]

The key which seemed to open all doors was, of course, the word 'expression'. So overwhelming was its appeal that people no longer stopped to analyse who expressed what, any more than they worried what was 'signified' by 'significant form'. But since the human mind must postulate some agency that does the expressing where 'expression' is found to exist, this creed reinforced that mythology of history which had dominated historiography ever since Hegel. He had peopled the past with the 'spirits' of nations and races: the true heroes of art history became what Malraux wittily describes as 'those imaginary super-artists we call styles' (p. 46) who, in their turn, 'expressed' the spirit of their respective ages. There is no doubt that art history during this hectic post-war period, owed much of its appeal and popularity on the Continent to this uncritical faith; that the visual arts provided the shortest route to the mentality of civilizations otherwise inaccessible to us. The contemplation of a suitable photograph of a piece of

fourteenth-century sculpture would bring one into immediate contact with 'the soul of Gothic Man'; a picture-book of Aztec idols would reveal 'the spirit of ancient Mexico'.[5] This furniture of the mind is what Malraux describes as the 'Museum without Walls'. And this Museum, he discovered, must be a temple dedicated to a myth. Strangely enough this conclusion follows directly from the expressionist premises. For if we accept the belief that each style of a period or race directly mirrors its group-mind there must be as many and as different species of human mind as there are types of art. But what common denominator, then, is left? How can we expect to understand what a strange style 'expresses'?

It was Spengler who drew the conclusion, that each race or culture represents a different species, that the idea of a united mankind is so much sentimental humanitarianism, and that the historian being immured in his own culture can never understand, only describe.[6] The faith in expression as the essence of art had ended in the destruction of all belief in the communicability of what art expresses.

Malraux was deeply impressed by the German prophet of gloom.[7] The hero of one of his first novels, *The Royal Way*, which he wrote some twenty-five years ago, already reveals the ferment of this doctrine. Like Malraux himself in the early twenties, this hero is an archaeologist hunting for temple sculptures in the jungles of Indo-China. Here he pronounces the theme on which all Malraux's subsequent writings are but variations:

My view is ... that the personal value we set on an artist may blind us to one of the main factors determining the vitality of his work. I refer to the cultural status of the successive generations appraising it ... what interests me personally is the gradual change that comes over such works ... Every work of art, in fact, tends to develop into a myth.

For me museums are places where the works of an earlier epoch which have developed into myths lie sleeping ... waiting for the day to come when artists will wake them to an active existence ... In the last analysis, of course, no civilization is ever understood by another. But its creations remain—only we are blind to them until our myths come into line with theirs.[8]

There is an unfortunate resemblance between the Cretan, beloved of logicians, who asserts that everything a Cretan says is a lie, and the interpreter of art who says that everything we say about art is a myth. Insofar as his statement refers to art it must, itself, be a 'myth'. We are left with nothing to hold on to. There are no standards by which myths can be tested or argued about. Truth is an illusion, the past, as expressed in its art, changes its shape as we watch it, like a cloud. But Malraux is no more consistent in this refuge of inconsistency than is Spengler. There are many assertions about the past in his book, though one would rather like to believe that the author regards them as passing myths:

Byzantium aimed at expressing the whole world as a mystery. Its palace politics and diplomacy, like its religion, kept that time-old craving for secrecy (and subterfuge) so characteristic of the East (p.212).

During the centuries in which . . . kings blinded their conquered rivals there arose great hieratic figures that peremptorily lowered men's eyelids lest the allurements of the visible should continue to distract them from the supreme mysteries (p.214).

These quotations come from Section II, entitled 'The Metamorphoses of Apollo'. It is not new, as the publishers claim, but a reshuffle of chapters in the earlier volumes.⁹ Perhaps Malraux himself somehow felt uneasy about these sections in which the expressionist myth is expounded rather than explained, and tried at least to combine them into a coherent story. As it stands this section is now an almost orthodox restatement of the expressionist interpretation of the retreat from classical standards in East and West. The opening makes effective use of an idea of Julius von Schlosser's who, at the turn of the century, analysed *Die Genesis der mittelalterlichen Kunstanschauung*¹⁰ by comparing classical coins with their transformations at the hand of barbarians. There follows a chapter on early Christian art, much on the lines of Dvořák's paper on the Catacomb Paintings,¹¹ while the evaluation of medieval sculpture is reminiscent of Worringer. Indeed there is little that is new in these pages on late antique and medieval art which explain all deviations from classical standards as forms of 'spiritualization' and select, for illustration, the characteristic close-ups of haggard, staring faces so popular in expressionist art books. What is remarkable is rather that Malraux should have allowed this chapter to follow on his opening section 'The Museum without Walls'. For here he had brilliantly analysed some of the reasons which make this expressionist interpretation of medieval art such dubious history. He knows that 'with special lighting, lay-out and stress on certain details, ancient works of sculpture often acquire a quite startling, if spurious modernism' (p. 27). He explains in a few illuminating words why Romanesque sculptures appealed to modern artists after they had been torn from their architectural and cultural context (p. 107). In fact the whole argument of that first and most famous section— insofar as Malraux's style allows one to speak of arguments—appears to be that it is we who impose the modern concept of 'art' on these ancient religious images by exhibiting or illustrating them side by side with works of a purely aesthetic character. 'A Romanesque crucifix,' Malraux opens his book, 'was not regarded by its contemporaries as a work of sculpture; nor Cimabue's *Madonna* as a picture.'

As a protest against the neglect in expressionist literature of the social setting and function of images, that sentence must surely stand. But if Malraux wishes to imply, as he appears to, that the whole notion of art is the creation of the last, godless centuries, he is mistaken. Did not Oderisi da Gubbio tell Dante in the *Purgatorio* that Cimabue thought that he held the field *in painting*? And when the same Oderisi humbly admits that the pages illuminated by Franco Bolognese 'smile more' than his own, he compares them as *art* and not as sacred images.¹² Clearly neither Pliny nor Vasari could have written their accounts of the rise of the

arts without the notion of contributions to 'art' made by individual masters—a notion that is not incompatible with a religious setting.[13] It is just because many works of art stand in a multiple context (that they both satisfy a demand *and* attempt a solution of an artistic 'problem') that it is so perilous to talk about them in isolation. Evidently Malraux himself is troubled by this problem, for Section III on the 'Creative Act' is entirely devoted to the continuity of art as an autonomous activity. Here the Museum is all but forgotten and so, thank heavens, are the mystery-loving, eye-gouging Byzantines. The creation of visual images is seen as an activity which one artist learns from another only to hand it on, transformed. Though here, as always, the emphasis with which Malraux presents his views would lead one to assume that no one had realized as yet that every picture owes more to other pictures painted before than it owes to nature (as Wölfflin put it[14]), there are many ideas in this chapter which need repeating.

Once more the real edge of Malraux's assertions is directed against certain misunderstandings, engendered by Expressionism. Impressionists—so we may supplement his argument—wished to be taken literally when they avowed that they represented the world as they 'saw' it. With expressionism this claim gradually and imperceptibly slid into a mere metaphor. Tempted perhaps by the ambiguity of the German word *Weltanschauung* (world-view) the Romantic belief that style expressed the 'world view' of a civilization led to a series of equivocations in which the history of art was identified with some metaphorical history of 'seeing'. It is a position which need only be made explicit to be shown up in its absurdity, and yet Malraux deserves our gratitude for having at last brought the problem into the open. For that there is a genuine problem of the relation of art to perception should not be denied. The solution which Malraux offers clearly applies only to one particular type of realistic art but as such it commands respect.

The non-artist's vision, wandering when its object is widespread (an 'unframed' vision), and becoming tense yet imprecise when its object is a striking scene, only achieves exact focus when directed towards some *act*. The painter's vision acquires precision in the same way; but, for him, that act is painting (p.279).

In other words the media and problems of art may compel the artist to look for certain aspects of reality. There is no innocent eye but there are knowing and searching eyes.

Starting from here Malraux might have explored the *terra incognita* of the real 'psychology of art', but somehow he fails to follow up his hypothesis. Instead he falls back on a new version of expressionism, which sees in each artist's transformation of the language of form nothing but a type of self-assertion, a victory over chaos. If only Malraux could be made to see that this chaos, with which he is so obsessed, is in itself a human creation. Whatever the world of an amoeba or an earthworm may be like, it certainly is not chaotic but structured. Where there is

life there is order. Vasari's beautiful words about Peruzzi's Villa Farnesina: *'non murato ma veramente nato'* reveals a deeper kind of aesthetic awareness than if he had talked of Peruzzi's self-assertion. It must be granted, however, that Malraux needs this idea of a perpetual revolution, of man as a defiant animal, to bring off his last coup—his victory, not over chaos but over Spengler. If Spengler had deduced from the changing styles of art that the concept of mankind is empty, Malraux dedicates the last section of his book on the 'Aftermath of the Absolute' to a confused but passionate assertion of the opposite point of view.

Works of art, he argues, transcend their own limited meaning in their constant metamorphosis, but this very change gives 'Art' to mankind. In the past this art (except, to him, Roman art) served religion and by doing so it defied the temptations of mere sensuous pleasure; it rejected the agreeable for the sake of 'higher' values. It is its glory, in Malraux's eyes, that artists continued this act of renunciation, this search, if not for truth at least for the avoidance of 'lies', (p. 495) when there was no belief in an 'absolute' left to justify their sacrifices. Modern art came into being as a protest against the commercial pseudo-art of prettiness. It is this element of negation that establishes its kinship with the religious art of the past, which we value more for what it is *not* than for what it is.[15] True, modern art will not be able to 'outlive its victory intact' (p. 640). As an act of defiance it will wither away when it becomes dominant. Is it because we are on the threshold of this victory that we begin to see that images of the past, which this art called upon as its allies, really meant something quite different? Is the 'Museum without Walls' simply built on misunderstanding?

The nearer Malraux, in his self-questioning, seems to come to some such conclusion the more excited grows his style and the more turgid his imagery. One can hardly avoid the suspicion that the voices he has lent to the art of the past are meant to drown a deep fear of the silence which would fall if Spengler were right:

> Though the Wei Bodhisattvas and those of Nara, Khmer and Javanese sculpture and Sung painting do not express the same communion with the cosmos as does a Romanesque tympanum, a Dance of Siva or the horsemen of the Parthenon, all alike express a communion of one kind or another, and so does even Rubens in *The Kermesse*. We need but glance at any Greek masterpiece to see at once that its triumph over the mystery-laden East does not stem from any process of the reasoning mind, but from the 'innumerable laughter of the waves'. Like a muted orchestra the surge and thunder, already so remote, of ancient tragedy accompanies but does not drown Antigone's immortal cry: 'I was not born to share in hatred but to share in love' (pp.635–6).

Who would not prefer the driest philological gloss on the exact meaning of Antigone's 'immortal cry' (which is not a cry but a reasoned statement in a momentous argument) to this 'surge and thunder'? For if we trouble to analyse the content of the paragraph we discover, as only too often with Malraux, that it dissolves into a truism. Buddhist art (the names of the schools which produced Buddhas

are mere ornament) differs in spirit from Hindu, Greek, and Christian art but they all (including Rubens's *genre*) are religious. Even Greek tragedy is (and who ever doubted that?). Perhaps the rhetoric serves no other purpose than to hypnotize and bulldoze the reader. But it is surely more charitable to assume that strings of names and rows of images function like the names of divinities in ancient incantations to reassure the writer rather than the reader. They may be an expression of that authentic *Angst* which is the true root of the Expressionist hysteria—the anxiety of that utter loneliness that would reign if art were to fail and each man remained immured in himself.

To return to sanity does not mean to ignore these problems but to face them. Perhaps they are not quite as formidable as they look. They become formidable only through the adolescent 'all-or-nothing' attitude that colours so much of the writing of Malraux's generation. To the question whether we can understand the art or mentality of other periods or civilizations, or whether all is 'myth', the answer of commonsense is surely that we can understand some better, some worse, and some only after a lot of work. That we can improve our understanding by trying to restore the context, cultural, artistic, and psychological, in which any given work sprang to life, but that we must resign ourselves to a certain residue of ignorance. In art, as in life, on certain elemental levels men of different civilizations have understood each other even though they were ignorant of each other's language. On others only an acute awareness of the context in which an action stands may prevent our misunderstanding.* This commonplace philosophy would hardly bear stating if it had not some relevance to the 'Museum without Walls'. For it is remarkable that this Museum only contains sculptures and paintings. Where the medium of art is words we can still distinguish between degrees of understanding. True, once in a while we have witnessed a metamorphosis of works of literature which parallels the examples adduced by Malraux. The tragic Shylock or the neurotic Hamlet may be a case in point. But by and large we know it needs a greater imaginative effort to understand the *Roman de la Rose* than to enjoy *Pride and Prejudice*, and we can say why. Nor are we frequently in serious doubt whether a piece of music is intelligible to us or not. We realize that in Oriental music we cannot distinguish a dirge from a ditty because we lack familiarity with the framework of harmonic conventions on which musical meaning so largely depends. Perhaps the way out of the expressionist impasse must lead through an analysis of similar relationships in the visual arts.

*There are many moving examples of understanding even without language in the travel literature of recent years, *e.g.* in Thor Heyerdahl: *Kon-Tiki*, and in A. Gheerbrant: *The Impossible Adventure*. And could anyone claim that Arthur Grimble of the *Pattern of Islands* had no access to the mind of his islanders or that Sir Edmund Hillary and Sherpa Tenzing failed to understand each other when they embraced on the top of Mount Everest? On the other hand there are moments when only an exact knowledge of cultural conventions allows us to assess the expressive quality of an act, gesture, or utterance. Malraux's own style would be a case in point. It would need much familiarity with contemporary France to tell exactly where he is just 'French' and where he is genuinely 'excited'.

It was the optimistic faith in the efficacy of colours and shapes as a universal language that landed us in this dizzy philosophy of myth and metamorphosis. Even shapes and colours acquire their meaning only in cultural contexts. The less we know of this context the more are we forced to dream it up. We may enjoy this challenge to our imagination and relish the sense of mystery that is aroused in us by what looks remote, exotic, and inscrutable. This is one of the reasons why our age is so ready, as Malraux says, 'to admire all it does not understand' (p. 598). But we may come to see that our fathers and grandfathers were not quite wrong, after all, when they thought that we understand certain styles better than others. That a Rembrandt self-portrait or a Watteau drawing 'means more' to us than an Aztec idol or a Negro mask. Not that we need forego the pleasure of looking at stimulating forms even where we do not understand. We also look at rocks or driftwood. Only we must try to relearn the difference between stimulation through self-projection, which, when applied to art, so often passes for 'appreciation', and that enrichment that comes from an understanding, however dim and imperfect, of what a great work of art is *intended* to convey. (Intention in art is not everything. Neither is expression. But where the intention is missed our response to the rest will also go wrong.) We need not worry about these distinctions every time we look at a work of art. What matters is only that we should not surrender our sanity by losing our faith in the very possibility of finding out what a fellow human being means or meant. Critical reason may be fallible but it can still advance towards the truth by testing interpretations, by sifting the evidence; thus it can widen the area of our sympathies while narrowing the scope of myths. It will need a good deal of clearing up, after the expressionist earthquake, to reconstruct the Museum on these more modest but more secure foundations. Meanwhile we owe a debt of gratitude to André Malraux for having recorded with such verve and intensity the impact of this traumatic experience on a rich and sensitive mind.

The Social History of Art

IF by the 'social history' of art we mean an account of the changing material conditions under which art was commissioned and created in the past, such a history is one of the *desiderata* of our field. Documents there are, of course, in profusion, but it still is not easy to lay one's hand quickly on information regarding, say, the recorded rules and statutes of lodges and guilds, the development of such posts as that of the *peintre du roi*, the emergence of public exhibitions or the exact curricula and methods of art teaching. What precisely is our evidence for the role of those 'humanist advisers' of whom we have heard a good deal of late? When did a job at an art school become the normal stand-by of young painters? All these are questions which could and should be answered by a social history of art. Unfortunately, Mr. Hauser's two volumes are not concerned with these minutiae of social existence. For he conceives his task to be quite different. What he is out to describe throughout the 956 pages of his text is not so much the history of art or artists, as the social history of the Western World as he sees it reflected in the varying trends and modes of artistic expression—visual, literary or cinematic. For his purpose facts are of interest only in so far as they have a bearing on his interpretation. Indeed, he is inclined to take their knowledge for granted and to address a reader familiar with the artists and monuments under discussion, assuming that he merely seeks guidance about their significance in the light of social theory.

The theory that Mr. Hauser offers us as a key to the history of human thought and art is dialectical materialism. His basic approach is exemplified in such statements as that 'Nominalism, which claims for every particular a share in being, corresponds to an order in life in which even those on the lowest rung of the ladder have their chance of rising' (p. 238), or that 'the unification of space and the unified standards of proportion [in Renaissance art] . . . are the creations of the same spirit which makes its way in the organisation of labour . . . the credit system and double entry book keeping' (p. 277). Mr. Hauser is deeply convinced that in history 'all factors, material and intellectual, economic and ideological, are bound up together in a state of indissoluble interdependence' (p. 661), and so it is perhaps natural that to him the most serious crime for a historian is the arbitrary isolation of fields of inquiry. Wölfflin, for instance, comes in for strong criticism on the score of his 'unsociological method' (p.430) and Riegl's *Kunstwollen* is rejected for its 'romantic' idealism (p. 660). He seems less conscious of the fact that this insistence on the

This article was written as a review of Arnold Hauser's *Social History of Art* (New York and London, 1951) in *The Art Bulletin*, March 1953.

'indissoluble interdependence' of all history makes the selection of material no less arbitrary. Where all human activities are bound up with each other and with economic facts, the question of what witness to call for the writing of history must be left to the historian's momentary preference. This is indeed the impression one gains from Mr. Hauser's book. Artistic styles are mainly questioned for the interpretation of periods where more articulate documents are rarer. Thus the first volume, which reaches from the 'magic naturalism' of the Early Stone Age to 'the baroque of the protestant bourgeoisie' concentrates on the analysis of sculpture and painting, though the Homeric epic and Greek tragedy, the Troubadours and Shakespeare are each in their turn related to the stylistic and social trends of their period. In the second volume, which extends from the eighteenth century to the present day, literary forms of expression, notably the social novel and the film, come to the fore, though the related movements of Rococo, Classicism, Realism, Impressionism and Symbolism are also evaluated for what they may tell us of the underlying cross-currents of society.

As far as the visual arts are concerned, Mr. Hauser's starting point seems to be the superficially plausible assumption that rigid, hieratic, and conservative styles will be preferred by societies dominated by a landed aristocracy, while elements of naturalism, instability, and subjectivism are likely to reflect the mentality of urban middle class elements. Thus the geometric character of Neolithic, Egyptian. Archaic Greek, and Romanesque Art may seem roughly to fit this first approximation, since the 'progressive' revolutions of Greek and Gothic naturalism are each connected with the rise of urban civilizations.

But Mr. Hauser is too conscientious and too knowledgeable a historian to be satisfied with such a crude theory. He is, moreover, well aware of the many instances which seem to refute it, and so we watch him almost from page to page thinking out ever new and ingenious expedients in order to bring the hypothesis into harmony with the facts. If an Egyptian King such as Akhnaton initiated a shift towards Naturalism, the movement must be rooted in urban middle classes (p. 61); if the urban culture of Babylon, on the other hand, exhibits a rigid formalism, this must be due to the hold of the priests (p. 65). If the classical age of Greek art is also the age of democracy this can be explained by the fact 'that classical Athens was not so uncompromisingly democratic nor was its classical art so strictly 'classical' as might have been supposed' (p. 95). In the course of these attempts to rescue his basic assumption, Mr. Hauser makes many shrewd and illuminating remarks on the limitations of sociological explanations (p. 70), on the impossibility of accounting for artistic quality by a 'simple sociological recipe' (pp. 103 and 162), on the possibility of time lags between social and stylistic changes (pp. 132, 293, 643), on the different stages of development in different artistic media (p. 153), and even on the futility of too facile comparisons between social structures and stylistic

features (ibid.). The more one reads these wholesome methodological reminders the more one wonders why the author does not simply give up his initial assumption instead of twisting and bending it to accommodate the facts. And then one realizes that this is the one thing he cannot do. For he has caught himself in the intellectual mousetrap of 'dialectical materialism', which not only tolerates but even postulates the presence of 'inner contradictions' in history.

A brief methodological digression may serve to elucidate the cause of Mr. Hauser's theoretical paralysis. To us non-Hegelians, the term 'contradiction' describes the relation of two 'dictions' or statements such that they cannot both be true, for example 'Socrates drank hemlock' and 'Socrates did not drink hemlock'[1]. Now we all know that there are many apparently contradictory statements both of which seem true—e.g., 'Socrates was mortal' and 'Socrates was not mortal'—but we also know that this apparent contradiction is simply due to the term 'mortal' being used in a different sense in the two statements. Ordinarily if the context leaves doubt as to what we mean by 'not mortal' we choose another term, or at least qualify it in some way, so as to remove any contradiction. This, however, is not the way of the dialectician. Mr Hauser, for instance, can describe a style as 'classicist and anti-classicist at the same time' (p. 627), or he can pronounce the terms 'symbolism' and 'impressionism' to be 'partly antithetical, partly synonymous' (p.896) without feeling the need to discard them. For Hegelians believe they have discovered the secret that Socrates, being both mortal and not mortal, 'harbours contradictions' and that this, indeed, is true of all reality. Now within the fantasy-world of Hegel's metaphysical system there was at least a reason why the distinction between statements and objects became blurred. For Hegel, of course, believed that reality was 'identical' with the process of reasoning, and that history was nothing but the unfolding of the Absolute Idea in time. Within this system the contention that any separate phase or aspect of history must 'harbour contradictions' (in the mind of God, as it were,) which are resolved in the cosmic syllogism is at least of a piece with the rest. Materialists who do not believe that reality is only the thinking process of the Absolute have no such excuse for retaining such 'dialectics'.

Clearly, material objects as well as human beings, societies, or periods may be subject to conflicting pulls, they may contain tensions and divisions, but they can no more 'harbour contradictions' then they can harbour syllogisms. The reason why Marxist critics so often forget this simple fact is that they are mostly concerned with the analysis of political systems. It may be true or not that 'capitalism'—if there is such a thing—contains 'inner contradictions' if we take capitalism to be a system of propositions, stating beliefs or intentions. But to equate the conflicts within capitalist society with its 'contradictions' is to pun without knowing it. It is where the politician turns historian that this confusion becomes disastrous. For it prevents him from ever testing or discarding any hypothesis. If he finds it confirmed by some evidence he is happy; if other evidence seems to conflict he is

even happier, for he can then introduce the refinement of 'contradictions'. Much as it is to Mr. Hauser's credit that he rejects the cruder version of historical materialism according to which 'the quality of the actual means of production is expressed in cultural superstructures' (p. 661), such a theory might at least be tested and found wanting. His more esoteric doctrine, according to which 'historical development represents a dialectical process in which every factor is in a state of motion and subject to constant change of meaning, in which there is nothing static, nothing eternally valid' (*ibid.*), denies the very possibility of such a test.

Of course it, too, rests on a Hegelian confusion. Granted that when we watch history we always watch changes, there is no reason why—given the evidence—we should not be able to describe such changes just as well as we describe changes of the weather. Mr. Hauser's 'factors' may conceivably be 'in motion' (e.g., the trade winds) but they cannot change their 'meaning' because meaning is a term that does not apply to things or forces but to signs or symbols. And, contrary to the belief of the dialecticians, we can make perfectly valid statements about these signs—else the hieroglyphs could never have been deciphered and the chronology of red-figured vases never established.[2] If Mr. Hauser finds that he is concerned with entities in history which constantly elude his grasp, if he finds that the bourt geoisie and the aristocracy, rationalism and subjectivism constantly seem to change places in his field of vision, he should ask himself whether he is looking through a telescope or a kaleidoscope. If one approaches the past with such statements as, "The late Middle Ages not merely has a successful middle class—it is in fact a middle class period" (p. 252), one cannot but run into various barons and dukes who will serve as 'contradictions'. And if the Duc de Berry sponsored such unhieratic works as the *Très Riches Heures*, Mr. Hauser need not revise his notion of aristocratic styles; he merely finds his view confirmed, for 'even in court art . . . middle class naturalism gains the upper hand' (p. 263).

But it is in Mr. Hauser's discussion of the social significance of French classicism that the dialectic tangle becomes well-nigh impenetrable. 'The archaic severity, the impersonal stereotyped quality, the die-hard conventionalism of that art [of Le Brun] were certainly in accordance with the aristocratic outlook on life— since for a class which bases its privileges on antiquity, blood and general bearing, the past is more real than the present, . . . moderation and self-discipline more praiseworthy than temperament and feeling—but the rationalism of classicistic art was just as typical an expression of middle-class philosophy . . . the efficient, profit-making burgher had begun to conform to a rationalistic scheme of living earlier than the aristocrat . . . And the middle-class public found pleasure in the clarity, simplicity and terseness of classicistic art more quickly than the nobility' (p. 451). 'Classicistic art certainly tends towards conservatism . . . but the aristocratic outlook often finds more direct expression in the sensualistic and exuberant

baroque' (p. 623). 'There arises in French art and literature a curious proximity and interaction of classicistic and baroque tendencies, and a resulting style that is a contradiction in itself—baroque classicism' (p. 627). It is in this way that we are led to the contradiction referred to above—the style that is classicist and anti-classicist at the same time.

Perhaps the above quotations have somewhat illuminated the method by which Mr. Hauser arrives at this logical absurdity. He has built into the groundwork of his system a psychology of expression that is simply too primitive to stand the test of historical observation. For though I have called superficially plausible the theory that rigid noblemen will like a rigid style and that agile merchants will be eager for novelty, the contrary assumption—that blasé aristocrats love ever new sensual stimuli while strict business men, with their 'double entry book-keeping', want their art neat and solid—sounds equally convincing. And so Mr. Hauser's sociological explanations really turn out to be vacuous as explanations.

To be sure, it would not be fair to blame Mr. Hauser for adopting a type of reasoning which has deep roots in the tradition of art historical writing. Specious arguments about expression are not, alas, Mr. Hauser's monopoly. His analysis of Mannerism is a suitable case in point. It is closely modelled on Max Dvořák's interpretation, to which he pays tribute (p. 357), and, although it lacks the sweep and subtlety of Dvořák's lectures and articles, it may have its value as the most detailed discussion of Mannerism that has so far appeared in the English language. Mr. Hauser is well aware of the roots of this interpretation in contemporary art movements; indeed he is at his best wherever he can point to the 'conditioning' of historians by their own period. But he has no qualms about following Dvořák and Pinder in projecting 'expressionist' and even 'surrealist' attitudes into Mannerism. The style (and he insists that it was a distinct style, whatever that may mean) becomes 'the artistic expression of the crisis which convulses the whole of Europe in the sixteenth century' (p. 361). He sees it connected with 'the religious revival of the period, the new mysticism, the yearning for the spiritual, the disparagement of the body The new formal ideals do not in any way imply a renunciation of the charms of physical beauty, but they portray the body . . . bending and writhing under the pressure of the mind and hurled aloft by an excitement reminiscent of the ecstasies of Gothic art' (*ibid*). One wonders what Benvenuto Cellini would have done to anyone who told him that he 'disparaged the body', or how Giambologna would have reacted on hearing his *Mercury* compared to the 'ecstasies of Gothic art'. And was there more 'yearning for the spiritual' at the court of Cosimo I than in the household of Cosimo *Pater Patriae*? Was there more of a 'crisis' in the Europe of 1552, when Bronzino painted his *Christ in Limbo*, than in 1494, when the French descended on Italy and the Florentines drove out the Medici and fell under the sway of Savonarola—while all the

time Perugino went on painting his utterly serene compositions? In other words, can we really use such generalities as 'explanations' or are we just shifting the responsibility into another, less familiar field? To attribute to the '*Zeitgeist*' of an epoch the phsyiognomic characteristics we find in its dominant artistic types is the constant danger of *Geistesgeschichte*.

No one would deny that there is a genuine problem hidden here. There is such a thing as a mental climate, a pervading attitude in periods or societies, and art and artists are bound to be responsive to certain shifts in dominant values. But who, in the middle of this twentieth century would still seriously assert that such crude categories as 'sensuousness' or 'spirituality' correspond to identifiable psychological realities? To say with Mr. Hauser that the Renaissance was 'world-affirming' and therefore given to placing figures in a 'coherent spacial context', in contrast to the 'otherworldly' Mannerists (p. 388), whose treatment of space betrays the 'weakened sense of reality of the age' (p. 389), may sound impressive, particularly when coupled with a reference to Spengler. But is all this true? Can we continue to teach our students a jargon which beclouds rather than clarifies the fascinating issue at stake?

Those of us who are neither collectivists believing in nations, races, classes or periods as unified psychological entities, nor dialectical materialists untroubled by the discovery of 'contradictions', prefer to ask in each individual case how far a stylistic change may be used as an index to changed psychological attitudes, and what exactly such correlation would have to imply. For we know that 'style' in art is really a rather problematic indication of social or intellectual change; we know this simply because what we bundle together under the name of art has a constantly changing function in the social organism of different periods and because here, as always, 'form follows function'. It is curious that all his insistence on 'dialectics' has not prevented Mr. Hauser from comparing, say, Mannerist art with late Gothic art as if they were commensurable. Before we ask ourselves what they 'express', we must know into what institutional framework they are meant to fit, and this frame of reference clearly changes between Gothic and Mannerism. In this sense Borghini's account of the origin of Gianbologna's *Rape of the Sabine Women* as a deliberate challenge to the connoisseurs who had doubted his power to create a monumental group, and the story of its subsequent naming and placing, tell us more of the background of Mannerism than all the religious tracts of the Counter-Reformation taken together.[3] It is not a story to be found in Mr. Hauser's book. Paradoxical as it may sound, the most serious objection to his approach is that it bypasses the social history of art.

It is true that the author sometimes interrupts his description of styles and movements to devote brief sections to the social position of artists or the organisation of their profession. Although there is little organic relation between these passages

and the main argument of the book, the information he supplies should be of use to the student. Mr. Hauser is a prodigious reader who has consulted most of the comparatively few studies which exist in this field. His chapter on the social position of the artist in the ancient world is mainly based on B. Schweitzer, *Der bildende Künstler und der Begriff des Künstlerischen in der Antike*, 1925. He might have made even more use, in later chapters, of H. Huth, *Künstler und Werkstatt der Spätgotik*, 1924, and of H. Floercke, *Studien zur niederländischen Kunst- und Kulturgeschichte*, 1905, both of which works are mentioned in his notes. He missed Jean Locquin, *La Peinture d'Histoire en France de* 1747 *à* 1785, (1912), which could have told him so much about the social and political background of classicism, but he has made extensive excerpts from W. Wackernagel, *Der Lebensraum des Künstlers in der florentinischen Frührenaissance*, 1938, which gives substance to his chapter on the social position of Renaissance artists. But even where he can thus rely on excellent groundwork, his preoccupation with generalities makes him careless of the significant detail. To find him speak of the 'St. Luke's Guild' in Florence (p. 311) shakes one's confidence in his reliability, for there was no such body. This is a confusion between the religious confraternity of St. Luke and the guild of the *Medici e Speciali* to which the painters belonged.

And where can Mr. Hauser have found evidence for his statement that Botticelli and Filippino Lippi were the 'close friends' of Lorenzo de' Medici or that Giuliano da Sangallo built for him the Sacristy of San Lorenzo (p. 304)? Sometimes it is only too clear how the information compiled in his reading is transformed in the re-telling. His impression of Bertoldo di Giovanni's relation with Lorenzo is obviously derived from Bode's monograph: 'Bertoldo lived with him, sat daily at his table, accompanied him on his travels, was his confidant, his artistic adviser and the director of his academy. He had humour and a sense of tact and always retained respectful distance from his master despite the intimacy of their relationship.' But this is not a social history but historical fiction.

All we really know from documents about this relationship is a.) that Bertoldo wrote one bantering letter to Lorenzo dealing mainly with cookery; b.) that a room in the Medici palace was called 'del Bertoldo o del cameriere'; c.) that Bertoldo died in Poggio a Cajano; and d.) that on one occasion 'Bertoldo schultore' is listed among the retinue of thirty-one that Lorenzo took with him to the baths at Morba—far below the musicians, by the way, and right above the barber. Would not this list have told the reader more of the social history of art than the romance about the tactful confidant? One hopes Bertoldo was not taken along as a 'cameriere' for his skill in cookery, and that he was at least allotted one of the fourteen beds available for the thirty-one members of the retinue.

One more example must suffice to show how dangerous it can be for the historian to think himself 'in the know' about the past. Speaking of Donatello's position,

Mr. Hauser says: 'What he himself thinks about the relation between art and craft is best shown by the fact that he plans one of his last and most important works, the group of Judith and Holofernes, as a decoration for the fountain in the court-yard of the Palazzo Riccardi' (p. 311). This Palazzo, of course, was the Medici Palace and, as it happens, the group was not planned as a 'decoration' (though it stood above a fountain) but was charged with an unusually explicit social and political message. Piero il Gottoso had placed under it the Latin inscription *Regna cadunt luxu, surgunt virtutibus urbes, caesa vides humili colla superba manu* (Kingdoms fall through luxury, cities rise through virtue. Behold the proud neck felled by the arm of the humble). Apparently the Medici wanted, by this *exemplum*, publicly to proclaim their continued belief in what Mr. Hauser would call their 'middle class virtues'—a proclamation much needed in view of the criticism their princely *magnificentia* had caused. When at last Piero di Lorenzo's 'reign' did fall *luxu*, the citizens of Florence must have bethought themselves of this prophetic image, for they placed it in front of the Palazzo Vecchio as a suitable reminder. Mr. Hauser, of course, need not, and possibly could not, know all the evidence,' but he gives no sign of really seeking out the vivifying contact with texts and documents.

Whatever the historian's individual outlook may be, a subject such as the social history of art simply cannot be treated by relying on secondary authorities. Even Mr. Hauser's belief in social determinism could have become fertile and valuable if it had inspired him, as it has inspired others, to prove its fruitfulness in research, to bring to the surface new facts about the past not previously caught in the nets of more conventional theories. Perhaps the trouble lies in the fact that Mr. Hauser is avowedly not interested in the past for its own sake but that he sees it as 'the purpose of historical research' to understand the present (p. 714). His theoretical prejudices may have thwarted his sympathies. For to some extent they deny the very existence of what we call the 'humanities'. If all human beings, including ourselves, are completely conditioned by the economic and social circumstances of their existence then we really cannot 'understand' the past by ordinary sympathy. The 'man of the Baroque' was almost a different species from us, whose thinking reflects 'the crisis of Capitalism'. This is indeed the conclusion which Mr. Hauser draws. He thinks that 'we are separated from all the older works by an unbridgeable gulf—to understand them, a special approach and a special effort are necessary and their interpretation is always involved in the danger of misunderstanding' (p. 714). This 'special approach', we may infer, demands of us that we look on the more distant past from the outside, as on an interplay of impersonal forces. Perhaps this aloof attitude accounts for the curious lack of concreteness in Mr. Hauser's references to individual works of art. The illustrations seem only to exist as an afterthought of the publishers and their captions have a strangely perfunctory

character. Has a 'social historian' really nothing to say about Ambrogio Lorenzetti's *'Good Government'* other than that its master, 'the creator of the illusionistic town panorama, takes, with the greater freedom of his spatial arrangement, the first important step in the artistic development leading beyond Giotto's style' (caption to plate XXII)? Even in the comparatively few descriptions of earlier works of art, the qualities Mr. Hauser emphasizes are more often than not those the works 'ought to have' rather than those we see. Thus we read that in the dedicatory mosaics of San Vitale 'everything complicated, everything dissolved in halftones is excluded ... everything is simple, clear and obvious ... contained within sharp, unblurred outlines ...' (p. 143). This, of course is as it should be with aristocratic works, but surely such a description is quite misleading. His similar remarks about Le Brun's 'orthodox style' almost make one wonder whether he has ever looked at one of these paintings with care.

The same sense of remoteness is certainly responsible for the difficulty of Mr. Hauser's style. The book is translated from the German and the author was not always well served by his translator, who puts 'the free arts' (*die freien Künste*) for the 'liberal arts' (p. 322) and is capable of writing: 'The perspective in painting of the Quattrocento is a scientific conception, whereas the Universum of Kepler and Galileo is a fundamentally aesthetic vision' (p. 332). But the basic character of the writing cannot be blamed on the translator. It is rooted in Mr. Hauser's approach, which may be illustrated by the following specimen, neither worse nor better than many others: 'For even where Italian culture seems to succumb to the Hispanic influence it merely follows an evolutionary trend resulting from the presuppositions of the Cinquecento ...' The abstractions set on their course here are in the thought, not merely in the language. The remarkable thing is how this bloodless, cramped style changes when the author reaches the 'Generation of 1830', 'our first intellectual contemporaries' (p. 715). Here he permits himself to trust his own responses and sympathies; the pace quickens, we are given some telling quotations and are made to feel that we are concerned with people rather than with 'factors'. These are the chapters where first literature and then the film predominates, but they include, for instance, a page on Impressionist technique alive with the thrill of intuitive understanding (p. 872). Such pages, no less than the various penetrating asides scattered throughout the two volumes, only increase one's regret that a misconceived ideal of scientific sophistication has all but cheated the author and the reader of the fruits of an immense labour.

Tradition and Expression in Western Still Life

IN the recent exhibition in London of the work of Giacomo Manzù a sculptured still-life attracted attention: a simple chair which might have been cast from nature with a bunch of over-life-size vegetables disposed on it, the bronze surface carefully worked to render the texture of the fruit, stalks and leaves (Fig. 38).[1] What is startling in this work is not, of course, the attempt to render fruit and vegetables in the medium of sculpture. Vitruvius' story of Callimachus deriving the Corinthian capital from a basket surrounded by acanthus reminds us how far back sculptors were expected to busy themselves with the study of plant life. But these ancient examples belong to the world of decoration, as do the marvels of naturalistic carving at Rheims or Southwell or the famous swags and wreaths of Grinling Gibbons. Within that curiously unexplored realm of fiction which we call ornament, these plants represent or suggest a real adornment of flowers or leaves to which the sculptor's skill has given permanence and precision. But it is neither usual nor desirable to give permanence to vegetables dumped on a chair, and so Manzù's sculpture detaches itself from the tradition of applied art and becomes what we call 'a work of art in its own right' and an intriguing one at that. What purpose, one wonders, would future archaeologists assign to it if they were to dig it up a few thousand years hence? Their records would have to be very full indeed to realize that one of the functions of such a work had been that of a challenge to painting, in the tradition of the *paragone*. Sculpture, too, can delight and surprise the eye by celebrating the beauty of humble things, sculpture also can conquer the still life. It is a fair guess that the purpose of this comparison can be narrowed down even further. Manzù would hardly have conceived of this challenge had the painted genre of the still life not included, among its possibilities, the famous chairs of Van Gogh. Without these elements of recognition and comparison, the discovery of the familiar in the unfamiliar, Manzù's chair would lose most of its meaning.

These reflections are occasioned by the welcome publication in England of a slightly amplified version of M. Charles Sterling's authoritative monograph on the still life which came out in France in 1952.[2] Owing its origins largely to an exhibition of still-life painting which the author organized in the Orangerie, the book has no occasion to refer to sculpture and is none the worse for that. Yet Manzù's *tour de force* illuminates some of the aesthetic and historical problems connected with the rise of those traditions of subject-matter which we call the 'genres' in a wider sense. It is perhaps characteristic of the situation in art history that M. Sterling tackles the historical problem with confidence and authority, while one can detect a note of

This article was written as a review of Charles Sterling's *Still Life Painting* (English edition, Paris, 1959).

uneasiness in his treatment of the aesthetic issue. He almost apologizes for writing the history of a category that is merely held together by subject-matter.

The critics against whom he has to argue question the validity of such categories on philosophical grounds. They have been persuaded by Benedetto Croce of the aesthetic irrelevance of subjects or traditions. The author all but concedes this point: 'Obviously it is the artist's attitude—his "intuition" as Croce would say—that determines the work of art. The subject whatever it is . . . is only a projection of the artist's inner life' (p. 124). M. Sterling goes on to admit that the conventional pigeonholes can be dismissed as valueless and that the 'inherent laws' which Academic doctrine wanted to deduce for each of these historical 'genres' must therefore be 'absurd'. He only pleads in defence of his chosen topic that there must still be some identifiable attitude of mind that corresponds to still-life painting. It is an attitude that finds inspiration in the inanimate world. On this interpretation there must be some psychological kinship between Manzù and Van Gogh because both were artistically moved by the sight of a simple chair. But this assumption would really leave the problem of tradition unaccounted for. The analysis of a 'genre' as coherent and as flexible as that of the still life might have offered an excellent opportunity to show up the 'desolation' of this kind of aesthetics.[3] Croce's artist who somehow bodies forth his inner state in sound or paint in unrelated 'insularity' is surely an artificial construct. But so is M. Sterling's psychological type, apt to be stirred into action by the sight of chairs or of apples on a table. If such motifs have aroused the imagination of artists, it was surely because they discovered in them a potential still life.[4] The genre, in other words, may often be said to come first, the emotion afterwards. What is more, the emotion could never have been communicated in the same way without the pre-existence of the genre.

This is indeed the decisive reply the author could have made in defence of his enterprise. He could even have done so without deciding whether expression or communication ever was or is the 'essence' of art. For the onus is on those who see art as either to prove that communication or expression can ever happen in a void.

Far from thriving on insularity, all communication pre-supposes a common frame of reference such as only the traditions of a particular culture can give. Where we lack this frame of reference, as frequently with exotic art, we can still project expressive characters into these works but we are usually aware of our uncertainty as to whether our meaning is indeed the intended one, whether anything like communication has taken place.

Within our cultural traditions our reactions are less arbitrary. The term 'still life', for instance, will evoke in most of us a similar cluster of memories that will influence our expectations if somebody tells us he has bought a still life he wants us to see. We should not register much surprise if we were then presented with pictures of dead pheasants or peeled lemons, of skulls and leather folios, pewter or flowerpots. Our

reaction to the painting in question cannot be separated from these expectancies.

Only where the painter and his public share this common background are we entitled to say that there is an element of 'communication': when the artist selects a potato and not an apple, a coarse brush and not a fine one (Fig. 51 and 52) for his still life, or when, like Picasso in one of his most magnificent exercises in the genre, he abandons his restless experimentation and impresses us with the grandeur of simple motifs simply rendered (Fig. 41).

While we enjoy these qualities we have every right to feel that it is the work itself that is charged with 'expression' and that any memories of other works would only obtrude on our communion with the artist's mind. But it is clearly a mistake to build a philosophy of art on this feeling. In fact what may still have been permissible in Croce's time has become untenable under the impact of scientific analysis. Those who study communication in the abstract know that 'Information can be received only where there is doubt; and doubt implies the existence of alternatives where choice, selection or discrimination is called for'.[5] It only makes sense to tell a person to 'keep right' where there is also a road to the left; and even a nod of the head will only serve as a signal where the recipient may watch for 'yes' or 'no'.

What the critic can learn from this simple insight of the theory of information is to watch out not only for what a message conveys but also for what it excludes It should be all too easy for us to assimilate this particular lesson, for both our artists and our critics lay such store by gestures of defiance and protest. But the more serious contribution of this theory lies in its demonstration of the reasons why neither the totally unrelated signal nor the totally expected one can be said to communicate. A work of art of complete originality—if it could ever be thought of—would communicate as little as does a work of a completely expected character. Such variations as the artist can introduce must always be felt to be related to specifiable expectations. Within the context of medieval art Manzù's chair would have lacked any meaning. Even for us, of course, its 'meaning' is not that of a 'message' investigated by engineers, but in so far as it has a message it must and does relate to a number of alternatives which it denies. It can be seen, for instance, as the answer to a hypothetical interviewer's question as to where the artist stands in the conflict between abstract and representational art, or between Academic conventions and their defiance. Never mind that these are *ad hoc* questions framed to fit the facts. It is part of our social existence, within the culture to which we belong, that we always scan any utterance with some such issue in mind. It is this fact alone that allows us to 'express ourselves' by the way we dress or speak. The absence of a haircut is made to stand for the refusal to accept other social conventions.

But is it really this kind of choice, one between simple alternatives, which we

consider when speaking of expression or communication in art or in life? Of course
it is not. Nobody in his senses wants to look at a smile as an instruction to select
friendliness rather than hostility from a limited range of expectations. The smile,
we feel, is indeed charged with emotion to which we respond with an immediacy that
makes rational analysis a mockery. It is this immediate response which people mean
when they speak of expression and of the communication of moods and attitudes;
and it is in this magic they trust when surrendering to their impression of a human
gesture or of a work of art. No doubt this trust is not entirely misplaced. There are
aspects of expressive behaviour to which the response may be automatic and even
inborn. But even here it would be rash to conclude that our instinctive reaction—
if it is instinctive—always secures communication. Within the context of social life
even the understanding of facial expression and of gestures is influenced and refined
by our capacity to size up probabilities and to distinguish the deviant from the
typical. 'The brain is a great averager' as Professor Colin Cherry puts it.[6] Without
being aware of the fact, we always adjust our reaction to a prevalent scale. We learn
to distinguish between the conventional, the warm, and the exaggerated smile of
welcome in any society to which we acclimatize. Our inborn response to expression
becomes attuned to communication.

Though both expression and communication in art are infinitely more subtle and
infinitely more elusive, they, too, are the result of both unlearned and acquired
reactions. Artists and critics have usually concentrated on the former. They have
been interested in the expressive character of shapes and colours as such. There are
'loud' and 'subdued' colours and 'violent' or 'melodious' lines. Hard as it may be to
test the validity of such metaphorical descriptions, there is no doubt that they
could not be swapped round at will.[7] And yet it is dangerous to underrate the dist-
ance between such natural reactions to forms and their articulated meaning in the
contexts of a culture. Even an art of pure form, such as music, needs a background
of expectations to become understandable. The same must be true of the still life.

No doubt even a layman who had never seen a still-life painting before might be
coaxed into an emotive response. But if he is really unsophisticated, this response
will almost certainly be determined by the motif. The painted spring flowers would
be found more gay than the painted folio volumes (Fig. 43). Traditional aesthetics,
however, has always insisted that the 'art' lies elsewhere, that the painter 'expresses'
himself in the way he transforms folios or flowers. M. Sterling is here well within
the tradition when he says (p. 128) that the perfect *trompe-l'œil* can only be achieved
by the craftsman and not by the artist. The artist, he believes, will always modify
the motif and it is in this modification, however subtle, that M. Sterling, together
with other critics, locates the 'expression'. In this reading of the situation the under-
standing of expression has indeed something to do with a deviation from expected
norms, an awareness of alternatives, but the norms and alternatives are those of the

'real'. When we see an apple painted in glowing red we compare it in our mind with memories of real apples and we find in this heightened colour an indication of the artist's mood.

This interpretation is certainly superior to those which concentrate on the 'pure' elements alone, in our case the expressive value of the red. For the element of comparison explains why our response would change if we discovered that what we took for a very red apple was an ordinary tomato. But even so, there are surely a number of flaws in this traditional account that looks for the artistic element in the painter's transformation of the motif. It presupposes for instance knowledge, on the beholder's part, of the 'real' appearance of standard apples without which he could not assess the expressive transformation. Not only can there be no such exact knowledge, but every representation, except perhaps a scientific wax facsimile, will bring about a 'transformation'. Any pencil drawing of an apple looks most unlike the real thing, but we do not find the grey tone of the medium expressive of gloom. Knowledge of the potentiality of the medium, in other words, is at least as important as is knowledge of the motif itself. Still life could never have come into existence but for the surprise the early collectors experienced in seeing a painting transcend the expected limitations of the craft and conjuring up the very texture of objects. What moves the *trompe-l'œil* into the vicinity of art is precisely the connoisseur's vicarious participation in the artist's skill. Manzù's way with bronze is as good an example as any to remind us that the unexpected transformation of the medium is at least as expressive as the unusual transformation of the motif.

Here is another gamut of alternative expectations, which the artist can interrelate with those of motif and form, to enrich his language to an extent beyond computation. His treatment of paint can put unexpected sweetness into the lemon, unsuspected vigour into tender spring flowers and sensuous softness into bronze vegetables.

It is the appreciation of the artist's choice and of the skill with which he carries out his decisions that forms an essential part of what we mean by understanding a work. Take the proverbial apples by Cézanne (Fig. 47). Surely those who merely compare them in their minds with apples seen at the greengrocers will not derive much solace or edification. It is rather by comparing them with standard still-life apples that we find in the master's single-minded concentration on their shape rather than on their texture a symptom of his attitude to life, his dogged search for essentials. Of course one cannot put down such a formulation without feeling its crudity and poverty. These apples would not be the marvel they are if their value lay only in being 'symptoms'. They 'say' infinitely more than can be summed up in words of this kind. We may surely concede to the Croceans that this unique character of personal expression makes it quite untranslatable into words. But this notorious difficulty has less to do with art than with language. Neither a real apple

nor one by Cézanne can ever be exhaustively described, for the simple reason that varieties of apples are infinite but the number of words in any language is strictly finite. In so far as painting is something like a language, the limits of its translatability are of a different character. They lie in the difficulty of finding clear and unambiguous terms for each of the possibilities the artist rejected or selected. Such terms cannot, in the nature of things, be at hand in the language of everyday life. All the critic can do is to search for equivalent gamuts that allow him to convey his meaning through metaphor and analogy.

We need go no further than M. Sterling's own table of contents to watch the sensitive critic at work constructing such a historical map of an expressive medium. In the chapter on the Golden Age alone we find such subtitles as '*intimité et opulence bourgeoise . . . la nature morte héroïque . . . de la sérénité caravaggesque au lyrisme baroque . . . la nature morte humble et mystique . . .*' All these descriptions depend on the author's knowledge of alternatives. What was 'bourgeois opulence' in seventeenth-century Holland would have been beyond the dreams of a twelfth-century nobleman. But the 'intimacy' of these motifs still stands out when compared to the typical repertoire of contemporary Flemish artists, the peacocks, game and silver dishes of Snijders. Naturally these in their turn would not be particularly 'heroic' (no courage was needed to paint them) if they were not so much larger and louder than the average Dutch counterpart, in other words if their deviation from some expected median were not felt to be equivalent to the similar deviations of other 'heroic' genres in literature or music. Likewise, if there is indeed 'serenity' in Caravaggio and humility in Spanish still lifes this character must also spring from their place within the field of possibilities. For neither the works nor the labels used by the critic have any of these meanings inherently and by themselves. They only communicate meaning within an articulated tradition.

It so happens that the English translation of M. Sterling's book provides a final object lesson of this interdependence of tradition and expression. When an isolated word is transposed from French into English it may on occasion retain its dictionary meaning but its expressive character will be transformed beyond recognition through the altered context. The English text of M. Sterling's book is full of tattered purple patches that did not survive the transfer. Take 'the sonorous pathos of Delacroix's lobsters and the crepuscular ostentation of Courbet's apples' (p.97). This is an attempt, it turns out, to come to terms with '*le pathos sonore ou crépusculaire des homards de Delacroix et des pommes de Courbet*'. Ineptitudes of this kind, alas, are so frequent in translations, particularly of art books, that they would not merit special mention except as one last illustration of this interdependence of expression and tradition. For within the 'genre' of English scholarly prose the type of vocabulary that comes naturally to the French critic will inevitably smack of that *pathos sonore ou crépusculaire* that M. Sterling feels to be present in Delacroix's

lobsters and Courbet's apples. (Figs. 49 and 50). A genuine translator, of course, would have to grope for a set of words no more unexpected in his English context than Sterling's is in its French tradition. Given that shift of scale that is known as the love of understatement, some two words like 'theatrical gloom' or 'sombre rhetoric' would lie sufficiently near the extreme beyond which the sublime tumbles over into the ridiculous. It is only after having settled on such a comparative equivalent that we can ask the second question, in what sense Delacroix and Courbet might be said to treat their motifs with sombre rhetoric. We will then find to our satisfaction that M. Sterling uses this characterization not so much to tell us something about the two artists named but rather to bring out by way of contrast the absence of melodramatic effects in Goya's still life (Fig. 48). To him this is on the other end of the scale, completely unrhetorical and all the more poignantly 'modern'.

Not everybody will agree with this particular section of M. Sterling's map. But, strangely enough, this possibility of disagreement vindicates rather than invalidates the author's search for such terms. If the critic's metaphors were all as meaningless as they inevitably look in isolation, the propositions of which they form part would be so much hot air. In fact the critic, no less than the artist, has a chance of communicating his reactions, but only to those who share his matrix of equivalences. It is most unlikely that even the most sensitive Chinese would find sonorous pathos or even sombre rhetoric in Delacroix's lobsters unless he had succeeded through years of hard work in absorbing that range of expectations that make up Western art and Western critical parlance.

Here, perhaps, is the element of truth in Croce's disregard of 'genres'. They are certainly not God-given. It is really a matter of historical accident which type of human activity becomes a vehicle for the communication of emotions. There is no inherent necessity why, for instance, this should have happened to calligraphy in China but to still life in the West.

<p style="text-align:center">* * *</p>

M. STERLING's account of the chain of events is both original and convincing. His principal point is the emphasis he wishes to place on the history of ideas as distinct from the history of artistic devices. To those who studied the slow progress of representational methods the still life appeared as the natural culmination of realistic tendencies which gathered momentum in the fifteenth-century styles of Northern Europe. But while the means for painting still lifes were certainly present in Van Eyck or Memling the idea of devoting an independent work of art to a show of artistic skill cannot be documented from that *ambiente*. M. Sterling has made a strong case for attributing this conception to Renaissance Humanism which, of course, derived it from classical antiquity.

It is a curious testimony to the power of ideas which are 'in the air' that the present writer came independently to the same conclusion with regard to the origins of landscape painting and published them almost simultaneously with M. Sterling's original volume on the still life.[8] Neither of us was able to quote the other in support, though both of our arguments could have been strengthened by such reference. It seems sure that all independent and secular genres in painting were greatly favoured by that new attitude to art and artist that we usually connect with the Italian Renaissance. When connoisseurs and collectors read in their Pliny and other ancient authors how greatly the ancients had valued the power of painting to deceive the eye, and how highly prized were specimens of such skill, they must have looked round for similar show pieces. The artists, in their turn, must have met this demand by a great emphasis on illusionism as a title to fame. Two examples not discussed by M. Sterling may illustrate this impact of a humanist attitude on the tradition of late medieval naturalism. One is Pintoricchio's self-portrait and its setting in the Baglioni Chapel in Spello of 1501 (Fig. 44). It is placed on the wall with the fresco of the *Annunciation* (detail, Fig. 45), a subject that had offered increasing opportunities for the loving depiction of a domestic interior with all its typical still-life appurtenances. Pintoricchio follows this tradition by painting a shelf with a prayer book and a candle but this shelf is both inside and outside the sacred scene. From it, suspended, we see the fictitious panel with his self-portrait accompanied by a proud humanist inscription and surrounded with a coral rosary and the painter's utensils, all painted in what must have looked like a startling *trompe-l'œil*. The merging of two traditions could hardly be clearer, for a year earlier Perugino had painted such a fictitious panel with his self-portrait in the *Cambio* (Fig. 46), but this must be imagined as suspended from a pilaster outside the religious or allegorical scenes, and it lacks the self-conscious display of still life motifs. Maybe Pintoricchio's solution can still be linked with religious preoccupations. He dedicates his portrait to the Virgin. And yet, which Northern artist would have done this in so self-assured a manner? There is but a small step from here to the complete emancipation of the still life.

There is a written document not hitherto discussed in this context that suggests that this step may indeed have been taken in Italy within the same decade. In the spring of 1506 Girolamo Casio writes to Isabella d'Este from Bologna that he is sending her some olives, a painting of the *Magdalen* by Lorenzo di Credi and 'a painting full of fruit made by Antonio da Crevalcore quite unique in this skill but, so we think here (*i.e.* in Bologna), he takes much longer than nature does'.[9] Now this Bolognese artist (also called Leonello), by whom only two or three paintings are known, was indeed celebrated for precisely his painting from the life in which—of course—he rivalled Zeuxis 'who deceived the birds with his painted fruit'.[10] No doubt those who appreciated his virtuosity felt reminded of this famous classical

precedent. Here, as in the case of Pintoricchio, it really seems as if the still life were sired from Gothic realism by Italian Humanism.

M. Sterling is on less sure ground when he wants to trace this invention back in unbroken line to Greek painters of the Hellenistic period. Literary sources at any rate are somewhat elusive. There are references in Vitruvius to pictorial representations of Xenia (gifts of food) and Pliny mentions that the notorious Pyreicus not only painted barbers' shops but also 'foodstuffs (*opsonia*) and such like things'. But a recent monograph on Pompeian and Herculanean still lifes[11] has thrown some doubt on the interpretation of these passages and stressed the importance of Roman decorative murals for the development of still life motifs in ancient art. Of course this would not invalidate M. Sterling's main thesis according to which the Renaissance still life is a deliberate reconstruction of a category fleetingly mentioned by classical authors. After all, the humanists may have over-interpreted these texts. But it must be admitted that there is no explicit literary evidence as yet to confirm this hypothesis in its extreme form. Classical antiquity certainly did not bequeath to the Renaissance any commonly current name for this category. The term 'still life', as M. Sterling shows, only emerged in the late seventeenth century when the genre had long been established.

Given the state of the literary evidence M. Sterling rightly concentrates on the continuity of typical still life motifs that survive in classical mosaics and decorative art. He has collected a number of striking comparisons that make the assumption of a direct link between ancient works and certain post-medieval still lifes almost inescapable. Here, too, Pintoricchio's example provides another intriguing case. For just as he added his painting utensils to his portrait there exists (or existed) a painted portrait in Naples with writing implements painted as *trompe-l'œil* outside the fictitious frame (Fig. 42).[12] M. Sterling is undoubtedly right that the painters who explored the *grotte* of Nero's Golden House must have known many decorative murals containing motifs we only know from other sites. But the problem of continuity becomes more intriguing when we turn to those details of Italian Trecento decorative murals which he regards as the true incunabula of the Renaissance still life.

One of these is a fictitious wall cupboard with flasks and cruet (Fig. 39), that forms part of Taddeo Gaddi's decoration in Santa Croce. The similarity between this detail and one from Pompei is suggestive and so is the link between such a *trompe-l'œil* and the marquetry of the subsequent century. And yet it may be argued that these virtuoso tricks are no more classifiable as still lifes than the 'Leaves of Southwell' can be called the true ancestors of Manzù's chair. The function of these decorations, after all, is still the traditional one of replacing, more or less playfully, objects or features that might really be there. Looking through Eve Borsook's illustrations of Tuscan frescoes[13] one realizes how natural is the transition here from a

painted stringcourse or curtain to the simulated chapels in Giotto's Arena Chapel, the true ancestors of Gaddi's niche. Even the objects of many *tarsie* are not quite emancipated from this tradition of decorative make-believe. They represent open cupboards with objects that might be expected in a *studiolo*. If it is true that even Jacopo de' Barbari's *Partridges* (Fig. 40) once formed part of a larger decorative ensemble, this painting would also lose its claim as the first independent still life. However much M. Sterling has illuminated the pre-history of the genre the moment of its general emancipation is not wholly accounted for.[14] Is there more truth than he is prepared to concede in the rival theory that accounts for the success of the easel still life mainly in terms of the emblematic tradition? Is the spread of the genre due to the religious appeal of the *vanitas* motif?

It may be that this question is wrongly framed. The historian who investigates the rise of a fashion, as we might call the sudden popularity of still lifes among the collectors of curiosities, may do well to ask himself what it is that makes any fashion 'catch on'. It is unlikely that such a success is ever due to one cause. On the contrary. The survival of any such innovation must rest on its capacity to satisfy a variety of conflicting aims. The success of the still life genre may be a case in point.

Its original appeal, no doubt, is to the naïve admirer of the *trompe-l'œil*, the collector of curiosities of the *Kunstschrank* type who can, if necessary, even justify his enjoyment with a quotation from Pliny or the Greek Anthology. But the still life scores over the other methods of displaying manual virtuosity by appealing to the simple pleasures of the senses. City dwellers of the twentieth century who can buy gorgeous flowers and appealing dishes the whole year round may have to be reminded of the added magic of the fruit- and flower-piece which graces the dining-room all through the year with pictures of the season's bounties. These rare things that feast the eye stir up memories and anticipations of feasts enjoyed and feasts to come. No wonder that this power of art to perpetuate sensuous enjoyment called forth, in the minds of the religious, the need to counteract such sinful leanings. The *vanitas* motif, as M. Sterling saw, will render the banquet innocuous: 'The Puritan spirit hovered over it all, calling for sobriety: hence the watch or timepiece which we find so often, symbolizing temperance and which might otherwise seem out of place among the heaped-up foods and precious objects of the Dutch still life' (p.51). But useful as such emblematic alibis may be, they are not really needed. For every painted still life has the *vanitas* motif 'built in' as it were, for those who want to look for it. The pleasures it stimulates are not real, they are mere illusion. Try and grasp the luscious fruit or the tempting beaker and you will hit against a hard cold panel. The more cunning the illusion the more impressive, in a way, is this sermon on semblance and reality. Any painted still life is *ipso facto* also a *vanitas*.

There is no proof of this interpretation. If it could be buttressed by texts it might also serve to fill the gap between two explanatory principles to which M. Sterling

resorts from time to time. The first is the changing psychology of a class or period, the other the changeless psychology of the individual that is rooted in childhood. The inherent weakness of the first becomes clear, for instance, when the lack of demand for still lifes during the period of classicism is attributed to those 'troubled times when men's minds were incapable of the quiet concentration required for the appreciation of still life painting' (p.93) (as if the times had been particularly untroubled for the Netherlanders who established the still life at the time of the Spahish Fury).[15] The second or individual factor which the author adduces as explanation of the still life is the baby's unique relationship with the inanimate world. In a beautiful concluding paragraph M. Sterling tries to link the psychological attitude of the artist, whose imagination is aroused by simple things, with this infantile concern for 'commonplace things within the reach of the hand'. No doubt we all know this mysterious appeal the toys and familiar objects of our nursery world always retain for us. But, curiously enough, it is not objects of this kind that form the repertory of still life. We are back at our starting point. The explanation of art in the psychology of the individual is insufficient. Art is a social activity yielding to social pressures. It is among these simple social and historical forces that we must look for the origin of a humble genre in which the sensuous appeal of food and glitter enjoyed a licence of its own. Maybe the early academic critics who rated this appeal rather low were not so benighted after all. How could they have predicted that the very frequency of repetition would gradually give this genre cohesion and articulation; that it would become all the more perfect a vehicle of expression, because it has never cut itself loose from an immediate appeal to the five senses?

Art and Scholarship

THIS being St. Valentine's day I should really begin by drawing a large heart round the two subjects of my title, art and scholarship, and then write some pleasing motto underneath. I would suggest, for instance, *amant se artes hae ad invicem*, a passage from the great Renaissance scholar, Enea Silvio Piccolomini, later Pope Pius II.[1] The two arts which he thus proclaimed love each other were Painting and Rhetoric, by which he meant that discipline of verbal mastery which, to the Renaissance, stood right in the centre of scholarship. But a good deal has changed in the five hundred years since Eneas Sylvius wrote of the mutual love of art and scholarship. There have been doubts, I am sorry to say, whether scholarship pursues honest intentions in its professed love for art. A master of rhetoric as well as of painting, Mr. Wyndham Lewis, has recently given vent to these doubts in that provocative book of his on the *Demon of Progress in the Arts*.[2]

When I see a writer, a word man, among a number of painters, I shake my head. For I know he would not be there, unless he was up to something. And I know that he will do them no good . . .

His blast is directed against the critic, or what he calls the pundit-prophet, but we are told that that dangerous suitor has 'recently promoted himself art historian'.

Despite the rhetoric, there is much in Wyndham Lewis's book that deserves to be pondered. He is surely right that image-men and word-men live in different worlds. Michelangelo is said to have spent months in the quarries of Carrara, unable to tear himself away from the sight of all the marble blocks in which he saw the shapes of works without number waiting to be liberated. The scholar's quarries are libraries. His form of indulgence is the reading of catalogues of second-hand books which, to his mind, conjure up visions of curious lore and possible clues to the riddles of the past. But there is at least one thing in common between art and scholarship: both may appear to be utterly useless—as useless in fact, as are all dreams and all memories.

'Papa, explique-moi donc à quoi sert l'histoire?' These are the opening words of Marc Bloch's moving *Apologie pour l'histoire*,[3] which was cut short when its author was killed by the Nazis. It is a question which would have scandalized scholars a few generations ago who were brought up on the Aristotelian prejudice that anything pursued for its own sake is more noble than something serving an end—whatever noble may mean in that context. But if we persist in this pose, the time may not be far off when those in authority will recognize the word scholarship only as what grammarians call a *plurale tantum*, they will only care for scholarships, and those, I am afraid, will be neither for art nor arts.

This was an Inaugural Lecture as Durning Lawrence Professor of the History of Art at University College, London, February 1957.

And yet I think it should not be difficult to answer the question which the young generation asks with understandable insistence. In fact, I have given it already. The scholar is the guardian of memories. Not everybody, of course, need care for memories. I personally would not much like to live in a world, or even work in an institution, in which all memories of the past have been blotted out. But that is not the alternative. The choice is *not* between knowledge of the past and concern for the future; if it were that, it would be a hard choice. It is between the search for truth and the acceptance of falsehood. For every community insists on what Professor G. J. Renier calls 'the Story that must be told' about its own past,[4] and where scholarship decays, myth will crowd in.

In this respect it has always seemed a cause for real wonder and surprise to me that the powers of science for good and evil should be on everybody's lips while the more dire powers of arts subjects should be ignored. Let me mount the soapbox for a moment and tell you that with all the drive for higher education £35,000 per annum cannot be spared to keep the library of the British Museum open in the evening.[5] The greatest power-house of knowledge must remain inaccessible to all who work in daytime; though one of the few things which everybody knows about its history is that it was here that two exiles, Marx and Lenin, concocted that explosive which exceeds in range even the most astounding devices of science. Apparently it has not yet struck anyone that where the myth originated it might also be rendered innocuous, through more accurate work in the quarry of books. Not even the experience of the last war has shaken the conviction of authority that science is a necessity, scholarship a luxury. Yet it would be easy to show that one element of the Nazi myth sprang up in the harmless field of comparative philology. The great Max Müller once ventured the guess that all peoples speaking the so-called Indo-Germanic languages might derive from the tribe of Aryans. He soon changed his mind, but the mischief was done,[6] and the ghastly tragedy of those who were idiotically labelled non-Ayrans should now suffice to answer the question of Marc Bloch's son.

I know that many of you will think that I am putting the cart before the horse. The horse which pulled the cart of perverted scholarship, you will say, was thirst for power, power which made use of any rags and tatters of scholarship to hide its true nature. I wish I could believe that. I wish it could be shown that it was power that perverted learning and not learning that perverted power. It would be more comforting, in a way, to think that the streams of adulterated scholarship that poured and pour from the presses of totalitarian countries were and are just the product of fear—fear of starvation, fear of torture even—from which none of us would be free in similar situations. But I think, in thus exonerating our colleagues, past and present, we are in danger of making too light of our own responsibility as scholars. While we preach to the scientist to heed the consequences of his work,

we believe, and make others believe, that we are just indulging in a harmless game because it is fun or because such leisurely indulgence produces wisdom where science only produces gadgets. I see no evidence of that. But I hope we may tell the young that in trying to preserve and recover the memories of past events, to use Ranke's famous words, 'as they actually happened', we maintain and extend the dykes of reason in an area which is particularly vulnerable to the springtides of myth.

The arts of the past are an important strand in the memories of mankind, and long may they remain so. Shrines, monuments, and images remain in front of everybody's eyes when books are forgotten and documents buried in archives. Great scholars such as Huizinga[7] and Ernst Robert Curtius[8] have been aware of the hold which visual records have over the imagination, and this hold will increase with the spread of travel and of visual aids in education. The idea which most of us form of Medicean Florence is coloured, and how pleasantly coloured, by that splendid cavalcade through a smiling landscape which Benozzo Gozzoli painted in the Riccardi Palace. Who would find it easy, after a visit to Ravenna and its solemn mosaics, to think of noisy children in Byzantium, or who thinks of haggard peasants in the Flanders of Rubens? Let me call this tendency to see the past in terms of its typical style 'the physiognomic fallacy'. It would be a harmless fallacy, if it did not strengthen the illusion that mankind changed as dramatically and thoroughly as did art. André Malraux has recently extolled this very power of art to transfigure the past into myth.[9] And may he not be right, you may say, at least where the artist is concerned? Why should the artist bother about that spoilsport the scholar and his past? The brief answer to this question, I fear, may sound moralistic. Because truth is better than lies. And a myth which is extolled as a myth deserves no name more polite than that. But I do not hold with the *terribles simplificateurs* who divide our mind into two halves, one for rationality devoted to science and utility, the other for art and dreams. Man is one. If there is anyone who is in need of undistorted memories it is the artist in our world. He needs them and makes use of them whether he wants to continue tradition or to defy it. His work is like a motif in a symphony which gains its meaning and its poignancy from what has gone before and what may follow. And it may well be argued that false memories, a haunted past, have created neuroses in art no less than in life—whether it was the academic myth that the Greeks had a special passport to beauty, or the romantic fairy tale that great artists were always derided and rejected by their contemporaries.

It seems to me entirely fitting, therefore, that the history of art was launched upon the world by an artist who was concerned with the memories of a great past—by Giorgio Vasari. It has always seemed strangely moving to me that it was Vasari who designed the Uffizi in Florence, where so many of the works he admired are

now enshrined. Vasari was a good architect, but as a painter his gifts were certainly unequal to the tasks with which he was confronted during a very successful career. He lacked the systematic training from childhood which moulded the outlook of the artist-craftsmen of the Renaissance. He had been brought up as the precocious companion to an aristocratic child and perhaps it was this element of distance which turned him into an historian. He could not take art for granted. He relates with genuine modesty how hard he laboured, on one of his first important portrait commissions, to imitate the sheen of the armour worn by his sitter, till the great Pontormo explained to him, what every artist discovers, that paint can never be matched directly against the gleam of light.[10] Later in his life, when he had achieved prosperity and decorated his house in Arezzo, Vasari painted a cycle of allegories in praise of art in tempera, since he had observed that this ancient technique was falling into oblivion and he thought it should not get lost altogether.[11]

In Vasari this conviction that only tradition and memory can keep art alive is paramount. He says in so many words that this is the reason which made him write the lives of the artists.[12] But Vasari himself was haunted by the spectre of a myth, a myth which he did much to propagate. He believed that the arts have their birth, growth, age, and death, as do our human bodies. And he felt, though he did not quite dare to say so, that the tremendous achievement of Michelangelo indicated that the life cycle of art had reached its climax and was heading for decay.

It would be interesting to speculate what effect this view of the past, which was no doubt shared by many of Vasari's friends, had on their art, on that much discussed style we call Mannerism.[13] For here we have one case where a myth of the past may really have created one of those collective neuroses I mentioned. Indeed, the irrational myth of the cycle and the dread of decline have haunted Western art ever since, sometimes of course in the form of an exaggerated emphasis on the belief in progress.

You will now see why I think that art history does indeed have a direct bearing on art, and, if you wish to keep the scholar out, remember the alternative is the non-scholar. Let us rather look at that discipline Vasari has bequeathed to scholarship and see what has become of it. For his questions, I think, are still our questions, even though our answers must differ from his.

It was not my intention when I undertook to write these Lives, to make a record of artists and a catalogue, as it were, of their works; nor would I consider it a worthy aim of my labours, which, if not splendid, have certainly been long and difficult, to set out their number, their names and places of birth, or where their paintings, statues or buildings are to be found at present. Because this I could have done by means of a simple tabulation without interposing my own opinion anywhere.[14]

The real historian, Vasari claims, will pronounce judgements which are the soul of history; he will discriminate the good from the better and the better from

the best and, most of all, he will investigate the causes and roots of styles, *le cause
e radici delle maniere*.[15]

In these days of fragmentation it has of course become impossible for one mind
to pursue all these aims with equal intensity. The artist who knows about the
painting of light and the technique of tempera is rarely the same as the connoisseur
who, like the first holder of this chair, Tancred Borenius, knows the names and
whereabouts of countless works of art; he, in his turn, will not necessarily aspire to be
a critic who, as Vasari puts it so politely, knows how to discriminate between the good
and the better. To drive through history triumphantly with a coach and four, as
Vasari did, would no longer be permitted.

I say 'permitted' because of the widespread conviction that the scholar *should*
specialize, since his concern is not with generalities but with the individual and
particular. I believe that this opinion rests partly on a confusion between ends and
means. The paradox of the historian's position seems to me precisely that the
cherished particular can only be approached by a spiralling path through the
labyrinth of general theories, and that these theories can only be mapped out by
those who have reached the particular. Think of the exciting adventure of decipher-
ing an ancient script which is not far from everybody's mind to-day. The individual
inscription is studied for what we can learn of the secrets of the script, and the
script in its turn for what it will tell us of individual inscriptions. To divorce the
one from the other would not only be foolish, it would be impossible.[16]

Now art is long and life is short and some degree of specialization is unavoidable
in our field. But it is at best a necessary evil. For in a sense Vasari even understated
his case when he wrote that without criticism and a theory of style he could only
have drawn up lists. He could not even have done that. The cataloguer does not
make lists of painted signboards but of Raphaels; that is to say, he relies on the
critic's evaluations. And how could he fight his good fight against myth, which
blurs and distorts the memory of great masters by false attributions, if he could
not use arguments which appeal to a theory of style? When he claims that a certain
painting cannot be by Raphael *because* it looks quite different from all the master's
documented works, the very word 'because' implies the general theory that a
master cannot change his manner of painting beyond a certain range.[17] If you
were to question this assumption by pointing out the astounding dissimilarities
which exist between various documented works by Picasso, the connoisseur would
reply, and quite rightly, that such a range may be possible for a twentieth-century
master but would be unthinkable in the sixteenth century. Already he draws your
attention to an unexpected turn in the labyrinth of his working theory, to the
assumption that different possibilities are open to artists in different conditions.
You may ask then what he thinks these conditions might be, which so restrict the
range of a master's manner that we can catalogue his individual undocumented

works with confidence, and unless he has shown you the door by then, he may remember that there are periods in art when styles change so rapidly that our assurance in matters of attribution becomes notoriously shaky. The famous controversies of art history seem mostly to centre round such periods of innovation and the pioneers who initiated them; the problem of Giotto in Assisi may come to your mind, of Masolino and Masaccio, of Hubert and Jan van Eyck, or perhaps that of the respective shares of Braque and Picasso in the creation of Cubism. Do we really know how much the style of one master may vary under conditions of crisis? Will we ever know, unless we turn round from the particular and face Vasari's problem about the causes and roots of style?

What is true of the cataloguers is, I believe, also true of the critics. But here it is not so much the question of the objective validity of their utterances which is at stake. Great practitioners of this delicate art have overcome this formidable obstacle by making their own, avowedly subjective, reactions to paintings and sculptures the theme and *raison d'être* of their writings. They know how to use words to articulate their sensations and they let us profit in our own sensibility by teaching us differentiation.

The word differentiation is decisive here, because without differentiation there could be no communication. In this College, which is also the seat of the Communication Research Centre, little more need be said about this aspect. Symbols do not carry meaning as trucks carry coal, to paraphrase Mr. Colin Cherry.[18] Their function is to select from alternatives within a given context. You remember the story of Ali Baba and the Forty Thieves. The robber marked one door he wanted to remember with chalk. His fair opponent took chalk and repeated the sign on all other doors, thus destroying the meaning of the symbol without touching it. You will understand, if you think of this parable, why Picasso said that his imitators make him sick. A meaningful distortion is emptied of meaning when it becomes a mannerism, a convention. It is only because we know the convention, on the other hand, that the artist's distinctive contribution makes sense to us. With contemporary works the critic may have little difficulty in responding to the delicate interplay between expectation and message which I have compared to the effect of a modulation within the context of a symphony. But with the messages which reach us from the past we must often try to replace by a conscious effort what we lack in instinctive assurance. Unless the critic, like the connoisseur, knows how to turn round from the particular to confront the problem of style, he may never be able to disentangle the message expressed *within* the language from the language itself.

. This was a problem which was very much in the mind of my teacher Julius von Schlosser at the time when I was privileged to study under him in Vienna. He had been much impressed by the demand of his friend Benedetto Croce to treat

every work of art as an incommensurable individual expression; but how could the historian get hold of that elusive insularity of the work of art if he found it embedded in the artistic idiom?[19] To hear him meditate about these perplexities in front of a lantern slide of the Arch of Constantine was not always an entertainment, but I hope it was an education. For Schlosser, if anyone, was a real scholar, and his living *rapport* with the past made it hard for him to accept the claims of a younger generation to have fulfilled Vasari's third and most difficult demand: to explain the causes and roots of style through a 'science of art', a new *Kunstwissenschaft*. My sympathies, at that time, were divided, but to-day I think that Schlosser's mellow scepticism was justified. For surely it is not scientific to take the signs, those marks on the doors, out of context, and investigate their 'structure' for what it may tell us about their makers? Too often this procedure only leads back to the physiognomic fallacy, the myth that the system of signs, the style, is not a language but an utterance of the collective, in which a nation or an age speaks to us. A great linguist, Edward Sapir, has explicitly warned us against this confusion in what he calls the most difficult problem of social psychology:

It is impossible to show that the form of a language has the slightest connection with national temperament. Its line of variation, its drift, runs inexorably in the channel ordained for it by its historic antecedents.[20]

I think these warnings of the linguist might be confirmed by the anthropologist. In a recent study of Eskimo art, Hans Himmelheber describes the habit of Eskimo girls, in certain regions of Alaska, of accompanying the stories they tell each other by drawing little pictures in the snow.[21] They carry special tools to have this means of enlivening their tales always at hand. But according to my authority this custom exists only in one area; on the neighbouring island of Nunivak girls do not draw in the snow. Clearly it would be rash to jump to the conclusion that this difference in habit reveals a radical difference in tribal character and outlook. And even if it did, who is to tell whether the snow-drawing habit influences the mentality of the tribe, or the mentality causes the different habits? The example is not as far-fetched as it may sound, for we art historians are often confronted with puzzles of a similar nature, though of a different order. Venice has a glorious tradition in painting; Genoa much less so. It is easy to see that at any given moment tradition had a good deal to do with this difference. Without Bellini and Giorgione there would have been no Titian, and without Titian, Tintoretto might not have risen much higher in Venice than Luca Cambiaso did in Genoa—though reflections of this kind are inevitably futile. But what about the start of the tradition?

Strangely enough Vasari himself was confronted with that very problem. Nobody knew better than he did, how much tradition counts in art. His whole framework of organic growth rests on the conviction that one artist learns from another and can add to his achievements and discoveries. The destruction of the

first tradition could be explained through the barbarians, who put an end to classical art: but why and how did it start again where it did, in Tuscany in the thirteenth century? The answer he gives in an incidental remark is portentous of things to come:

The spirits of those who were born, aided in some places by the subtlety of the air, were so purged that in the year 1250 the heavens were moved to have compassion with the fine minds which the Tuscan soil brings forth every day and returned them to pristine form.[22]

Those of you who are familiar with writings on art and archaeology know that this type of incidental nonsense has by no means disappeared from our books. But in Vasari it was more excusable. To him, to seek for the cause of something was to seek for some agency, a substance or a will inherent in the air, the soil or the movements of the heavens. After all, his book was published fourteen years before that other great Tuscan was born who put an end to this idea of explanation; I mean Galileo Galilei. It was Galilei who fought the type of explanation by verbal trick in his attack on Aristotelian habits of thought, and judged it better for people 'to pronounce that wise, ingenious and modest sentence "I know not" '.[23] It became the word of power that created the modern world. Two generations later, Molière could already make fun of the Aristotelian type of explanation in his immortal skit on the medical examination that forms part of *Le Malade Imaginaire*, where the candidate is asked why opium causes sleep and replies in his beautiful dog-Latin:

> Mihi a docto doctore
> Domandatur causam et rationem quare
> Opium facit dormire.
> A quoi respondeo,
> Quia est in eo
> Virtus dormitiva,
> Cujus est natura
> Sensus assoupire.

'Benè, Benè, Benè . . .' Molière's examiners react with enthusiasm to this explanation that opium sends you to sleep because of its sleep-inducing nature. And that puts an end to their questioning, not only of the candidate but of nature. Herein, of course, lies the great danger in this type of explanation by essences. They are not only empty in themselves, they put a full stop to further enquiry.

I have asked a colleague from the Department of Pharmacology Molière's question, and, not quite unexpectedly, I received the Galileian answer. We do not know why opium induces sleep, but a good deal of research is going on, on what happens when opium, or rather the morphium it contains, enters the bloodstream and how it affects the actions of certain nerve cells. I take it that there are at present a number of rival hypotheses about the reactions involved, which scientists are

busy testing and discussing, extending the frontiers of knowledge *because* they have given up the idea of a full-stop explanation.

I think if we are ever to have a more promising science of the causes and roots of style, we shall have to catch up with the Galileian revolution. This is a point on which I can afford to be brief, since the links between Aristotelian Essentialism and the Hegelian myth of Historicism have been so clearly laid bare by Professor K. R. Popper.[24] Let me just give you one example from our own field. There was a much debated concept in *Kunstwissenschaft* which derived from an interesting book by Alois Riegl on the history of patterns in art.[25] It was called *das Kunstwollen*, the will-to-form. It turned out that the reason why the style of ornamentation changed in history was that the inherent will-to-form had changed. Now I do not want to give you the impression that Alois Riegl was a fool. He was not. He had originally coined the term *Kunstwollen* in a polemic against the explanation prevalent in his time that patterns are always the result of techniques such as those of weaving or basketry. It made, of course, sense to emphasize the importance of artistic intentions against this purely mechanical explanation. But he, too, fell victim to what Marc Bloch calls the fetishism of the single cause, and ultimately failed to see that what he produced was not an alternative explanation, but a form of words which soon assumed the character of a mythology. For where there is a will there must also be a willer, and this he found in those Hegelian collectives, the spirit of the age and the spirit of the race.[26] I have explained before why I believe that it is in these unswept corners of our intellectual universe that the germs of epidemics are often bred. But you now see, I hope, that this type of explanation is not only hostile to reason; it is also hostile to scholarship because it produces that simulacrum of an explanation which puts an end to further search.

There is no better testing ground for the relative merits of rival approaches than the field of Renaissance studies. As you may know, I really resemble the favourite hero of Hollywood films, I boast of a split personality. Before you honoured me by appointing me to this Chair, I was proud to hold the position of a Reader in History at the Warburg Institute, where I still hold a special lectureship. Now the historian of the Renaissance developed a rather ambivalent attitude towards my present activities. Historians feel, I believe, that art history since Vasari has tended to mislead rather than to enlighten them. We have often been told by students of style that a new epoch began for mankind when Giotto first painted tangible bodies, and that this epoch came to an end when these solid forms gave way to the flaming apparitions of Tintoretto or Greco. The very success of the concept of the Renaissance and its delimitation in time owes a great deal to these visible testimonies of a change.[27] But change of what? The nineteenth century, as you know, had no doubts on that score. Change of the philosophy of life, of the world-view of those men who produced and commissioned such works. How else could you

explain their profound difference from all that came before and after? To quote that persuasive historian of the Renaissance, J. A. Symonds:

> The first step in the emancipation of the modern mind was taken thus by art, proclaiming to men the glad tidings of their goodliness and greatness in a world of manifold enjoyment ... Whatever painting touched became by that touch human; piety, at the lure of art, folded her soaring wings and rested on the genial earth. This the Church had not foreseen.[28]

It is the view which, I think, ultimately goes back to Hegel, according to which Renaissance naturalism must be linked with geographical discoveries as harbingers of the greatest change of all, the Reformation.[29] Think of the Prior in Browning's 'Fra Filippo Lippi' who is scandalized by the painter's naturalism:

> Make them forget there's such a thing as flesh ...
> Paint the soul, never mind the legs and arms!
> Rub all out, try at it a second time.

We have no evidence that there ever was such a prior. But to the nineteenth century, with its choice between Etty and Rossetti, the only possible explanation of naturalism was sensuality. Since art, moreover, must reveal the essence of the age, such sensuality, when found, was listed as a confirmation of the original explanation. Where it was absent or less marked, you had to make excuses for features which were obviously a mere survival of the middle ages. The technique worked as well as all such techniques will work. You got in the end what you set out to find, a colourful Renaissance teeming with supermen who said 'yea' to life, contrasting impressively with the ethereal Age of Faith, populated by monks who were busy denying the body—though the word populated is perhaps already stressing an inessential aspect of these spiritualized centuries.

I believe Aby Warburg was one of the first students of the Renaissance to break through this magic circle of the mutually reinforcing historical cliché, when he was led by his researches to question the basic assumption that naturalism in art betrayed a lack of interest in religion. Not that he had set out to do so when he began his studies in the 1880s. His enthusiasm for the circle of Lorenzo il Magnifico was fed by the same predilections for a secular culture which had also inspired Burckhardt and Symonds. Like Ruskin and Taine he was fascinated by the fresco cycles of Ghirlandaio; these depict this society with such fidelity that it seems that the sacred subjects are really no more than a pretext for the glorification of the life of this world. Nowhere was this apparent contrast between the subject and the treatment more striking than in Ghirlandaio's life of St. Francis in Santa Trinità in Florence. In trying to investigate this cycle which had been commissioned by one of Lorenzo's elder business partners, Francesco Sassetti, Warburg came across a series of documents which strangely contradicted this assumption of carefree worldliness.[30] He found that Sassetti had been the wealthy patron of

one of the most splendid churches of Florence, Santa Maria Novella. It was there that he wished Ghirlandaio to paint the life of his patron saint, St. Francis. But the monks of Santa Maria Novella objected to this plan. They were Dominicans and firmly refused to have the founder of the rival order glorified in so prominent a place in their church. Sassetti did not say: 'one saint to me is as good as another'. He insisted, and when he failed, he transferred his patronage to the more accommodating Vallombrosan foundation of Santa Trinita, where he lies buried, with his wife, surrounded by the images of his patron saint. It was this dogged allegiance by a prominent member of the Medici circle to his saint which made Warburg wonder whether these men could have been all that indifferent to the world beyond the grave? Was naturalism really a sign of such indifference? Did not documents exist to show that another church in Florence was crowded with life-size wax images in natural clothes portraying donors from the same circle?

The explanations which Warburg sought in the peculiar mental make-up of these individual people need not convince us in themselves. What matters is that the vicious circle was broken at last and that new types of evidence became admissible to the scholar. The subject-matter of Renaissance paintings, for instance, which had so often been looked upon as carefree pageantry, turned out to be concerned with dark astrological superstitions or philosophical perplexities. A whole new field of problems was opened up in the study of iconology, which searches for the texts and contexts to restore the original meaning of works of art. Both admirers and critics have spoken in this connection of 'the Warburg method', but I believe that the only method which would deserve this name is that willing suspension of belief which found its finest flower in the mind of Warburg's successor, the late Professor Saxl. For without such willingness to distrust one's own assumptions, iconology is subject to the same dangers to which the interpretation of styles had been so prone, the danger of circularity. It matters little that the vicious circle now often runs the other way round. The fashion now is to take it for granted that the appearance of carefree sensuality in works of Renaissance art can never reveal the essence, and that there must always be some hidden spiritual meaning behind the deceptive form. If we were confronted with the tomb which Browning's Bishop ordered in Saint Praxed's church with

> The Saviour at his sermon on the mount,
> Saint Praxed in a glory, and one Pan
> Ready to twitch the Nymph's last garment off

we would assume without question that there must be some spiritual meaning behind the image of Nymph and Pan to confirm our new cliché of the Renaissance. Pan, of course, signifies the Universe, and the stripping of the Nymph's last garment symbolizes the liberation of the soul from the fetters of flesh.

Only recently Professor Momigliano has uttered a timely warning against the

pitfalls of circular interpretations of images.[31] The only escape from this danger lies in that outward spiralling movement I have described, the attempt to draw in new evidence from ever-widening circles, which may offer new vistas onto the particular. Unless iconology is to become barren it will have to find new contact with the ever present problem of style in art.

I am proud to be able, in this context, to pay a more than formal tribute to my predecessor in this Chair, Professor Rudolf Wittkower, who has brought about this contact and thereby revolutionized the study of architecture.[32] Here, too, the accepted way of looking at Renaissance buildings was, he reminds us, to stress their worldliness. Wittkower distrusted the cliché. He is a scholar who likes books, as anyone who has ever seen him leaving a library with piles of folio volumes under both arms will testify. I think we all envy New York this sight. Wittkower actually reads these long treatises in Latin and can extract from their abstruse reasonings a clear conception of the modes of thought and, what is more, of the *modus operandi* of these architects. Thanks to him, we can now picture much more clearly what happened when a church was commissioned in the Renaissance or when a patron had a villa built by Palladio; we can guess at the type of argument that was used in favour of one solution rather than another. The individual and particular has been brought to life and in the process Wittkower has churned up a host of new problems upon which future research can be brought to bear and which will keep generations of scholars busy.

We have not reached this stage in our research on the causes and roots of style in Renaissance painting and sculpture. Indeed, we have no theory of style which might account for its stability or its changes.[33] After I have tried to convince you that we would need such a theory, you may find this a discouraging conclusion. I take the opposite view. I could imagine nothing more discouraging for a student than the dreary notion that the past is all taped, and that his task consists only in swotting up the facts which are listed in books. Scholarship is an activity; and teaching, as I see it, consists in rousing the student's spirit of adventure by telling him of the blank patches which still exist on the map of knowledge.

For me, at least, the enigma of style is wrapped in a thrilling mystery. The more I become aware of our profound ignorance in this field, the more exciting do I find it. Even to frame the right questions would seem to me eminently worth while; for I believe that in these matters Riegl's idea that all style is intentional has obscured rather than illuminated the problem. We may have to retrace our steps to Vasari and acknowledge the role of skill, of the learning process which is involved. Vasari knew, because he was himself an artist who had struggled with representation. We, I think, should again turn to the working artist to learn what actually happens when somebody makes an image. What use does he make of tradition, what difficulties does he encounter? I once asked one of my present colleagues,

who wishes to be nameless, the shockingly naïve question how he explained the startling fact that many an untutored new arrival at the School can produce a reasonable likeness of nature which appears to have eluded the genius of Giotto. His answer was immensely enlightening to me. These students, he thought, have been surrounded throughout their lives by books, photographs, and posters which show the three-dimensional world already translated into a flat image; it was from them that they must have learned that difficult trick. Word-man that I am, I am just engaged on a lengthy book which attempts to test this explanation against psychological evidence.[34] But you will see that psychology alone can never suffice to explain the riddle of history, the riddle of particular changes. Why were artists really only concerned with these discoveries in the two brief isolated periods and centres which figure in Vasari's story—classical Greece and Renaissance Italy? I do not think that we can ever hope to produce a final explanation of this type of problem, but I do not see why any question should be barred in history if it may direct attention to new and possibly neglected aspects of the past. Was there, perhaps, a change of function in the image? Did it play a different role in these astounding societies of exploring minds?

Scholarship, as I see it, can only profit by such wild questions being asked; for without them it is always in danger of submitting to a self-perpetuating routine —the refining of techniques for their own sake. It is true that the older one gets the less is one inclined to dismiss technique in either scholarship or art as unworthy of respect. The expertise of a classical scholar who can edit a Greek papyrus, or the skill of a painter who can draw a blade of grass, will arouse our increasing admiration the more we approach reactionary old age and realize how many things we missed learning while there was still time. Perhaps this melancholy process will be somewhat arrested by a new contact with a world in which the term academic is not always a word of praise. For in that world of art nobody doubts that what counts is the search, the constant probing, the taking of risks in experimentation. Indeed, I believe that in this respect scholarship can always profit from the spirit of art to venture into the unknown rather than to apply and repeat what has already been done.

But is there anything academic scholarship can give the artist in return? I think and hope there is. It can show, by its example, that boldness alone is not yet exploration unless it is coupled with a critical sense. In clarifying the memory of the past it can pin down and render innocuous those catch-words which buzz around the artist's ears. For, personalities apart, Mr. Wyndham Lewis may not have been altogether wrong when he blamed the demon of progress on the demon of historicism. The art historian who sees the styles of the past merely as an expression of the age, the race or the class-situation, will torment the living artist with the empty demand that he should go and do likewise and express the essence

and spirit of his time, race, class or, worst of all, of the self. The more we exorcize those spirits which still haunt the history of art, the more we learn to look at the individual and particular work of art as the work of skilled hands and great minds in response to concrete demands, the more we shall teach authority that what the artist needs is not more myth or more propaganda, but simply more opportunities, opportunities for experiments, for trial and error, which alone can lead to the emergence of those skills which can meet the ever changing challenge of the here and now.

I suggest, Mr. Provost, that we make a beginning by having this hall decorated by the staff and students of the Slade. There are very good precedents in the history of art for the employment of great masters by departments of anatomy. If I may ask a favour, let the Durning-Lawrence Professor, assisted perhaps by the Special Lecturer in the History of the Renaissance at the Warburg Institute, work out what is called the programme of these decorations. Maybe, after all, its centrepiece might be a Valentine which could then display, with greater conviction, the motto from Enea Silvio Piccolomini: *Amant se artes hae ad invicem.*

Imagery and Art in the Romantic Period

MOST print rooms of Europe have in their care vast accumulations of prints brought together for the sake of their subject-matter rather than for any artistic merit. These collections of historical and topographical illustrations, of fashion plates, theatrical subjects, and portraits are now rarely consulted except by antiquarians or writers of popular books in search of suitable illustrations. The British Museum's collection of political and personal satire has, on the whole, shared this fate. These prints are rarely considered as art. They are more frequently looked upon as part of the imagery of the past that is the domain of the historian of manners rather than of the historian of stylistic trends. This estimate is hardly surprising, for side by side with the best works of Gillray, Rowlandson, or Cruik-shank, these folders contain a good many prints whose aesthetic value is scarcely higher than that of the humorous seaside postcards and comic strips of our own day. Nevertheless, the neglect of this imagery by the art historian cannot reasonably be defended. As a class of images, caricatures are neither more nor less embedded in a definite historical context than are state portraits or altar paintings. And if art history were to restrict its attention to inspired masterpieces we would have to exclude many a work that usually figures in histories of style.

As a matter of fact, the art historian's reluctance to deal with this type of material has been due much less to theoretical or aesthetic scruples than to practical difficulties. The knowledge and research needed to unravel the symbolism of these ephemeral productions and to resuscitate the humour of their topical allusions have often appeared to be out of all proportion to the intrinsic value of the works themselves. We have all the more reason to be grateful to the distinguished social historian who has undertaken this prodigious labour, thereby opening up to the non-specialist the greatest collection in existence of English caricatures. With each new volume of Mrs. M. D. George's Catalogue, it becomes increasingly evident that only now will it be possible to study the great period of English graphic journalism and to see its most creative phase in a wider perspective.

A few examples, picked almost at random from the last volume that has so far appeared, the volume covering the years 1801–10, must suffice to show the value to the art historian of the information placed at his disposal. The connection between these caricatures and the art and taste of the times can be well exemplified in a print such as James Gillray's spirited *A Phantasmagoria; Scene—Conjuring-up an Armed Skeleton* of 1803 (Fig. 53).[1] It is an impressive warning against the Peace of

This article represents some marginal notes to the *Catalogue of Political and Personal Satires preserved in the Department of Prints and Drawings in the British Museum*, VIII, 1801–10, by Mary Dorothy George, London, 1947.

Amiens and its Francophile sponsors who are caricatured as the witches in *Macbeth*. The skeleton emerging out of the cauldron (in which the claws and tail of the British lion are seen to simmer) is the gruesome phantom of Britannia conjured up by Addington (ladling guineas into the pot and raising the olive branch entwined with serpents), Hawkesbury (feeding the fire with papers inscribed *Dominion of the Sea, Egypt, Malta, Cape* . . . etc.) and Fox (holding up the broom). The crouching figure in the foreground, we learn, is Wilberforce in monkish robes, chanting a *Hymn of Peace*. The lavish display of French insignia on the politicians and the Gallic cock in the foreground perching on the decapitated head of the British lion drive home the point of Gillray's attack.

The link between this Shakespearean fantasy and the pre-occupations of contemporary academic art needs no elaboration. It is clear that Gillray—who had satirised Boydel and his Shakespeare Gallery—knew and exploited the vogue for these Romantic subjects.[2] But the catalogue helps us to recognise another link with the taste and mentality of the time.

'*Phantasmagoria*'—Mrs. George tells us—'was the name invented in 1802 by Philipsthal for an exhibition of optical illusions produced by a projecting lantern. It was a new French invention. . . Philipsthal exhibited on a transparent screen at the Lyceum representations "in a dark scene" of apparitions and spectres which appeared to advance or recede. . . by means of lenses and concave reflectors.'

Philipsthal's magic lantern lights up, in a flash, the background of Gillray's print and the taste for which it catered. It is the exact parallel to Loutherbourg's *Eidophusikon*, which appealed to the lovers of Romantic scenery, by presenting on the stage such sensational effects as 'thunder and lightning, the changes of cloud forms, the tumbling of waves and a shipwreck . . .'[3] Romanticism pervaded political imagery no less than it transformed topographical imagery. In the sphere of literature it changed from an affair of lonely poets to a widespread fashion affecting the reading matter of the circulating libraries and producing the mystery novel, best remembered through Peacock's parodies. In the visual sphere it found its reflection not only in the art of those masters we now call the Romantic painters but also in the cheaper thrills of Philipsthal's and Loutherbourg's stage effects and in the fantastic inventions of Gillray and his followers.

Mrs. George draws attention to a number of satirical prints called *Phantasmagoria*.[4] Many more deserve the same label. In fact the prints of the period exceed in extravagance and daring nearly everything that the official art of this time produced. In passing in review these grotesque inventions we are reminded of Haydon's description of Fuseli's studio with its 'Galvanized devils—malicious witches brewing their incantations—Satan bringing Chaos, and springing upwards like a pyramid of fire—Lady Macbeth . . . humour, pathos, terror, blood and murder, met one at every look!'[5] (Fig. 57).

How are we to explain this ready response of graphic satire to the Romantic trend? Should we merely attribute it to the crudeness of popular taste which relished spectral visions and horrors? No doubt it was partly the conservatism of the Academy which—despite Fuseli's prestige—prevented the Romantic movement from finding full outlet in 'serious' art. Unlike the acknowledged artist, the graphic journalist could give the public what it liked without fear of infringing any real or imagined code of good taste. But perhaps there is yet another reason for the prevalence of the 'phantasmagoric' spirit in the great period of English caricature; a reason more intimately bound up with the specific problems of pictorial satire: a glance at the history of these problems suggests that these specific methods of visual propaganda could only be absorbed by the language of art, when Romanticism had brought about a shift in the function of the image.

To express the complex meaning of his message the satirical artist must often resort to the methods of the rebus and of primitive ideographic script.[6] He must crowd on to his page a number of incongruous images which stand for the ideas or forces he wants to symbolise. In periods such as the Middle Ages, when artistic conventions were entirely based on the symbolic use of images, no special problems arose from this need. The configuration of images was understood and read as purely symbolic. With the victory of a realistic conception of art, however, a dilemma makes itself felt. To a public accustomed to see images as representations of a visual reality, the mere juxtaposition of disconnected symbols produces a disquieting paradox in need of resolution. Thus, while the mediæval idiom and mediæval motifs lived on in satirical broadsheets with astonishing tenacity,[7] we also witness continuous efforts to rationalise and justify this antiquated language and to reconcile it with realistic conventions. This problem was tackled in various ways. The simplest was also the most frequent: to give up all pretensions at artistic coherence and to rely on an elaborate text in verse or prose explaining the meaning of the political emblems or 'hieroglyphicks'. Here the very disjointedness of their imagery is used to attract attention and to force the public to resolve the paradox by reading the 'key'. Close to this form—which has returned in a different guise in our posters and advertisements—is the exploitation, for humorous effects, of the contrast between symbolic sense and visual absurdity. The literal illustration of figures of speech, a legitimate means of didactic imagery in the Middle Ages, shades off into comic art at the time of Bruegel. His proverb illustrations rely on the shock effect of a topsy-turvy world in which real people try to run with their heads through the wall or to kill two birds with one stone.[8] Hogarth chose the opposite way. Following Dutch seventeenth-century precedents he was fond of hiding his symbolic meaning behind a plausible pseudo-realistic façade. His cuckold does not show symbolic horns: he happens to stand 'accidentally' in front of a bull whose horns seem to be protruding from his head. The symbolic image is given a rational justification,[9] and this is part of its wit.

In between these possibilities there lie a number of other methods of combining the emblematic use of imagery with a satisfying visual aspect. To the seventeenth century the apparatus of classical mythology and allegory provided the favourite instrument for the translation of complex statements into accepted pictorial forms. Here, where the borderline between symbol and illustration is blurred, where Mars represents war and Envy may be chased from the Temple of Peace, realism and symbolism are less likely to clash. In Rubens's political paintings, and—on a lower plane—in some of Romeyn de Hooghe's complicated allegorical prints, the world of human beings and conceptual symbols appears to be reconciled.[10] But there is yet another form of rationalisation of visual symbolism and this is of the greatest interest in our present context. It is in the transference to the field of visual art of the stock method of justification used by mediæval poets. To justify the incongruities of symbolic narratives these poets were fond of representing their allegorical stories as real dreams or visions. A realistic introduction describes how the poet fell asleep and leads us to a different level of reality. This simple device allowed the narrator to introduce fantastic beings into a realistic setting without being accused of 'lying'. The application of this formula to visual imagery has a long and varied history. There are a number of sixteenth- and seventeenth-century prints whose fantastic agglomerations of incongruous images are explained as the literal transcriptions of portents, visions, and prophetic dreams.[11]

It was in this mode of justification that the political print may have met the Romantic movement half-way, as it were. There are certainly many social and political reasons which account for the mounting tide of graphic satire towards the end of the eighteenth-century. There are also obvious stylistic elements, like Hogarth's heritage and the influence of Italian *caricatura* which had its share in the increasing popularity of the pictorial lampoon. But besides these reasons, the congenial climate of the Romantic era might well have been an important contributory factor in the transformation of the hieroglyphic print into the triumphant idiom of Gillray and Rowlandson. For now the weirdest combinations of symbols, the most grotesque conglomerations of images, were no longer merely tolerated as the pardonable licence of a low medium of illustration. They could be attuned to the taste of the time if they were presented as phantoms, nightmares, and apparitions.[12] It seems that the Romantic movement gave new sanction to the inevitable visual inconsistencies of political imagery much in the way in which Surrealism to-day has given licence to the gayest absurdities of our humorists on the screen, on the air, and in the comic weeklies.[13] The device of the *phantasmagoria* is one instance of such a rationalisation. It not only enabled Gillray to find a unified theme for his collection of symbols, it allowed him to endow the warning image of Britannia as a skeleton, with truly visionary intensity.

There was no need for the caricaturists to discard the older methods of allegory,

humorous illustration and allusive realism. But the new spirit of the Romantic era made it possible for them to stray beyond the narrow limits of traditional emblems and allegories into the open field of free imagination. The artist was now entitled to create his own images of spiritual forces and psychological states. Figures like Woodward's *Income Tax*[14] (Fig. 54) or Williams's *Jack Frost*[15] (Fig. 55) are not only the direct ancestors of those kindly or malevolent imps which now haunt our daily lives—Mr Therm, the Squanderbug, or the Traffic Jimp—they are the legitimate offspring of Fuseli's phantoms and the poor relations of Blake's noble visions. But while Blake held fast to the belief that his figures represented a higher reality,[16] the ghosts and spectres of the caricatures are presented with the same 'suspension of disbelief' which must have given its edge to Philipsthal's show. Without disbelief this Romantic thrill is impossible. The grotesque ghost is a child of Enlightenment.

In his stimulating 'picture book' on Hogarth and English caricature,[17] Mr F. D. Klingender has not only drawn attention to the influence of Fuseli's *Nightmare* on the caricaturist's stock images, he has also suggested a parallel between these fantastic scenes in English political prints and the art of their greatest contemporary, Goya. If our analysis is correct it allows us to specify the nature of this parallel. Like Gillray, but on a still higher plane, Goya sought social justification for his fantastic visions by pouring them into the pre-existing mould of satirical art. Under different social conditions he was also forced—unlike Gillray—to exploit the twilight region of the grotesque for camouflaging his political comments in the guise of mere *Caprichos* and dreams of a fevered brain. But the motto of his capriccios, 'The Sleep of Reason produces Monsters', sums up his own personal approach to the problem of the age. To him the suspension of disbelief, or the recurrence of belief, may not have been a free fancy to be relished for its thrills but the oppressive nightmare of the sleep of Reason.[18]

These examples illustrate one way in which the study of imagery may benefit the understanding of art. It can focus attention on latent tendencies which were never allowed to unfold fully in the sphere of high art and sought expression in more pliable media; a period's imagery may, through its very crudity, throw light on the more subtle problems of its great artists. It so happens that Mrs George's present volume also contains an example of yet a different type of interaction between imagery and art, of the direct influence, that is, which works of indifferent quality may yet exercise on the creations of genius. Once more the material of the volume leads back to the giant of the period, to Goya.

Among the anti-Napoleonic prints of the year 1803, Mrs George lists various plates illustrating atrocities perpetrated by Buonaparte.[19] They bear the signature of R. K. Porter, a poor artist but an interesting figure. A pupil of Benjamin West, Porter seems to have been very active in various patriotic schemes.[20] In 1805 he displayed his powers in a huge panorama of the battle of Agincourt on more than

2800 sq. ft. of canvas.[21] This Romantic showpiece of a patriotic theme was displayed at the Lyceum, the same place where Philipsthal had conjured up his Phantasmagorias. Porter then went to Russia and published illustrated travel books on Russia and Persia. He also accompanied Sir John Moore on his unsuccessful expedition to Salamanca, which ended in the evacuation at Corunna. He finally married a Russian Princess.[22]

What is interesting in the propaganda prints conceived in his facile melodramatic idiom (Figs. 56, 58, 59) is their date and their motif. They anticipate by some nine years Goya's terrifying scenes of Napoleonic massacres in and after the Spanish wars (Figs. 60–62). It is tempting to speculate whether the two could have met. There is a tradition that Goya went to Saragossa in the autumn of 1808 to paint scenes of the war which had broken out—during the very same months, that is, when Porter was attached to Sir John Moore for the identical purpose. But the tradition is unsubstantiated.[23] It is possible that Porter may have distributed his prints in Salamanca and that this is the way in which they reached Goya, but it is not necessary to make this assumption. We know that British propaganda prints were circulated (and copied) in Spain[24] and we need not strain our historical imagination to explain the connection between these violent designs and Goya's great compositions. It is not only the tenor and the character of the episodes with their mixture of horror and defiance which are similar, but also many individual features: the protruding eyes and violent distortions of the victim's face, the effective contrast between pointing guns and helplessly kneeling figures, the abbreviated forms through which the masses of similar victims are conveyed while attention remains focused on the principal scene—all these recur in many variations in the paintings and etchings of Goya's war scenes.

A detailed comparison between Porter's crude atrocity prints and Goya's heartrending protests against human cruelty only serves, of course, to enhance the magnitude of Goya's achievement. But it does more. It helps us to adjust our assessment of the historical role of these works. Recent descriptions of Goya's anti-Napoleonic compositions have stressed the documentary realism of this phase of his development. They have represented these creations as a revolutionary break with tradition, and as the true beginning of the nineteenth-century approach to art which sees in the painter the eye-witness who fashions his work out of his personal experience.[25] The existence of Porter's prints does not altogether disprove this interpretation but it shows up its dangers. The very idea of 'documentary realism' requires qualification. These are not scenes at which a Spaniard and a patriot could easily have been present and survived. But even if Goya should have been an eye-witness to one or the other of the terrible episodes he portrayed (and this cannot be proved) he might never have recorded his experience in visual shape had not the existing type of atrocity imagery, as exemplified in Porter's prints, provided the

crystallising point for his creative imagination. We realise to-day more and more how long and tortuous is the road from 'perception' to 'expression'. The original genius who paints 'what he sees' and creates new forms out of nothing is a Romantic myth. Even the greatest artist—and he more than others—needs an idiom to work in. Only tradition, such as he finds it, can provide him with the raw material of imagery which he needs to represent an event or a 'fragment of nature'.[26] He can re-fashion this imagery, adapt it to its task, assimilate it to his needs and change it beyond recognition, but he can no more represent what is in front of his eyes without a pre-existing stock of acquired images than he can paint it without the pre-existing set of colours which he must have on his palette.

Seen in this light, the importance of imagery for the study of art becomes increasingly apparent. In tracing the motifs, methods, and symbols of these modest productions we not only study the pale reflections of creative art, but the nature of the language without which artistic creation would be impossible.

The Cartoonist's Armoury

Except in the few instances when great artists such as Honoré Daumier or Goya were driven to take up graphic journalism, the professional art historian has had little occasion to busy himself with the vast mass of ephemeral propaganda prints, broadsheets, and cartoons which were produced in ever-increasing volume from the sixteenth century onward. He is quite happy to leave these puzzling and often ugly images to the historian who may know how to unriddle their recondite allusions to long-forgotten issues and events. But historians in their turn usually think they have more important and more relevant documents to study in the state papers and speeches of a period, and generally they leave the old cartoons to the compilers of popular illustrated histories where these crude and often enigmatic scrawls jostle uneasily with portraits, maps, and pictures of pageantries and assassinations. I do not want to sound ungrateful to books such as Roger Butterfield's *The American Past*[1] or Stephan Lorant's *The Presidency*[2], to mention only two American examples which I have used with much profit. But it is in the nature of these books that they take the cartoon for granted, as we all do when we open our newspapers. Let us try for once to discard this protective attitude and to look at these strange configurations with puzzled curiosity, not so much for what they can tell about historical events as for what they may reveal about our own minds. In studying cartoons we study the use of symbols in a circumscribed context. It is indeed the kind of study to which the Warburg Institute has always bent its efforts, not so much (as is sometimes thought) to unriddle some individual picture puzzles, but precisely for the purpose of finding out what role the image may play in the household of our mind.

I. *Figures of Speech*

As you have invited me to North Carolina I shall begin with this crude but moving cartoon (Fig. 63) which appeared in the *Philadelphia Centinel* in 1787. It celebrates the erection of the Eleventh Pillar of the great National Dome, when the State of New York had at last ratified the Constitution and it was hoped North Carolina would follow suit. A hand reaches down from the clouds and is about to put the pillar marked North Carolina into its place, while Rhode Island still wobbles dangerously. The poem underneath celebrates the Federal Edifice:

> Eleven stars in quick succession rise—
> Eleven columns strike our wondering eyes
> Soon o'er the whole shall swell the beauteous Dome
> COLUMBIA'S boast and FREEDOM'S hallow'd home.

This was a lecture given at Duke University, North Carolina, in March 1962.

Not memorable poetry, however sincerely felt. Why, then, is the illustration of interest? After all, the images are all in the words of the poem: the edifice, the pillars supporting the Dome where Freedom will dwell; such similes must have been used in innumerable speeches and editorials which we skip rather than read. But something clearly happens to us when the image is transfixed and lifted out of the flux of speech. You actually watch North Carolina joining the others and see the great edifice going up in front of you. You can hardly wait to see the last column put in its place. The metaphor takes on a greater measure of reality. For clearly the 'edifice of state' is a metaphor and even the state itself is an abstract entity, a shorthand formula for a very complex relationship between people under the same laws. It can no more be seen than I could see the State of North Carolina as I flew in from New York. But here it is embodied in front of my eyes and I see it joining the federal structure. The state papers probably reveal the realities of these events, the debates and waverings, the arguments used on either side, the conflicts of interest and the clash of personalities. But when all is said and done neither the contemporary nor the later historian will ever be able to record and explain every individual step in the minds of all participants which ultimately resulted in a majority decision for ratification. History, or that contemporary section of history we call politics, is not only bewildering, it is, in practice, inexplicable in terms of the people who shape it.

It is certainly so for those of us who would have been called 'nominalists' by the mediæval philosophers. This, as you may remember, was the party among schoolmen who thought that all that really existed here on earth were individual things. The words we use when we group these things together and speak of chairs, or horses, or nations, the so-called universals, are only noises we make, a *flatus vocis*, a puff of air, as they put it. The opposite party, and in the Middle Ages the dominant one, thought differently. It insisted that where there is a word there must also be some kind of entity. As there are words for concepts such as chair, dog, or democracy, these universals must have an existence of their own; they must indeed be more permanent and somehow more real than the individual instances we can see with our mortal senses. It is a position which looks rather abstruse at first, yet we are inclined to accept it unreflectingly.

When we write or even think about history or politics, the individuals, their sufferings and waverings, their efforts to be left alone, inevitably disappear behind the abstractions. Try as we may, we cannot be strict nominalists. It is the strength and the danger of the cartoonist that he appeals to this tendency and makes it easier for us to treat abstractions as if they were tangible realities. The cartoonist, in other words, merely secures what language has prepared. The abstraction takes hold of our mind: North Carolina must and will join the Federal Edifice.

It is fitting that such a solemn image is charged with religious and prophetic

over-tones. The faith of the Free-masons, so powerful in the late eighteenth century, may have reinforced the imagery of erecting a Temple where Freedom may dwell, and the quotation from Virgil's Fourth Eclogue, *Redeunt Saturnia Regna*, expresses the fervent belief that individuals are indeed acting in a large plan when they bring about the fulfilment of that ancient prophecy of the return of the Golden Age.

One of the things the study of cartoons may reveal with greater clarity is the role and power of the mythological imagination in our political thought and decisions. Historically this is obvious. For the so-called personifications, which cartoonists can so rarely do without, are the direct descendants of the ancient Olympians. Both the naive cartoon of 1782, *Britannia reconciled*, with America personified as an Indian girl (Fig. 64), or the even more naive drawing from *Life* celebrating the achievement of the women's vote in the United States (Fig. 65), are typical examples of a tradition that goes back without break to the mythological world of Greece and Rome. It was the peculiar attitude of the Greek mind toward language which disposed the ancient world to personify abstract concepts in terms of living presences. We learn at school that Nike was 'the Goddess of Victory', but this formulation hardly does justice to the twilight region of the mythological attitude. Nike or Victoria *was* Victory, it was Victory that settled on the prow of the conqueror's ship, it was Fame that proclaimed his glory and Calumny that tried to obscure it. No other culture, as far as I know, permitted this easy and effortless transition from abstract noun to an imagined reality, and in no other culture were these personified words admitted into the company of the immortal gods. Victory had a temple on the Acropolis, Fortuna was worshipped in Rome, every city and every state was embodied in a divinity that was both a tutelary spirit and an abstraction. A monument of the fourth century erected to commemorate and preserve the treaty between Athens and Samos shows their tutelary gods, Athene and Hera, clasping hands (Fig. 66) precisely as Gaul and Belgium are clasping theirs on a medal of Louis XIV (Fig. 67) and as they are still apt to do in the pages of our dailies. Roman coins often show the images of countries and provinces in the news. The coin of Vespasian struck after the conquest of Jerusalem shows the mourning figure marked *Judea Capta* (Fig. 68), while the coin of Nerva, A.D. 97, shows an abstraction or divinity whose continued vitality I need not emphasize, the figure of Liberty (Fig. 69).

I do not want to imply that the Romans necessarily believed in the bodily existence of these entities any more than we do. We surely do not often give much thought to the dignified but somewhat bloodless ladies that grace our coins and bank-notes. But let a great cartoonist touch them, and they spring to life again, as in this masterpiece by Daumier, who shows us a terrified Europe balanced on a smoking bomb, *L'équilibre Européene* (Fig. 70). Here another metaphor or figure of

speech is made visible in all its terrible vividness. It is this freedom to translate the concepts and shorthand symbols of our political speech into such metaphorical situations that constitutes the novelty of the cartoon. Political rhetoric had always abounded in images, from the days when the ancient Hebrew prophets spoke of Egypt as a 'broken reed' and of Persia as a 'Colossus with feet of clay', but the ancient world would not have illustrated such comparisons. Here, I believe, the cartoon is the heir to the symbolic art of the Middle Ages, at a time when the didactic image was intended by the Church to teach the illiterate layman the sacred word. The development of these techniques and their gradual application to secular wisdom in proverb illustrations and satirical prints would take too long to trace. What matters is the increasing ease with which imagery could respond to the flourishes of the preacher and the orator.

Clearly our political campaigners and orators keep the cartoonist's imagination well supplied. Open any newspaper and you will find that someone is always rocking the boat or sitting on the fence, wielding the big stick or slinging mud. There are the hardened metaphors of political jargon such as the summit meeting or the iron curtain; we can or cannot police the world, live under the shadow of the bomb, trim our sails to the winds of change, join hands with that group and steal a march on the other, the road ahead is arduous but the future, of course, is bright, if only we avoid the pitfalls, skirt the abyss, and stop that downward trend. One draws attention to the imagery of language at one's own peril, for as soon as you are alerted to these dormant pictures they will crowd in on you from every side. They are all, if I may continue to speak in images, grist to the cartoonist's mill, or, if you prefer the image of my title, weapons in his armoury.

II. *Condensation and Comparison*

CONSIDER the image of balance used again by Daumier to represent the balance of Europe poised on the edge of a Japanese sword (Fig. 71). What a marvellous summing up of the situation in 1867 when, as he saw it, the European nations were only prevented from seizing each other by the throat by their fear of the rising power of Japan! It is in this condensation of a complex idea in one striking and memorable image that we find the continued appeal of this great cartoon. And condensation, the telescoping of a whole chain of ideas into one pregnant image, is indeed the essence of wit. It was my late friend and teacher Ernst Kris, the art historian turned psychoanalyst, who first showed how much the student of cartoons and caricatures could profit from Freud's analysis of the verbal joke. In his book on *The Wit and Its Relation to the Unconscious*, Freud drew attention to the kinship between the mental processes that are harnessed in the wit and those that run riot in the dream. In both cases the fusion of disparate elements results in an unfamiliar and weird configuration which may still hide a lot of sense.

The wit who first called Palestine the 'too much promised land' telescoped the Biblical term with the thought of the conflicting promises made by British statesmen to Arabs and Jews. The momentary shock of bewilderment at the absurdity of a 'too much promised' land gives way to laughter when we recognize that the description is only too apt. Indeed the neatness of the formulation may even effectively block our reflection whether or not it contains the truth and nothing but the truth, whether, for instance, the charge is correct that conflicting promises were made to the two parties.

It is the same with the condensations of the cartoonist. Take a more up-to-date picture of that terrifying balance, Rube Goldberg's 1948 Pulitzer prize cartoon (Fig. 72) telescoping all our fears into the picture of a peaceful home precariously poised on the bomb on the brink of the abyss into which it may topple any moment. For one brief moment we seem to see our predicament, face to face, as it were, in this nightmare picture which persuades us of its reality. The same may be true of another cartoon by H. M. Brockmann from the German weekly *Simplicissimus* (Fig. 73) in which the bomb itself is made to boast to the assembled statesmen: 'What is all that talk of peace here, Gentlemen? It's I who am peace.' Both cartoons seem to hit the nail on the head, but it can't be the same nail.

There is danger in a discussion of cartoons that we stress the elements of humour or propaganda too much at the expense of the satisfaction the successful cartoon gives us simply by its neat summing up. Humour is not a necessary weapon in the cartoonist's armoury. Whether or not we laugh will depend on the seriousness of the issue. Whether or not cartoons will be effective as propaganda and make us change our opinion is also a question that is more easily asked than answered. What the so-called editorial cartoon does is to provide some kind of momentary focus. A cartoon from the *Observer* (Fig. 74), neither better nor worse than many of its kind, illustrates the 'arms race' and what must follow if it goes on at its current pace. The convention is humorous, the topic is not, and most readers, including myself, will let their eyes rest on it for a few seconds, take it in and say to themselves, 'Clever, that's how it is', and turn to the book reviews, the sports reports, or the financial page.

Perhaps we are like children who are easily fobbed off with an answer. Any comparison that will make the unfamiliar clearer in terms of something more familiar will give us the satisfaction of pretended insight, whatever else it may stir up in us. But is this not precisely, again, what we may call the function of myth? The inquiring primitive who wants to know why the sun sets in the evening may be quite happy to learn that it is going to rest for the night, and even thunder and lightning are less unbearable if we are told of Jove's thunderbolt or of electric discharges (it hardly matters which).

Among the most famous of all pictorial comments on world events is Tenniel's

cartoon from *Punch* on Bismarck's dismissal, deceptively called 'Dropping the Pilot' (Fig. 75). It has been pointed out how misleading the analogy really is. A pilot leaves of his own free will as soon as the ship he has guided out of port reaches the open sea. Bismarck certainly wanted to stay at the helm when Wilhelm II abruptly dismissed him. But this action of the young Kaiser must have seemed so utterly unexpected and irrational to the British public that they greeted Tenniel's pictorial tribute as a reassuring image.

It may be asked whether the last few cartoons I have mentioned still deserve to be called illustrations of figures of speech. The borderline between the simple metaphor and the extended comparison is obviously a fluid one. 'Dropping the pilot' does not happen to be a current image in our speech but it easily might become one. Certainly cartoonists at all times have claimed the right to invent their own comparisons or similes and to characterize new events in terms of familiar situations whether or not language had preceded them. How convincing Daumier is when he represents Thiers in 1870 as the prompter hidden in his box giving the cues to the new government (Fig. 77); how compelling and how topical in his analogy of the disarmament talks between France and Prussia of 1868 with two gentlemen refusing to go through a door (Fig. 79), and once more the picture itself is so satisfying that you have the illusion of an explanation while really the analogy is rather incomplete.

III. *Portrait Caricature*

HERE we come to the real reason why old cartoons are often so difficult to appreciate. The analogies used, once topical and illuminating, so often have faded. Both sides of the equation, as it were, need long footnotes and commentaries, and by the time we have realized the point of the comparison it can no longer produce that flash of pleasant insight but will go off like a damp squib.

It is still easy for us to see the force of the eighteenth-century cartoon showing America in 1779 as a horse throwing off its cruel rider, George III (Fig. 78). But in the cartoon devised by Benjamin Franklin in 1765 (Fig. 80) the explanation has to be a bit longwinded. The figure is obviously Britannia who has fallen from her proud seat on the globe, her severed limbs being marked with the names of her overseas provinces. She exclaims '*Date obolum Belisario*' ('Give a dime to Belisarius'). Our cartoonists no longer use Latin tags and certainly allusions to Byzantine generals of the sixth century would be ruled out of order by even the most highbrow or eggheaded of editors. But the story of Belisarius, the general who conquered Italy for Justinian only to be dismissed and according to a sentimental legend reduced to beggary in the streets of Constantinople, had been made popular in the eighteenth century by plays and romances. Belisarius would be understood as exemplifying the fate of the mighty and the fickleness of fortune. From the

extended metaphor, that is, we have crossed into the large field of what are called literary allusions. Once more I must insist on the artificiality of any such distinction. Every culture and every language contains innumerable references to a common stock of knowledge which are not felt to be allusions because they are immediately accessible to anyone. The spread and intelligibility of this lore will clearly vary from circle to circle and group to group. Some will find a reference to Br'er Rabbit or the Wizard of Oz part of their common speech, others may have to consult a reference book.

One more borderline example: Raven Hill, one of the leading cartoonists of *Punch* during World War I, represented Admiral Tirpitz as the Old Man of the Sea on the shoulder of Wilhelm II (Fig. 76). I do not know how well known is the story from the *Arabian Nights*, of the fiendish beggar who asked his victims to carry him across a brook and then clung to them until they dropped dead. I do not know either how well known it is that Tirpitz was the special bête noire of the English because his provocative naval policy resulted in the increasing tensions between Germany and England. I do not pretend to know myself how far the cartoon applied to a real situation, how far, that is, Tirpitz could really be said to have restricted the freedom of action of the Kaiser in the first years of the war. Can it be surprising, after all, that both historians and art historians have shied away from cartoons and that such books or articles as are devoted to graphic journalism usually become so engrossed in the task of explanation that the medium and its history are largely unexplored?

In my present context these extended analogies are of interest in illustrating the process of condensation and fusion which always has been the major aim of the cartoonist. A symbolic print of 1577 glorifying William of Orange in the guise of St. George liberating the princess Belgium and the lamb of religion from the dragon of tyranny (Fig. 81) has all the characteristics of a cartoon. But in this rearly stage the point was made doubly clear by a detailed key to make the reade aware of the general applicability of the image. The shield of the saint represents Faith, the horse's head Obedience, its tail is the scourge of criminals, the dragon's tongue is blasphemy, its tail the Spanish Inquisition. The advantages which the political propagandist reaps from these identifications are almost too obvious to need elaboration. The projection of the ancient legend onto a particular political event makes it all appear so clear and simple. The viewer now knows even better who represents the forces of good and who stands for evil; moreover, knowing what happened to the dragon when St. George took it on, he also sees what is going to be the fate of the Spanish power. The future is contained in the present.

What distinguishes such an early example of symbolic propaganda from the modern cartoon is not its intention but only the treatment of the medium, particularly in two respects. The first difference is in the elaboration of the captions,

the detailed and somewhat pedantic letterpress. The modern draughtsman usually works for a busy public who want to take it all in at a glance. But then the earlier artist did not have to compete with the mass of pictures and editorial material that assails the newspaper reader today. We can be sure that those who bought an engraving of this kind in the sixteenth century—and the price of such broadsheets was not all that low in comparison with the cost of living—would regard it as food for thought, contemplation, and conversation during the long winter evenings for weeks to come, and for these the detailed references added richness to the fare. But the second difference from the majority of modern cartoons is more essential and more instructive. There is no element of caricature in the earlier works. A modern cartoonist might have given William of Orange the face of a shining hero and the dragon, perhaps, the distorted physiognomy of the Duke of Alba, just as Raven Hill gave the old man from the sea the features of Tirpitz. As it is, the analogy with Wiliam of Orange's act of rescue remains an intellectual affair. The specific viewpoint is worked out in the captions, but different captions would make it apply equally to different political situations. The topical quality that the portrait caricature gives is a later development. At its best the caricature gave the artist the means of turning an intellectual equation into a visual fusion and thus presented the cartoonist with one of the most effective weapons in his armoury.

The inventors of portrait caricature in the sense in which we now understand the word were not propagandists.[3] They were academic artists of high standing who developed the mock portrait to tease their friends. Their inspiration, I believe, came from the so-called science of physiognomics that had long insisted on the comparison between human types and certain animals. The man with the aquiline nose would be noble, the man with the sheepish face sheepish. These visual equations were for the first time illustrated in the late sixteenth century in a book by Porta (Fig. 84), which demonstrated to the discerning artist how little the impression of likeness depended on an accurate mapping of the sitter's features. A few strokes might suffice to catch a characteristic expression and yet transform the man into an animal. This is precisely what Annibale Carracci, the Bolognese painter active in Rome around 1600, is reported by his biographers to have done in moods of relaxation. The sources credit him with the invention of the charged or loaded portrait, the *caricatura*, and this tradition is reflected in a sketchbook from his school (Fig. 82), which is perhaps the earliest such transformation extant.

When I stress the novelty of this graphic joke, I do not wish to imply that the element of portraiture had been entirely absent from earlier propaganda. But the earlier pictures contained crude abuse and aggression rather than witty comparisons. The public enemy would be represented hanging on the gallows on the façade of the town hall, and such hangings in effigy, as Kris has reminded us, were still closer to witchcraft than they were to art. Their aim was to wreak

vengeance on the enemy and to destroy, if not the person, at least that aura that
was his honour. Insults of this character were so much dreaded that it was consider-
ed a good security for a person entering a financial transaction to ask for a de-
famatory image that could be exhibited in case of default. A late medieval example
(Fig. 83) shows the debtor hanging by his feet, complete with ravens and the coat
of arms dishonoured.

There was no loss of honour in being caricatured by a master such as Pierleone
Ghezzi about 1700 (Fig. 85). Indeed, witty distortion was much appreciated by the
enlightened connoisseurs who formed the international public in seventeenth-
and eighteenth-century Italy. Thomas Patch, an Englishman living in Italy, even
made elaborate portrait groups of these travelling virtuosi, presumably as pleasant
souvenirs of their boon companions (Fig. 87).

Yet it was among this class of Englishmen in about 1750 that the potentialities of
the new trick for political polemics were first discovered[4]. George Marquess of
Townshend is credited with the idea of circulating *caricatura* portraits of his
political colleagues and rivals, much to the amusement of their friends and enemies,
and his drawings were spread more widely by the printing press soon after the
middle of the eighteenth century (Fig. 86). Sometimes the old context still asserted
itself and the *caricatura* was placed under the gallows (Fig. 88), but even in these
cases there was no longer the feeling of savage aggression, but rather of crude
horseplay. Townshend's most witty inventions combined a relaxed scrawl with the
weapon of irony, as when he placed the stocky Duke of Cumberland, cleverly charac-
terized by his fat bubble-head, on the globe as the 'Glory of the World' (Fig. 89).

Here then we watch the meeting of the symbolic print with the new art of
caricaturing. A generation later, in the work of Gillray in England, the combina-
tion is taken for granted. The connection can be illustrated by Gillray's attack on
Charles James Fox as a gambler and indeed a devil defying Shelburne, the prime
minister (Fig. 90). The new art of the caricaturist offered to the cartoonist two
great advantages. The reduction of the physiognomy to a convenient formula
made it possible to keep certain politicians constantly before the public eye in all
sorts of symbolic roles. Gillray's Fox with his steep eyebrows and sensuous
mouth was certainly a good likeness, as we can see from Nolleken's bust (Fig. 91).
But who could disentangle truth from falsehood in such a ludicrous mock portrait
as Fox in the guise of a Jacobin and Sansculotte, another of Gillray's typical
cartoons fomenting suspicions against the great Whig (Fig. 92)? Or take Gillray's
William Pitt the younger, familiar from many a famous cartoon of the Napoleonic
period, with his pointed nose and angular face, carving up the globe with Napoleon
getting the smaller share of the pudding (Fig. 94).

The real advantage the cartoonist derived from the new weapon was the possi-
bility of extending the equation into a virtual fusion. Gillray's famous print of

Pitt as a poisonous toadstool growing on the crown shows what I mean (Fig. 93). Many an orator must have called many a minister a 'parasite', but to make the identity visible is another matter.

IV. *The Political Bestiary*

THIS capacity of making visible depends on the complete mastery of the medium both in caricature and in other aspects of cartooning, and this mastery demands a master. This crucial point can be illustrated with the help of that persistent device which may be called the most typical of all cartoon symbols—the animals from the cartoonist's zoo. Once more the popularity of this method is due to several obvious possibilities it affords. One is the fixed meaning that has become attached to certain animals since the days of Æsop and La Fontaine. Allusions to these stories are indeed common coinage in all languages. We call somebody a sly fox and another, I am afraid, an ass, and Sir Winston Churchill is reported to have referred to a political rival as a 'sheep in sheep's clothing'. For the cartoonist, these universally understood meanings merge easily with another sphere of conventional animal lore, the heraldic beasts derived from coats of arms and national emblems; the British lion, the American eagle, or the Russian bear will lie down peacefully with the innocent lamb and the timid rabbit.

Even a mid-sixteenth-century print shows this natural combination of metaphor and convention. While the Netherlandish lion is asleep, the fox steals the geese which stands for the provinces (Fig. 95). This, like its contemporary, the glorification of William I of Orange, is a purely emblematic print, crowded with further incidental detail. My purpose is to contrast it with another political print of somewhat later date by Jacques de Gheyn, a real master of draughtsmanship. His 'Belgian lion' (Fig. 96) is more than a heraldic device. It is expressive of the majesty and power of the nation for which it stands. Here, too, we can speak of the mastery of physiognomics in a wider sense, the capacity of the artist to make us see rather than merely intellectually know the significance the symbol has for him.

Countless as are the cartoons which draw on these heraldic devices, it takes an artist to bring them to life. Thus Goya in his ghostlike vision of *Disasters of War* shows us the Napoleonic Eagle (or is it a Vulture?) plucked and bedraggled, being pitchforked out of Spain by patriotic peasants (Fig. 97).

It was not before the nineteenth century, however, that cartoonists invented what might be called *ad hoc* symbols to populate their cartoons and ease their task of communication. Every American knows the invention of Joseph Nast, the elephant as a symbol of the Republican party. His famous cartoon from *Harper's Weekly* of 1874 for the first time symbolized the massive Republican vote as an elephant which is about to blunder into the 'Third Term Trap' while the ass in lion's skin marked *New York Herald* brays about 'Caesarism' (Fig. 98). Some

seventy-four years later we see the same animal, still young and vigorous, beaming confidently and therefore riding for a fall in a prophetic cartoon by Dorman Smith (Fig. 99), which correctly diagnosed the situation before the sensationally unexpected Truman victory in 1948. It illustrates once more how much the image gains in power by the draughtsman's mastery of physiognomic expression.

It is this mastery, as we have seen, which made possible the perfect marriage between the cartoon and the portrait caricature, the fusion of symbol and likeness in a dreamlike fantasy. In Kemble's cartoon of the end of an earlier election campaign (Fig. 101), the defeated, wounded elephant is shown complaining about the bull moose (the cartoon symbol for Theodore Roosevelt after he had declared that he felt as fit as a bull moose). Here the artist has managed to give the animal the glasses and the conspicuous grin of the President which had long been his most distinctive cartoon features (Fig. 102). More successful even, because more simple, is the fusion between the portrait and the symbol in Fitzpatrick's summing up of the 1944 Democratic convention (Fig. 103), where the cigarette holder marks the candidate and the grin his assurance (Fig. 104). We are one step closer to that condensation of images which Freud has analysed as belonging to the wit as it belongs to the dream. As with a dream any fragment can stand for the whole. The cigarette holder or the flashing teeth become the physiognomically significant residue which in their turn stand for the man.

There is indeed no telling what incidental may be seized upon by the popular imagination, manipulated sometimes by publicity experts, but even active without their intervention. Dress and headgear, for instance, always have been obvious marks of distinction which acquire their own aura and significance in any culture. Was not a whole party known as the 'roundheads' and another as the 'sans culottes'? Did we not all learn of Peter the Great that he trimmed the beards of the Russians? Don't we say that a brasshat has been bowlerhatted?

There is another Pulitzer prize cartoon by Reg Manning of 1950 which poignantly exploits the associations which go with the soldier's tin hat and the diplomat's tophat (Fig. 100), and it is not in a spirit of carping criticism that I would add the reminder that if the tophats were more successful there might be less need for helmets and crosses.

All these evocative signs and badges, in their turn, can enter into any combination and condensation. Take, for instance, Daumier's idea of Napoleon III's arrival from England in 1848 on the shores of France, his vehicle the Napoleonic hat being pulled by the Napoleonic eagle (Fig. 105). He had in fact taken a live eagle along on an earlier abortive mission. If this is a masterly caricature, there is an even more convincing Daumier characterization of the type that became Napoleon's pathmaker and cheerleader, the desperado going round with the hat (Fig. 106). Once more the scene reminds us of the twin resources of the cartoonist's armoury,

the topical and the permanent, the passing allusion and the lasting characterization.

Clearly there is a whole spectrum that extends from the one to the other. Whether or not you know about the campaign for the second Empire or can guess the meaning of the three-cornered hat, you will feel that these men are not Daumier's favourite characters. You may not know the exact passage in La Fontaine telling us of the wolf turned shepherd and may not even recognize the typical Prussian helmet worn by the wolf, but you still might be a bit anxious about the fate of the sheep (Fig. 107). When Daumier finally, in a stark cartoon, one of the last of his long career, shows us the same Prussian helmet eclipsing the sun of liberty (Fig. 108), you may also have to read the label and learn the significance of that particular shape of a helmet, but there is scarcely any doubt that something sinister and gloomy is happening.

V. *Natural Metaphors*

IN cartooning, as in language, there are metaphors which are so widespread that one may call them universal or natural metaphors. The contrast between light and darkness as a symbol for that between good and evil is perhaps the first that comes to mind. One can hardly imagine a language in which a bright future would be called gloomy and a gloomy mood bright. A term such as fair still means bright, beautiful, and good without even being experienced as a metaphor. The notion of light as the visible symbol of the good is important in philosophy, from Plato to the Enlightenment, as it is also within the Christian tradition. The transition, from religious to political symbolism, is quite natural. There are countless Baroque allegories in which saints or rulers are transfigured in radiance while angels or personifications of divine virtues are hurling evil monsters into the dark pit. Andrea Pozzo's ceiling of the Jesuit Church of St. Ignazio, glorifying the light of the saint's mission (Fig. 109), is a religious example; Rubens's apotheosis of James I, a political one.

I hope I do not overstrain the meaning of a term when I also call these expressive resources of shapes and colours 'physiognomic'. We respond to them with that same immediacy with which we react to expressive features in the world around us. The dark, huge, frightening monster is obviously evil, as one sees it in many a hate cartoon such as Robinson's anti-German print of World War I, 'The Goth Returns' (Fig. 110), or Raemaker's print showing a dignified though angry France unmasking the German brute (Fig. 111).

I believe indeed that these physiognomic reactions are the ultimate resource of the cartoonist's armoury, the most potent and also, perhaps, the most dangerous. For the equation between these sensuous and moral qualities or feeling tones is so natural to all of us that we are hardly aware of their metaphorical or symbolic

character. Racial propaganda has at all times exploited this unthinking fusion—witness these ghastly cartoons from the Jew-baiting rag of the Nazi period called *Der Stürmer* (Figs. 112-3). Neither Hitler nor Goebbels were even physiognomically creatures of light, but the Nazi myth was built round the type of the fair, blond Siegfried figure opposing the dark monsters of evil, murderous Jews. In the Nazi universe the type and image of the Jew was fused with the traditional physiognomic type of the devil—I need not say with what consequences.

I should have liked to avoid this pathological example, but I think we must squarely face the psychological lessons which the study of cartoons suggest. If I may use a shorthand formula, the cartoonist can *mythologize the world of politics by physiognomizing it*. By linking the mythical with the real he creates that fusion, that amalgam, that seems so convincing to the emotional mind.

Recall the image of Spain as a dragon in the emblematic print of William of Orange liberating the Netherlands (Fig. 81). In a miserable scrawl again from the *Stürmer*, it is Spain which is the victim of the dragon, and the dragon, far from being a mere emblem, is 'physiognomized' in the likeness of the Jewish type (Fig. 114). That same type, sufficiently lifelike to mobilize memories of real people is blown up to mythical size blotting out the sun and casting its evil shadow on the globe (Fig. 115). The cartoonist, however negligible his artistry, is more likely to impress in such a campaign of hatred than even the mob orator and the columnist. There is something peculiar, as Goethe knew, about seeing things bodily before one's eyes:

> Dummes Zeug kann man viel reden,
> Kann es auch schreiben,
> Wird weder Leib noch Seele tödten,
> Es wird Alles beim Alten bleiben.
> Dummes aber, vors Auge gestellt,
> Hat ein magisches Recht:
> Weil es die Sinne gefesselt hält,
> Bleibt der Geist ein Knecht.*
>
> (Zahme Xenien, II.)

The myth-making faculty is latent in all of us; it only waits to be aroused. I am not suggesting that these cartoons caused the Nazi myth; they are only its most tangible expression. The cartoonist's armoury is always there in the workings of our mind. When perplexed and frustrated, we all like to fall back on a primitive,

*Stupidities you can talk at your will
You may also write even more.
Neither body nor soul are they likely to kill,
All will remain as before.

But stupidity placed before our eyes,
A magic power gains.
As our senses it rivets and ties,
The mind is held in chains.

physiognomic picture of events which ignores the realities of human existence and conceives the world in terms of impersonal forces.

The co-ordinate system in which we allocate a place to these forces and events exists, as it were, ready-made in our minds. We have seen that the metaphors of language bear witness to this. Contrasts such as light and dark, beautiful and ugly, big and small, which form the co-ordinates of the cartoonist's mythical universe, would not be so effective if we all were not inclined to categorize the world around us in such basic emotional metaphors.

In his book on the *Measurement of Meaning*, Charles Osgood has tried to devise an instrument to probe into this most primitive of our mental filing systems by asking his subjects apparently senseless questions of the type whether 'republic' is for them more dark than light, more tall than small, more smooth than rough, or more sweet than sour. He claims, if I understand him rightly—and I am reducing his complexities for my purpose—that by and large these answers coincide or cluster round certain emotional synonyms so that what is light is also good, what is tall is also strong, and what is rough is also active. He has therefore chosen these pairs of opposites to represent what he calls our semantic space. I have tried to show in other contexts how interesting this approach should be to the student of artistic symbolism. It suits me well in my present context that Osgood and his collaborators have also examined these reactions in relation to political opinion.

Briefly, their method was this. During the 1952 presidential elections they asked samples of Taft Republicans, Eisenhower Republicans, and Stevenson voters to plot twenty concepts along various scales. The investigator would ask them whether, say, price controls (No. 12) are strong or weak, fair or unfair, active or passive, and to grade their answers into fair, fairer, fairest, strong, stronger, strongest, in three steps from the median. Taft Republicans placed the concept on the slightly unfair, weak, and not very active point; Eisenhower voters did the same, while Stevenson voters, not unexpectedly, put it on the fair side, slightly more active but a trifle weak. Obviously, and by definition, the leaders of the respective groups, Taft (No. 1), Eisenhower (No. 15), and Stevenson (No. 3), are on the most active, most strong, and most fair plot. Stalin (No. 11) to the Taft voters was equally strong and active but on the correspondingly unfair end, while for the other two groups he was equally unfair but one degree less strong. Senator McCarthy (No. 19) looked to Taft voters reasonably fair, strong and active; to Stevenson voters even fairer, equally active but less strong, while Eisenhower voters found him equally strong but less active and even a little unfair. The passive dimension is almost empty, except for a reference to America's China policy, but this, I believe, is due to the type of question Osgood's investigators asked.

In every other respect Osgood's findings can, I think, be applied to the study of cartoons. When Daumier represents Thiers in 1850 as an evil imp making ready

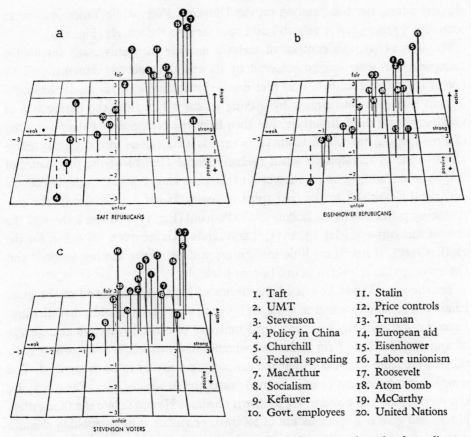

1. Taft	11. Stalin
2. UMT	12. Price controls
3. Stevenson	13. Truman
4. Policy in China	14. European aid
5. Churchill	15. Eisenhower
6. Federal spending	16. Labor unionism
7. MacArthur	17. Roosevelt
8. Socialism	18. Atom bomb
9. Kefauver	19. McCarthy
10. Govt. employees	20. United Nations

Models of the semantic spaces for three voting groups. Each of 20 concepts is numbered according to key. The fair-unfair and strong-weak ratings are given by the position on the 'base' immediately above or below the concept numbers. The length of the line from the number to the base gives the rating on the active-passive scale, a continuous line indicating a rating toward active and a broken line a rating toward passive.

to cudgel the Freedom of the Press (Fig. 116), he naturally thinks in terms of black and white, darkness and light, ugliness and ideal beauty. So automatic is this correlation that we need not think that David Low borrowed from Daumier when more than eighty years later he shows us Baldwin who has assassinated the radiant figure of Peace and now protests: 'You know you can trust me' (Fig. 118).

VI. *The Power of Contrast*

ONE of the less obvious functions of these mythical personifications, like 'Freedom of the Press' or 'Peace', may precisely be to set off the world of divine idealized abstractions against the dark and puny world of man. Once more Daumier knows best how to turn this conventional device into artistic power. His French Republic looks sadly on as the politicians, including Thiers and Napoleon III, make ready to assail her (Fig. 117). In another cartoon she continues on her forward march, a

gigantic figure, her hand resting on the Universal Vote, while Thiers and other such ugly pygmies try in vain to put a spanner into the wheels (Fig. 119).

Needless to say, this contrast of scales is another such universally intelligible metaphor, and what can be achieved by its manipulation was demonstrated by one of the greatest satirists who ever lived—Jonathan Swift. He made the world of man look ridiculous simply by making us see it first from the perspective of Gulliver among the Lilliputians, and then from the perspective of the giant King of Brobdingnag, for whom Gulliver in turn is a ridiculous insect. Gillray made effective use of this episode when he had George III look at the tiny figure of Napoleon and address him in the words of the giant king (Fig. 121). More effectively even, and closer still to the true spirit of Swift, David Low shows us the tiny posturing politicians in the hollow of God's hand (Fig. 123). When I think of the date of this cartoon, May 15, 1933, it still sends a shiver down my spine, for the caption reads, 'Little men, little men, must you be taught another lesson?' and the answer, alas, is written in our history books.

Yet the same David Low used the device of increasing scale and of the giant hand with equal conviction to show, in his campaign against Hitler, that disarmament is not everything (Fig. 120). But I must not be carried away into a discussion of content. Like Low I am undecided whether disarmament is necessarily a good thing. I certainly would not want the cartoonist's armoury to be dismantled. The weapons it contains can be used in good causes and in sinister ones. The cartoonist can mythologize the world or try to dispel illusions. He can inflate the thoughtless phrase and give it a specious life of its own, or deflate it by contrasting rhetoric with the realities it describes. It was not for nothing that the Pulitzer prize of 1945 went to Bill Mauldin, then a young cartoonist of 23, for a thoroughly unsymbolic drawing captioned 'Fresh American troops, flushed with victory, are bringing in thousands of hungry, ragged, battle-weary prisoners' (Fig. 122). It shows us the nominalist reality behind the empty clichés.

'McGraw Gallery? Dolan here.
I think I've entered a new period.'
From *Punch*.

The Vogue of Abstract Art

I

WHEN the Editor of the *Atlantic Monthly* asked me to write about the vogue of abstract art in our time, my first reaction was one of uneasiness. I have friends among painters and critics who sincerely believe in these experiments. To them faith in abstract art is faith in the future. Would they not accuse me of giving aid and comfort to the enemy, the forces of sloth and inertia which oppose the march of progress? Should I not rather evade such an explosive issue and write about the problems of the past which rarely hurt anybody's feelings? I have every excuse for taking this course, for it so happens that I am really not a critic. My knowledge of exhibitions is scanty and my experience of abstract art therefore limited. But in the end it was the very lure of the temptation to evade the task which decided me to take it on. For I suspected that my own misgivings were sufficiently typical to make them of more than personal interest. The fear of being found in the wrong camp may be quite respectable in certain situations; in matters of art, as I hope to show, it may prove disastrous. It threatens to degrade art into a mere badge of allegiance. With a badge it matters little whether it is good or bad as long as it is right. In art it is only the quality of the individual work that ought to matter. By succumbing to the idea that what belongs to the future must not be criticized we will not help the artist.

II

LIKE all good jokes the drawing from *Punch* on the opposite page has its serious and even tragic side. For we should miss its point if we took it to be a crack at the expense of Dolan the artist or his dealers McGraw. The true butts, I am afraid, are ourselves, the art historians who introduced this solemn terminology and spread the conviction that artists 'enter' into periods, as planets enter into constellations, travelling on some mysterious pre-ordained course. The artist in his studio, surrounded by his unsold sub-Mondrians, cannot help it, or so he may think. He is only the instrument, the sensitive seismograph of the 'spirit of the age'. An extra bottle of whisky may have changed his universe of forms. But whatever it was, it was not he who willed it. Dolan can do nothing to divert the stream of history on which he and the owners of the McGraw galleries are both drifting, helplessly but not hopelessly. For an unexpected tide may carry them both to affluence.

Am I exaggerating? Of course I am. I mean to. But I am not, I think, inventing.

This article was originally published in 1956 under the title 'The Tyranny of Abstract Art'. The present title was that given by the author, the other by the editor.

There are conservative critics who think that the main trouble with modern art is that painting has become too easy, a mere splashing about of colours. But the true objection to Dolan's ideology may be that it has become impossibly difficult to be an artist at all in his situation. It is a commonplace of psychology that nothing is harder to bear than complete freedom from any restraint. Add to this burden of freedom the horror of being watched, discussed and registered, and you will see that it needs a tough mind indeed to survive the freedom of art today. Artists are rarely conspicuously tough—though they sometimes want you to believe them to be. Imagine Dolan's state of mind in front of his canvas, really facing that existentialist nightmare, the responsibility for every decision, every move, without any convention to guide him, without any expectation to live up to except the one of creating something recognizably his own and yet significantly different. No wonder that he seeks to disclaim responsibility, that he looks for aesthetic creeds which place the responsibility for his work somewhere else, in his personal automatisms or the collective unconscious, in the spirit of the age or the class struggle.

His public, in its turn, trained by us, the art historians, to think historically, watches eagerly for where the cat will jump, ready to label any leap as a 'new movement', and having done so to await the next move. Gone are the days when you could shock the critics. Hang up an old stocking dipped in paint at your next exhibition and all you can hope for is to go down in history as the inventor of *trickotage*. Will it catch on? And for how long? How degrading for the genuine artist to have to ask such a question. What an opening for Ananias the False Artist!

III

IT was Walter Pach[1] who, thirty years ago, coined that telling label as the title of a book in which he denounced the timidity of those in power in the world of art—those who wanted to play safe and bought or commissioned meretricious trash, slick, sentimental and hollow works of which he illustrated a devastating series. The painting by Albert Besnard commissioned by no less a city than Paris for its Town Hall to represent 'Meteorology' (Fig. 124) is a fair sample of the horrors pilloried by the critic. What makes such works repellent, he rightly insisted, is their striving after fashionable effect. For Pach, Besnard was an Ananias because he was less than a plodding Academic artist; he was a trickster who decked out his own emptiness with a few surface qualities borrowed from 'modern art' such as the deviation from ideal beauty, the show of frenzy and the rough brushwork. Besnard is forgotten. But what about the ubiquitous Trebla Dranseb, the abstract artist? He is the master, if you can call him so, of fig. 125, which you will surely remember from last year's show. Admittedly it is less unpleasant to look at than the Besnard. It lacks the pretentious pathos of the ugly nude and that is something to be thankful

for. But nobody knew better than Walter Pach that it is not enough to avoid cheap sentiment. 'Cheap aesthetics is just as futile' he wrote. My new Ananias, of course, is none other than Albert Besnard written backwards and his 'work' a patch from the other's background with the relationships inverted.

IV

ONCE more, I know that I exaggerate. But how much? Last year there appeared a beautiful volume under the title 'The New Landscape in Art and Science', edited by Georgy Kepes and sponsored by the M.I.T. of Cambridge. The list of contributors and supporters make impressive reading. On its glossy and costly pages we find the reproduction of a painting by André Masson which, in black and white at any rate, looks surprisingly similar to my Trebla Dranseb. Underneath, these words of the painter, written in 1953, are quoted:

'. . that which goes contrary to prevailing taste is, for me, the most precious of things . . . whatever is scorned, despised or not understood by the society in which one lives has prospects for the future . .'

Perhaps these are noble sentiments, but by now and in this context they are also silly. Strictly speaking they imply that the New Landscape which does, in fact, appeal to prevailing taste, must be rejected and that what is scorned by the enlightened sponsors of the book, philistinism, slums and vulgarity, must hold prospects for a future which, I hope, we need not live to see.

What is called loosely 'modern art' sprang indeed from a protest against the lie in the soul, a revulsion from false values. When new classes of patrons acquired unexpected wealth and were bent on ostentation, cheap vulgarity stifled our cities and choked our drawing rooms. Sentimental trash was taken for Great Art. This sickened the heart of the true artists who went on their lonely and perilous way in the face of public neglect and derision. This, at least is the treasured legend of the modern movement, and there is a sufficient element of historical truth in it to silence criticism before the shrines of its martyrs. No-one, perhaps, has described more feelingly than André Malraux this element of almost religious abnegation, of proud resistance to the temptations of success which made an artistic movement a moral force in society. No wonder that the movement looks back with genuine nostalgia to these days of purity and persecution and likes to picture itself still in the catacombs. The danger is only that this very pretence may grow into the new lie in the soul.

V

THERE is a more immediate danger. It is the increasing power of negative rules in the fashions of art. In these times of mass education it is not a surprising

development. All education, after all, starts with *don'ts*. We first learn what to avoid if we are not to disgrace ourselves in public. In matters of behaviour this is as it should be. In matters of art it leads to an unthinking acceptance of mere taboos. These fashionable *don'ts* are so easily picked up. Anyone can learn without much trouble that a picture must no longer be 'photographic', 'anecdotal', or even immediately pleasing. A Dranseb is always safe in that respect. Remove that compromising print of a pretty girl from your wall. Pin-ups are vulgar. Put an abstract into your room and you have proclaimed your allegiance to the right kind of thing, to the future, whatever that may mean. If you do not like it yet, it may be your own fault, and after all, what can one *not* make oneself like if only one tries hard enough and if the reward of an enhanced self-respect beckons at the end of the arduous road?

Admittedly there is a brighter side to this situation. In a society where art has lost so many of its uses it might still be the worth retaining its function as a 'badge'. After all it is not the badge of a bad allegiance. Experience shows that the room with these pictures is likely to witness and encourage the most stimulating conversations, least trammelled by prejudice and intolerance. It will invite exploration, experiment and that tolerance for non-conformist views which André Masson probably wished to express and which is the most precious inheritance of the Western World. As long, therefore, as both the extreme Right and the extreme Left attacked this type of art as subversive one felt almost in honour bound to stand by it.

But how long must we still accept such categories of nineteenth century political thought? How long are we to be subject to what may be called the 'polarization' of intellectual life into 'progressive' and 'reactionary', 'left' and 'right'? These terms and sentiments, after all, are not God-given. They once derived their meaning from the hopes and dreams of the French Revolution, when parties began to array themselves in that political spectrum from 'right' to 'left', those who represented the past and those who stood for the future. But as soon as we cease to believe in the inexorable march of progress, as soon as we refuse to imagine ourselves drifting on the vast stream of history it is we ourselves who become responsible for picking our course on the uncharted oceans of time. Maybe Dranseb will be the future, if we choose to make him so. But can't we do better?

In all spheres of life the oversimplified view of history and human destiny has been recently giving way, to a sober mood of empiricism. It ought to prove a blessing to art. The fear of being found in the wrong camp when criticizing certain of its aspects has vitiated rational discussion for too long. And, paradoxical though it may sound, this reluctance has threatened to atrophy what is most vital in the Western tradition, the spirit of experiment which it was meant to protect.

This assertion may need a word of explanation. When we speak of 'experiments'

in science we mean something very well defined and clearly circumscribed. The arrangement, that is, of tests to confirm or refute a scientific theory about the nature of things. They serve progress in that well defined meaning of the term which applies to the progress of science even where it results only in bigger and better motor cars, bombs or space ships. What matters, of course, is that there are public standards by which the success or failure of experiments can be judged.

If words like 'exploration' or 'experiment' are to be more than vague prestige words in art, aimed at spuriously imparting to the studio the aura of the laboratory, we have to find our way back to some standard of success *or failure*. Obviously such standards cannot be quite as clear-cut as they are in science. Obviously, also, the 'success' of an experiment cannot be equated with public acclaim. But I can see no way of discussing *theories* of art, of assessing their value, other than by submitting them to the test of experiment and such rational discussion as is possible, to establish whether the theories *work*.

VI

IT is here that abstract or non-objective art provides the most obvious example The theory on which its experiments were originally based is much older than is generally realized. It is nearly ninety years ago that the English critic Philip Gilbert Hamerton reported on a curious tendency which was gaining ground among the extreme classicists of Paris. 'They are beginning to express contempt for all art which in any way depends on the interest of the subject . . .' Such interest, Hamerton reports in 1867, is felt to be as degrading and as extraneous as the premiums in the form of free books which French newspapers offer to their subscribers.

Painting, like journalism, should in their view offer nothing but its own merchandise. And the especial merchandise of painting they hold to be the visible melodies and harmonies—a kind of visible music—meaning as much and narrating as much as the music which is heard in the ears and nothing whatever more . . . when they paint a woman they do not take the slightest interest in her personally, she is merely for them, a certain beautiful and fortunate arrangement of forms, an impersonal harmony and melody, melody in harmony, seen instead of being heard. It may seem impossible to many readers that men should ever arrive at such a state of mind as this and come to live in the innermost sanctuary of artistic abstraction, seeing the outer world merely as a vision of shapes; but there is no exaggeration in the preceding sentences, they are simply true, and true of men now living.[2]

Hamerton obviously kept up his interest in this trend of art, for some thirty years later, in a book on *Imagination in Landscape Painting*[3], he described a state of mind which

may perceive the most unsuspected relations between colour and form in landscape, and even in accidental combinations of mere pigments, as when Turner got three

children to dabble water-colours together till he suddenly stopped them at the propitious moment. These researches and exercises may easily be condemned as trifling, or even as a desertion of nature, but they are certainly not a desertion of art, for there may be a colour music without meaning, invented by the imagination, exactly as there is a sound music without meaning, or, at least, of which the meaning could not possibly be expressed in any other language but its own.

Reading the words of the half-forgotten Victorian critic one is surprised that the experiments of 'abstract' art were not made earlier than they were; that they were delayed till the first decade of the twentieth century. It is of course right that they were made. We owe it to the spirit of the modern movement that artists dared to explore the potentialities of shapes and colours with greater boldness than their Victorian ancestors. But how are we to decide which experiments are successful and which are not?

VII

IT is in such a concrete case that the dangers of the 'religion of progress' to the progress of art become most easily demonstrable. What Hamerton called the innermost sanctuary of artistic abstraction is thronged with worshippers, exhorted by lecturers to prostrate themselves before its ʿcult images. But there is an old German saying that 'pious images are often bad paintings'. The appeal to other extraneous issues has proved as vitiating to art as was the 'premium' of subject matter. This makes it hard to discuss the success of the experiments in abstraction in rational terms.

To me it seems that there are works of colour music, canvasses by Kandinsky which are really pleasing, just as there are figures or shapes by Mondrian or Nicholson which command respect and interest. Many of them are quite obviously better, more interesting and more ingenious than the works of Dranseb or Dolan (whether of the earlier or the later period) shown in the drawing from *Punch*; and even among those, some are less inane than others. But when I seriously compare my reactions to the best 'abstract' canvas with some work of great music that has meant something to me, it fades into the sphere of the merely decorative.

It should not be hard to account for this relative failure of the experiment. Music is more than a configuration of sounds. Something happens to the motif. It undergoes a series of transformations and vicissitudes, it returns triumphantly enriched by its passage through various keys and rhythms. Painting, of course, lacks the dimension of time. In fairness, therefore, its combinations of shapes and colours should not be compared to a symphony but to a chord. There are thrilling chords in music, and empty ones; chords which sound like elementary exercises from a text-book played by a student on an old 'upright', and captivating combinations enhanced by colourful or witty orchestration. But how good is the best

chord in isolation? Not even the laconic Anton Webern ever reduced his musical meditations to one simultaneous sounding of tones, which is all the painter can give us within the four sides of his frame.

It may be argued that what subject matter imparts to painting is not so much an 'extraneous interest' as another dimension for the development of relationships. Whatever Mr. Hamerton's classicists have felt, something happens to the motif, the nude or the still-life, as it is transposed into shapes and colours, transfigured or distorted, and this event, as Picasso or Klee never cease to realize, is part of the complex structure we call a painting.

A fair trial between music and pure shapes could only be made if shapes were allowed to develop in the dimension of time, for instance in the medium of the film. Perhaps it is a pity that Walt Disney's *Fantasia* has partly discredited this rivalry of the arts by trivializing it prematurely, and that other experiments are so rarely seen in public. There may be films in which shapes undergo destinies comparable to the themes of a symphony; rearing up here into unexpected brightness, shrinking there into gloom. Such an art might even gradually build up a framework of conventions like the one which made Western music possible; that system of expectations within which the musician creates, even where he defies it. How shall we know when these experiments are successful? Only when we enjoy them for their own sake, quite regardless of our historical interest; as we enjoy Mozart's *Eine kleine Nachtmusik*. The notorious tag 'I don't know anything about art but I know what I like' is habitually held up to ridicule in books on art appreciation. It may yet become the cornerstone on which a new art can be built.

IX

I HAVE chosen the musical theory of non-objective art not because it is the only one that has been put forward but because it is both the oldest and the clearest. That there are others, I know. The graphological one, for instance, which is based on the expressive character of marks and traces, or the culinary one which relies on the sensuous appeal of pigments. All these contain a measure of truth and even a measure of triviality. They deserve to be tested, sometimes perhaps even in laboratory experiments, to see how far they can take us. For why should we perpetuate that facile opposition between science and art which gives to art only what is murky, instinctive and by definition inaccessible to rational discussion? This is the kind of cheap aesthetics denounced by Walter Pach. It finds no warrant in either psychology or history. Many scientists have testified to the role which creative dreams have played in their work, dreams that were hammered into rational theories by hard and inspired work; many artists, on the other hand, use the power of intellect with a lucidity and concentration that rivals

that of the scientific pioneer. The cult of art as pure emotional abreaction, expression or automatism, the belief of Dolan from the pages of *Punch* is a debased form of the Romantic belief in inspiration.

Two thousand years ago St. Paul was confronted with a similar debasement. Members of the first Christian congregations experienced strange seizures when they were 'speaking with tongues' uttering what sounded like inspired gibberish. The words of the Apostle in the First Epistle to the Corinthians should be pondered by all critics who feel the urge to speak with tongues about artists similarly afflicted:

Now, brethren, if I come unto you speaking with tongues what shall I profit you, except I shall speak to you either by revelation, or by knowledge, or by prophesying, or by doctrine?
And even things without life giving sound, whether pipe or harp, except they give a distinction in the sounds, how shall it be known what is piped or harped?
I thank my God, I speak with tongues more than ye all:
Yet in the church I had rather speak five words with my understanding, that by my voice I might teach others also, than ten thousand words in an unknown tongue . . .

How reactionary these words must have sounded to the fervant enthusiasts who had at last got rid of the deadweight of conventional speech! But would Western civilization have survived at all, one wonders, if this dyke had not been erected against the tide of unreason, enabling the Church to use and preserve the texts and disciplines on which a revival of rationality could ultimately be based?

Illusion and Visual Deadlock

NONE of Molière's immortal witticisms is surer to get a laugh from a modern audience than the surprise of his *Bourgeois Gentilhomme* when he is told that he has been 'talking prose' all his life. But was poor M. Jourdain all that silly? What he had discovered in his frantic efforts to climb into the class of noblemen was, of course, not prose, but verse. The notion of prose as a special kind of speech could never have been thought of without the poet's truly surprising ways with language, so well described by the author of *Alice in Wonderland*:

> *For first you write a sentence,*
> *And then you chop it small;*
> *Then mix the bits, and sort them out*
> *Just as they chance to fall:*
> *The order of the phrases makes*
> *No difference at all.*

The corresponding ways with images practised by twentieth-century artists have turned us all into M. Jourdains. They have shocked us into a fresh awareness of the prose of pictorial representation.

If we had told an art lover of former days that a picture needed deciphering, he would have thought of symbols and emblems with some cryptic 'hieroglyphic' content. Take the still life by the Dutch seventeenth-century painter Torrentius (Fig. 126). It seems clear enough as a representation, and for good reasons: We know that the artist used an optical device, the camera obscura, to project the image of the motifs onto the canvas where he traced it as one might trace a projected photograph. What wonder that it seemed just as easy to recognize the objects in the picture as it would be to recognize them on the table. If deciphering came in at all, it applied to a second level of meaning, as it were—to the question of what these objects might signify. To the learned *gentilhomme* they would suggest more than a jug, a glass and a yoke, for he would recognize in this curious assemblage the emblems or 'attributes' of the personification of Temperance, a lady with the laudable habit of pouring water into her wine and a corresponding disposition meekly to accept the bridle and the yoke.[1]

It was only when learned allusions of this kind went out of fashion, and when everybody could reproduce the image of objects by means of his own photographic camera, that artists began to question the simple assumptions underlying the still-life painter's craft. No sooner had they done so than the public questioned their competence. What impudence of the Impressionists to demand that we

This article was originally published, under the title 'How to Read a Painting' in the *Adventures of the Mind*, series of the *Saturday Evening Post*, 1961.

decipher their blots and splashes! But this is easy, retorted the painter's champions. Just step back and half-close your eyes, and the blots will fall into place. The magic worked, and the outcry subsided. What remained was the conviction that the artist knew more about seeing than the layman. Surprising as it may sound, some concluded that the blots must be all we really see of a motif on the table. If we recognize things more easily in life than on impressionist pictures, it is because we can touch and handle objects and thus acquire knowledge of properties which we have no right to ask the artist to paint.

No right? Why not? Should we not demand of the artist precisely for this reason that he must somehow include in his pictures that indispensable information gained from touch, those tactile values we need for recognition and participation in his world? If so, where should he stop? It is not only touch that gives us information. It is movement, looking at objects from several sides. Without such movement we would never learn to sort out the impressions received by our eyes.

So the debate went on, and representation became self-conscious. The Cubist revolution some fifty years ago established the painter's rights to present his own commentaries to the conundrum of vision. Instead of tracing the image of a camera obscura, the artist superimposes and telescopes fragments of representations which follow a mysterious order of their own (Fig. 129). No longer will a simple trick suffice to recover the object on the table. Like the ghost of Hamlet's father, "'Tis here! 'Tis here! 'Tis gone!'.

There were and still are critics who claim that this tantalizing method represents some higher order of reality than does the photographic picture. It may well be that Picasso and Braque, who invented the style, were inspired by echoes of similar mystic beliefs. But the continent they found on their voyage of discovery was not the never-never land of the fourth dimension, but the fascinating reality of visual ambiguity. We are in danger of missing this fascination through sheer familiarity with cubist methods which have long since penetrated into commercial art. The shock has worn off, and we no longer attempt to decipher the images that play hide-and-seek among the facets of ambiguous patterns. And thus we are apt to miss the real problem posed by the first of the 'modern' styles that broke resolutely with the 'photographic' rendering of reality: How should each individual form be read? How are the shapes related to each other? Where is the key to the code?

> *For first you paint an object,*
> *And then you chop it small;*
> *Then mix the bits, and sort them out*
> *Just as they chance to fall:*
> *The order of the aspects makes*
> *No difference at all.*

This strange and fascinating way of jumbling the elements of representation is

perhaps a novel kind of verse that makes us aware of the existence of prose. For how are the elements ordered in naturalistic pictures, that we should find it so easy, by contrast, to read into them images of tangible things? The formulation may cause some shaking of heads. Surely we do not read the shape of a jug and a glass *into* the Dutch still life; we simply recognize it. Of course we do, but where exactly is the borderline here between reading into and reading? We are all familiar with the clouds, rocks or ink blots into which the fanciful can read pictures of monsters or masks. Some vague similarity to a face or body engages our attention, and we proceed, as far as we can, to transform the remaining shapes into an appropriate continuation.

Psychologists and psychiatrists have become interested in this game of the imagination, and ink-blot-reading tests, such as the Rorschach, are supposed to tell them much of the working of a person's mind. They are interested, in other words, in the different interpretations that are given of the same blot. It is these differences we have in mind when we speak of 'reading into'. Where people normally see the same image, we call it reading. We all read the jug correctly because it looks like a jug. But this simple formulation begs a good many questions and hides the mystery of reading from us.

We come a little closer to its core with some of the trick pictures in which surrealist artists conjured up the ambiguities of dreams. Tchelitchew, for instance, turns a tree into the image of a hand growing out of a foot (Fig. 131). He guides our projection by assimilating the shape of the tree to other recognizable forms. But such visual punning is still comparatively simple. For here (not in his other pictures) the artist has taken care that we should know where to look for the meaning. We cannot always take this for granted. Indeed, our tendency to jump to conclusions here has been used by the devisers of puzzle pictures and even by propagandists to catch us off our guard. Figure 130 looks for all the world like the representation of a classic urn set amidst willows. It was circulated during the French Revolution as a clandestine tribute to the royal family. For if we don't focus on the urn, but on the background, we discover the profiles, facing each other, of Louis XVI and Marie Antoinette and, guided by these cues, two further heads, presumably of the Dauphin and some other victim, made by the outline of branches and twigs.

The principle here exploited by a humble draughtsman has played a great role in the discussions of twentieth-century psychologists—it is the relation between 'figure' and 'ground'. As long as we regard the urn as the figure we are not aware of the shape of the ground. Here, therefore, is the simplest case of all where our reading depends on our initial interpretation. We tend to regard the enclosed and articulated shape as the figure and to ignore the background against which it stands. But this interpretation itself is based on an assumption which the artist may choose

to knock away. It is then that we discover that there really is something logically prior to the identification of the jug or the urn and so implied by it—the decision on our part which to regard as figure and which as ground.

This is the moment to introduce a contemporary artist whose prints are meditations on image reading. His name is M. C. Escher, and he lives in his native Holland, keeping more contact with mathematicians than with artists and critics.[2] It is indeed doubtful how much the critics would approve of his ingenious exercises in applied geometry and psychology. But to the explorer of the prose of representation, his nightmarish conundrums are invaluable. His double image of *Day and Night* (Fig. 132) demands an imperceptible switch from figure to ground. The white birds flying across the dark toward the black river come from another side of the world where there is still daylight and where black birds go the other way. And as we search for the dividing line between the two halves, we notice that there is none. It is the interstices between the white birds—the ground—that gradually assume the shape of the black birds, and these checkered patterns merge downward into the fields of the countryside. Easy as it is to discover this transformation, it is impossible to keep both readings stable in one's mind. The day reading drives out the night from the middle of the sheet, the night reading turns the black birds of the same area into neutral ground. Which forms we isolate for identification depends on where we arrive from. Reading becomes an alternating 'reading into'; representation merges with guided projection.

But Escher has more tricks in his bag to undermine our confidence in the simplicity of representation. His print *Solid and Hollow* (Fig. 133) makes use of other forms of ambiguity which had been known to artists and psychologists for a long time, but had never been explored and exploited with such single-mindedness.

Here it is not the relationship between figure and ground that is reversed on the opposite side of the picture, but the very shape and direction of any part of the architecture. Start on the left with the black woman walking over a curved bridge toward some stairs. As long as you stay on her side of the picture you are presented with a weird but plausible view of an old town. Start with the man climbing a ladder on the opposite side and you will read the shapes as equally coherent forms representing an unfinished courtyard with a bridge vaulting over it. But once again either reading is contradicted when you read on towards the central axis. For what looks like a pavilion seen from the outside if you approach it from the side of the black woman on the bridge, is switched into a vaulted corner when seen from the other side. The switch is all the more puzzling as the identical shape nearby must surely be read as a solid pavilion. But soon we discover the same punning with inside and outside all over the print. The floor on which a boy has fallen asleep is a ceiling nearby from which a lamp dangles. Everywhere corresponding shapes must be read as hollow in one context and solid in another and, every time, the

meeting of both readings creates a stalemate. The assumption with which we have started breaks down, and we have to begin all over again, only to discover that here too we are led into perplexity.

But even this probing of the mechanisms of image reading is not the most disconcerting of Escher's exercises. The *Belvedere* (Fig. 134), completed in 1958, may not be very pleasing as a print, but as a demonstration piece it trumps the others. For what looks at first like a rather crude historical illustration is, in fact, a brain teaser of no mean ingenuity. It would make an excellent test of the powers of observation to time the moment when it dawns on the beholder that he is confronted with a self-contradictory structure.[3] Look at the ladder and try to locate it in space. You will find that it leads from a first-floor terrace to a second at right angles to it. The man with the plumed hat on the lower terrace looks out into the landscape behind, the woman under the corresponding arch of the floor above looks sideways. Small wonder, for the arcades of the lower terrace are not composed of columns carrying the vault above them; they are interlaced, as it were, shifting from back to front as we trace their course.

Who can blame the poor imprisoned man in the cellar who looks with amazement at the designer on the bench, for the object he holds in his hands is as unrealizable as the building itself: a cube with interweaving sides.

Whatever we may think of Escher's artistic taste, his prints are worth a whole course in the psychology of perception and its relation to art. Their complexity is far from whimsical. It reveals the hidden complexity of all picture reading. What all these prints have in common is that they compel us to adopt an initial assumption that cannot be sustained as we try to follow it through. The perplexity that ensues suggests that this is an unusual experience.

When we look at a normal representation, there is nothing to prevent us from forming a hypothesis about the figure-ground relationship or about the way the shapes add up to pictures of objects. We therefore believe that we take in the picture more or less at one glance and recognize the motif. Our experience with Escher's contradiction shows that this account is inadequate. We read a picture, as we read a printed line, by picking up letters or cues and fitting them together till we feel that we look across the signs on the page at the meaning behind them. And just as in reading the eye does not travel along at an even pace gathering up the meaning letter by letter and word by word, so our glance sweeps across a picture scanning it for information.

Critics like to tell us how the artist 'leads the eye' along the main lines of his composition. But our roving eyes will not be thus led. The critic's phrase should have become obsolete when eye movements could be filmed and fixation points plotted on pictures.[4] These records confirm what Escher made us suspect: Reading a picture is a piecemeal affair that starts with random shots and these are followed

by the search for a coherent whole. If that sounds a little abstract let us remember what we would do if we had to 'read' a statue blindfolded. Our first groping for information would be quite hit and miss. We would just try to find contact with the object and moving up and down we'd try to seize on an identifiable feature, the nose, the arms or the breast. From that moment our movements would become more purposeful; if that is the nose, the eyes must be somewhere there and they will guide us towards the ears, etc. Sometimes our expectation would be confirmed, often we might have to revise it; our first guess, for instance, may be that the head will be directly over the feet but we may quickly discover that the statue is not standing but sitting or striding. What may take many minutes in this predicament may take less than seconds with the help of the eyes. But however unlike the two processes may be in our experience, their logic is similar. The eye, like the groping hand, scans the page, and the cues or messages it elicits are used by the questioning mind to narrow down our uncertainties. Every piece of information that reaches us through the senses can be thus used to answer a further question and remove a further doubt.

The first truth, which Escher's visual paradoxes illuminate is this piece-meal character of picture reading. There is a clear limit to the visual information we can assimilate in any given glance. This fits in well with the results of scientists who have studied this limit in the severely practical context of how many pointers a pilot can read at a glance on an instrument panel. His capacity will, of course, vary according to training and experience but the basic fact remains that the eye can take in much less at one glance than the layman imagines. But what about the musician who can read an orchestral score with surprising ease and at amazing speed? Does he not have to take in information at an uncanny rate? Certainly the feat is admirable, but it is only possible because the notes of the score, unlike the pointer readings, are not unconnected signs. Music is an art that follows certain laws or rules which enable the musician to scan the score with certain expectations. Though he cannot know what to expect in the next bar, he knows at least that many possibilities are ruled out. Indeed, if any of those occurred he would probably disregard it as a misprint.

In reading a familiar language, of course, we proceed in a similar way, looking ahead for cues to confirm our expectations and filling in the remainder more or less from experience. The reading of pictures must follow a similar pattern. But once we set out to discover how we read the 'score', in particular how we have to revise our expectations, we become aware of the part which assumptions play in the reading of images.

What, more precisely, are these assumptions? Take any isolated part of Escher's *Belvedere*, the outside terrace, for instance, with its checkerboard floor and the low walls surrounding it. This is quite a normal realistic representation of an architectural feature and does not differ much from a photograph or picture post card

of such a motif. How is it that we take in such a situation with such speed and ease ? Surely because we are in no doubt about how to supplement the information with which the picture supplies us. We assume that a pavement will most probably be level and a wall upright, that the slabs of the floor will be square and the seat of the bench rectangular. If the shapes representing these objects are tapering and unequal in size, this will obviously be due to foreshortening and perspective.

Assumptions of this kind are so ingrained in us that it needs quite a jolt to prevent our interpretation from running along these convenient grooves. Yet, after all, there could be such things as sloping floors with irregularly sized slabs, tapering walls or rhomboid benches. Such odd shapes might serve a very good purpose in the theatre, near the back of an illusionist stage to give the impression of greater depth (Figs. 127–8). Once we admit this possibility, our assurance in reading the image collapses. We discover the hidden ambiguity in all representations of solid objects in the flat. If the reader enjoys a whirling head he can now return to a fresh scrutiny of all the three Escher prints (Figs. 132–4) to discover that these teasing images are 'ambiguous' only on the assumption that floors or ceilings are horizontal, columns upright or the water of rivers reasonably level so that the bridge across it cannot lead uphill. Drop these hypotheses, and the neat ambiguity of a mere double meaning sinks into chaos.

We return from this giddy switchback ride with one tormenting question in mind. If the prose of ordinary representations hides such unsuspected ambiguities, what about the reliability of our eyes for telling us about the real world ? We need not worry too much, for here the answer is more reassuring. To put the matter briefly, pictures are infinitely ambiguous because they present a flat two-dimensional geometrical projection of a three-dimensional reality. To say of such a projection that it 'looks like reality' begs the question. It may, but it also looks like an infinite number of possible, if improbable, configurations. But this type of ambiguity will rarely trouble us in real life. After all, we experience the real world by moving about it, and our eyes are eminently suited to guide us.

The eyes alone can quickly resolve the question of the real shape of a terrace, for we have a built-in predictor that tells us how any given shape will change when seen from different angles. If one moves straight toward a door, its shape will remain constant, but its size will increase at a predictable rate. The object near the fringe of our vision, on the other hand, will be transformed in shape in a regular and predictable sequence that we can study if we move a film camera in the same direction. It is this melody of transformation that would be entirely different if we moved toward a flat or shallow perspective stage.

The decisive part that movement must play in our visual orientation has only recently been fully brought out by psychologists, notably by James J. Gibson.[5] Here, too, a fresh alternative shocked us into awareness of an old truth we had

lazily taken for granted. The problems of vision in rapid flight or even in motoring rendered the old idea of static vision obsolete. Moreover, our engineers had meanwhile learned to simulate the function of sense organs with the uncanny gadgets of homing devices, used in the deadly game of missile development. Cybernetics has taught us to look even at the senses not as passive registration devices but rather as receptors geared to the receipt of a flow of information, which the nervous system is somehow programmed to compare with expectations. Some psychologists think that the simplicity hypothesis, the idea that the floor is 'probably' level, may be built into our receptor organ. But whether they are inborn or acquired, it is now clear that every message sets up a set of expectations with which the incoming flow can be matched to confirm correct assessments or to modify and knock out false guesses.

In looking at a picture we are deprived of this dynamic aid for the weeding out of false interpretations. All we have is a consistency test that compares the messages from various parts of the picture for compatibility. Having done so, our mind makes ready for further tests through movement, but here it is frustrated. This frustration has a curious side effect that can paradoxically increase the illusion and will never cease to tease our reason. It is the illusion that objects pointing toward us from paintings will follow us as we shift our position.

The most bored and footsore tourist will spring to attention when the guide demonstrates the ancestral portrait that follows him with its eyes or the pointed gun that always aims at him wherever he stands in the hall. It is easy to dismiss this surprise as naïve, but less easy to exhaust the implications of this little mystery. One thing is sure: The mystery does not rest in any particular skill on the part of the painter. The effect is quite frequent and indeed inevitable. The only reason why we need the guide's patter to enlist our attention is that we are but rarely interested in what happens to the appearance of a painting while we shift our position in this way. If we were, we would see that the principal condition for the effect is a sense of depth combined with an unforeshortened portion of an object that appears to lie quite close to the frontal plane.

The woodcut by the German Renaissance artist Hans Baldung Grien (Fig. 135), for instance, fulfills these conditions admirably. It is known under the title 'The Bewitched Stableboy' and it shows the victim of some evil spell lying on his back, the soles of his feet turned toward us. Critics have wondered what the picture signifies, but surely it is meant to tease us with this magic trick. When we have it in front of us, it works like any picture using perspective. The strong foreshortening is 'read' as depth, and we feel the three-dimensional character of the representation as a compelling illusion. It is consistent with this reading that we should look straight at the soles of the man's shoes and that they should hide from us his feet and ankles which we imagine to be there. But the more firmly we project

the image of the whole figure into these marks on the paper, the more will we instinctively expect it to respond to our usual reality tests. A real figure would present different aspects to us if we moved sideways. But since what we have in front of us is not a three-dimensional figure but only a flat piece of paper, the expected melody of transformation fails to materialize.

What makes this experience remarkable in our context is the confirmation it provides for our argument that the picture becomes a picture only if the marks on the paper are sorted out by the mind into a consistent and coherent message. Once this consistency is perceived and an interpretation emerges, it takes a great effort to dislodge it. Easy though it is to know intellectually that our poor stable-boy's head lies objectively in the same plane as do his feet, we still do not quite see it that way.

It is here, at last, that these investigations of the prose of representation lead back to the problems of artistic poetry. For it is the strength of the forces of illusion that alone accounts for the violent reactions against these forces in twentieth-century art. At all times, of course, the aesthetics of picture-making had more to do with composition than with illusion. Artists have always been poets, striving to achieve a fine balance of shapes and colours and to devise a beautiful pattern to fill the painting surface in a pleasing way. But these efforts could easily be destroyed by the reading mind that rearranged these shapes in an imaginary depth.

Critics wrote and still write as if we could see both the surface and the representation, but artists knew better. Their rebellion against illusion came into the open more than fifty years ago in those conundrums of Cubism which lead our eye a frustrating chase after guitars and bottles, teasing us with false clues only to entrap us in contradictions. It was by exploring these paradoxes that artists wanted to discover new modes of organization.

It is not only Escher who shows us their success. Even abstract art owes some of its most interesting possibilities to the fascination of unresolved ambiguities as in many of the ingenious designs by Albers.[6] By presenting us with these scrambled codes the artist shocks us into realizing how much more there is in pictures than meets the eye.

Josef Albers:
Drawing. 1958.

NOTES

MEDITATIONS ON A HOBBY HORSE

1. In the sphere of art this process of differentiation rather than abstraction is wittily described by Oliver Wendell Holmes in the essay 'Cacoethes Scribendi', from *Over the Teacups* (London: 1890): 'It's just the same thing as my plan . . . for teaching drawing. . . . A man at a certain distance appears as a dark spot—nothing more. Good. Anybody . . . can make a dot. . . . Lesson No. I. Make a dot; that is, draw your man, a mile off. . . . Now make him come a little nearer. . . . The dot is an oblong figure now. Good. Let your scholar draw an oblong figure. It is as easy as to make a note of admiration. . . . So by degrees the man who serves as a model approaches. A bright pupil will learn to get the outline of a human figure in ten lessons, the model coming five hundred feet nearer each time.'

2. *Discourses on Art* (Everyman Edition, p. 55). I have discussed the historical setting of this idea in 'Icones Symbolicae', *Journal of the Warburg and Courtauld Institutes*, XI (1948), p. 187, and some of its more technical aspects in a review of Charles Morris, *Signs, Language, and Behavior* (New York: 1946) in *The Art Bulletin*, March 1949. In Morris's terminology these present meditations are concerned with the status and origin of the 'iconic sign'.

3. Leonardo da Vinci, *Paragone*, edited by I. A. Richter (London: 1949), p. 51.

4. Paul Klee, *On Modern Art* (London, 1948). For the history of the idea of *deus artifex* cf. E. Kris and O. Kurz, *Die Legende vom Künstler* (Vienna: 1934).

5. H. A. Groenewegen-Frankfort, *Arrest and Movement: An Essay on Space and Time in the Representational Art of the Ancient Near East* (London: 1951).

6. Perhaps it is only in a setting of realistic art that the problem I have discussed in 'Icones Symbolicae', loc. cit., becomes urgent. Only then the idea can gain ground that the allegorical image of, say, Justice, must be a portrait of Justice as she dwells in heaven.

7. For the history of this misinterpretation and its consequences cf. my article on 'Art and Imagery in the Romantic Period', republished in this volume.

8. This, at least, would be the opinion of Lewis Spence, *Myth and Ritual in Dance, Game, and Rhyme* (London: 1947). And also of Ben Jonson's Busy, the Puritan: 'Thy Hobby-horse is an Idoll, a feirce and rancke Idoll: And thou, the *Nabuchadnezzar* . . . of the *Faire*, that set'st it up, for children to fall downe to, and worship'. (*Bartholomew Fair*, Act. III, Scene 6).

9. Cf. Géza Révész, *Ursprung und Vorgeschichte der Sprache* (Berne: 1946).

10. Cf. Konrad Lorenz, 'Die angeborenen Formen möglicher Erfahrung', *Zeitschrift für Tierpsychologie* V (1943), and the discussion of these experiments in E. Grassi and Th. von Uexküll, *Vom Ursprung und von den Grenzen der Geisteswissenschaften und Naturwissenschaften* (Bern: 1950).

11. K. Lorenz, loc. cit. The citation of this article does not imply support of the author's moral conclusions. On these more general issues see K. R. Popper, *The Open Society and Its Enemies*, esp., I, pp. 59 ff. and p. 268.

12. F. Sander, 'Experimentelle Ergebnisse der Gestaltpsychologie', *Berichte über den 10. Kongress für Experimentelle Psychologie* (Jena: 1928), p. 47, notes experiments that show the distance of two dots is much harder to estimate in its variations when these dots are isolated than when they are made to represent eyes in a schematic face and thus attain physiognomic significance.

13. For a large collection of such faces cf. Laurence Whistler, *Oho! The Drawings of Rex Whistler* (London: 1946).

14. G. H. Luquet, *The Art and Religion of Fossil Man* (London: 1930), pp. 141 f.

15. G. A. S. Snijder, *Kretische Kunst* (Berlin: 1936), pp. 68 f.

16. Franz Boas, *Primitive Art* (Oslo: 1927), pp. 118–28.

17. E.g., E. Löwy, *The Rendering of Nature in Early Greek Art* (London: 1907), H. Schaefer, *Von aegyptischer Kunst* (Leipzig: 1930), Mr. Verworn, *Ideoplastische Kunst* (Jena: 1914).

18. Karl Bühler, *The Mental Development of the Child* (London: 1930), pp. 113–17, where the connection with the liguistic faculty is stressed. A criticism of this idea was advanced by R. Arnheim, 'Perceptual Abstraction and Art', *Psychological Review*, LVI, 1947

19. G. H. Luquet, *L'Art primitif* (Paris: 1930).

20. The idea of avoidance (of sexual symbols) is stressed by A. Ehrenzweig, *Psycho-Analysis of Artistic Vision and Hearing*, (London: 1953), pp. 22–70.

21. E. Kris and O. Kurz, loc. cit., have collected a number of legends reflecting this age-old fear: thus a famous Chinese master was said never to have put the light into the eyes of his painted dragons lest they would fly away.

22. It was the intellectual fashion in German art history to work with contrasting pairs of concepts such as haptic-optic (Riegl), paratactic-hypotactic (Coellen), abstraction-empathy (Worringer), idealism-naturalism (Dvořák), physioplastic-ideoplastic (Verworn), multiplicity-unity (Wölfflin), all of which could probably be expressed in terms of 'conceptual' and 'less conceptual' art. While the heuristic value of this method of antithesis is not in doubt it often tends to introduce a false dichotomy. In my book *The Story of Art* (London: 1950) I have attempted to stress the continuity of tradition and the persistent role of the conceptual image.

23. H. Wölfflin, *Principles of Art History* (New York: 1932).

24. The fallacy of a passive idea of perception is discussed in detail by E. Brunswik, *Wahrnehmung und Gegenstandswelt* (Vienna: 1934). In its application to art the writings of K. Fiedler contain many valuable hints; cf. also A. Ehrenzweig, loc. cit., for an extreme and challenging presentation of this problem.

25. This may be meant in the rather enigmatic passage on the painter Parrhasius in Pliny's *Natural History*, XXXV, 67, where it is said that 'the highest subtlety attainable in painting is to find an outline . . . which should appear to fold back and to enclose the object so as to give assurance of the parts behind, thus clearly suggesting even what it conceals'.

26. Cf. E. Panofsky, 'The Codex Huygens and Leonardo da Vinci's Art Theory', *Studies of the Warburg Institute*, XIII (London: 1940), pp. 90 f.

27. Cf. J. v. Schlosser, 'Gespräch von der Bildniskunst', *Präludien* (Vienna: 1927), where, incidentally, the hobby horse also makes its appearance.

VISUAL METAPHORS OF VALUE IN ART

1. I should like to thank Professor Hoxie N. Fairchild and Professor G. Bing (The Warburg Institute, University of London) for valuable criticism. I do not know whether such revisions as I have been able to make (including the addition of Section VI) will remove all the differences of opinion, but I hope they will somwehat clarify my meaning without upsetting the tentative and provisional framework of the hypothesis which is here offered for discussion.

2. Cf. W. Bedell Stanford, *Greek Metaphor*, Basil Blackwell, Oxford, 1936, p. 25. This work also contains a stimulating discussion of recent theories of metaphor.

3. The relation between metaphor and visual symbol is discussed by Fr. Vischer, 'Das Symbol', in *Philosophische Aufsätze, Eduard Zeller gewidmet*, Leipzig, 1887, a paper that directed the attention of Aby Warburg, founder of the Warburg Institute in London, to this complex of questions.

4. A brief survey of the history of this distinction is to be found in K. Bühler, *Sprach-theorie*, Gustav Fischer, Jena, 1934, pp. 185–86.

5. A distinction between 'codes' and 'symbols' is proposed by A. Kaplan and Ernst Kris in 'Esthetic Ambiguity', Ernst Kris, *Psychoanalytic Explorations in Art*, New York, 1952.

6. For the connection between 'metaphor' and 'visual emblem', cf. Mario Praz, 'Studies in Seventeenth-Century Imagery', *Studies of the Warburg Institute*, London, 1939, 3, p. 55. For the quotation from St. Thomas (*Quaestiones Quodlibetales*, VII, art, XIV, ad. 4) and its application to problems of visual symbolism, my article on 'Botticelli's Mythologies', *Journal of the Warburg and Courtauld Institutes*, 1945, VIII, p. 37, note 2.

7. For an older version of this belief cf. my article, 'Icones Symbolicae', *Journal of the Warburg and Courtauld Institutes*, 1948, XI. The philosophical implications of a belief in an 'inherent meaning' of symbols or words are placed in their historical perspective by K. R. Popper, *The Open Society and its Enemies*, Routledge & Kegan Paul, Ltd., London, 1945, chapter II, section 2.

8. *Cf.* H. Hartmann, Ernst Kris, and R. M. Loewenstein, 'Some Psychoanalytic Comments on Culture and Personality' in *Psychoanalysis and Culture*, edited by G. B. Wilburt and W. Muensterberger, International Universities Press, Inc., New York, 1951.

9. 'Meditations on a Hobby Horse' reprinted in this volume.

10. Stanford, *op. cit.*, pp. 47 ff.

11. The theory of facial expression first propounded by Piderit in 1859 (*cf.* K. Bühler, *Ausdruckstheorie*, Gustav Fischer, Jena, 1933), according to which reactions to taste (sweet, bitter, etc.) provide us with the elements of mimic expression, suggests that this unity reaches back to a stage of development when impressions are not yet differentiated and sorted out. Here, too, as with perception, it might be claimed that the most generalized global reaction is not a stage of 'abstraction', but the most primitive way of apprehending the world—a state of affairs which Aristotle's description of the metaphor as the outcome of analysis and transfer of qualities tends to obscure, (*Cf.* K. Bühler, *Sprachtheorie*, Gustav Fischer, Jena, 1934, p. 346) and to which a purely associationist psychology cannot do justice.

12. *Abbot Suger on the Abbey Church of St. Denis and its Art Treasures*, edited, translated, and annotated by Erwin Panofsky, Princeton University Press, Princeton, 1946, pp. 21 and 64.

13. J. Bodonyi, '*Entstehung und Bedeutung des Goldgrundes in der Spätantiken Bildkomposition*', *Archeologia Ertesitoe*, 1932–1933, XLVI, and my review in *Kritische Berichte zur Kunstgeschichtlichen Literatur*, 1935.

14. Edwyn Bevan, *Symbolism and Belief*, Allen & Unwin, London, 1938, pp. 28 f.

15. L. B. Alberti, *De Re Aedificatoria*, book VII, chapter 7.

16. L. B. Alberti, *Della Pittura*, book II.

17. G. Boccaccio, *Decamerone*, *Giornata*, VI *Novella*, 5.

18. Life of Cosimo Rosselli.

19. N. Elias, *Über den Prozess der Zivilisation*, Haus zum Falken, Basel, 1939.

20. *Der Wille zur Macht*, Aphorism 943.

21. I need hardly say that this introspection is guided by theoretical expectations, derived, in my case, from the thought and the writings of Ernst Kris, whose *Psychoanalytic Explorations in Art* contain several models in which the idea of an 'optimum distance' is developed.

22. *Cf.* Christopher Hussey, *The Picturesque*, Putnam, London, 1927.

23. E. Loewy, '*Ursprünge der bildenden Kunst*', *Almanach der Akademie der Wissenschaften in Wien*, 1930.

24. *Cf.* Meyer Schapiro in his review of Arthur Upham Pope's 'Survey of Persian Art', *The Art Bulletin*, March, 1941, p. 85.

25. *Loc. cit.* The value of Elias's findings seems to me to lie in the fact that he allows us to dispense with the assumption of a biological evolution in historical times such as seems postulated by A. Ehrenzweig, *Psycho-Analysis of Artistic Vision and Hearing*, London, 1953, for here the methodological warnings formulated by K. R. Popper, *The Poverty of Historicism*, London, 1957, apply.

26. Sir Joshua Reynolds, *Fifteen Discourses*, Everyman Edition, J. M. Dent & Sons Ltd., London, 1928, p. 135.

27. L. Klages, *Ausdrucksbewegung und Gestaltungskraft*, J. A. Barth, Leipzig, 1923.

28. Bernard Shore, *The Orchestra Speaks*, Longmans Green & Company, London, 1938, p. 182.

29. Paul Hindemith, *A Composer's World*, Harvard University Press, Cambridge, Massachusetts, 1952.

30. *The Letters of John Keats*, edited by J. B. Forman, Oxford University Press, Oxford, 1947, p. 67f.

31. *Das Ideal und das Leben*; for the philosophical background see also Schiller's essay, *Über das Pathetische*, which is of great interest in our present context.

32. For this criticism *cf.* P. Hindemith, *loc. cit.*, pp. 35 f.

33. *Cf.* Ernst Kris, 'Laughter as an Expressive Process', *loc. cit.*, pp. 127 ff.

34. Somewhat similar distinctions between symbol and symptom are made by R. G. Collingwood, *The Principles of Art*, Oxford University Press, Oxford, 1938, but I cannot quite share the author's conclusions. The most stimulating discussion of the problem of personal expression, as far as poetry is concerned, may be found in the exchange of letters by E. M. W. Tillyard and C. S. Lewis, *The Personal Heresy*, Oxford University Press, Oxford, 1939.

35. *Loc. cit.*, 'Of Symbols'. The whole chapter deserves the attention of students of the subject.

36. Alfred North Whitehead, *Symbolism, Its Meaning and Effect*, Cambridge University Press, Cambridge, 1928.

37. For a brief but telling analysis of snobbery, *cf.* George Boas, *A Primer for Critics*, The Johns Hopkins Press, Baltimore, 1937.

38. Some equally devastating remarks on certain idols of modern criticism can be found in Sir Donald Tovey, *A Musician Talks*, I. The

Integrity of Music, Oxford University Press, London, 1942, especially pp. 38–39, where the intellectual respect for such compositional devices as 'inversion' is held up to healthy ridicule.

39. The emptiness of this claim has been shown up by George Boas, *Wingless Pegasus*, The Johns Hopkins Press, Baltimore, 1950, Appendix I.

PSYCHO-ANALYSIS AND THE HISTORY OF ART

1. Reprinted in *Papers on Psycho-Analysis*, 5th ed. (London: Baillière, Tindall and Cox 1948, pp. 87 ff.).

2. I have discussed one aspect of this dream-style (as applied to satire) in 'Art and Imagery in the Romantic Period', reprinted in this volume.

3. Giuseppina Fumagalli, *Eros di Leonardo* (Milan: Garzanti, 1952). The romantic tone and tendency of this book (which is to vindicate Leonardo's sexual normality) need not blind us to the fact that much of the author's criticism of Freud's data (which were mainly derived from Marie Herzfeld's studies) must be accepted as philologically sound.

4. For a vigorous criticism of this view from a different angle cf. G. Boas, 'Communication in Dewey's Aesthetics', *Journal of Aesthetics and Art Criticism*, December 1953.

5. For a facsimile of this letter cf. *Transformation*, 1951, I. The translation published alongside it hardly brings out the charm and force of Freud's reply.

6. 'The Madonna's Conception through the Ear', *Essays in Applied Psycho-Analysis* (London: Hogarth Press, 1951, Vol. II, pp. 326 ff.).

7. Jaime Sabartés, *Picasso* (London: W. H. Allen, 1949).

8. Daniel Schneider, *The Psychoanalyst and the Artist* (New York: Farrar, Strauss & Co., 1950); pp. 113 ff. and 208 ff., looks at the same material from a slightly different angle.

9. C. Zervos, *Pablo Picasso* (Paris: Edition Cahiers d'Art, 1942. Vol. II, 1, p. 10).

10. cf. H. Hartmann, E. Kris and R. M. Loewenstein, 'Some Psychoanalytic Comments on Culture and Personality', in *Psychoanalysis and Culture*, edited by G. B. Wilbur and W. Muensterberger (New York: International Universities Press, 1951). The interpretation of the relevant

data by these authors appears to me more fruitful than the one given by A. Ehrenzweig, *The Psycho-Analysis of Artistic Vision and Hearing*, (London, 1953). For the methodological aspect of this question cf. K. R. Popper, 'The Poverty of Historicism'. (London 1957).

11. For this aspect of representation as a creation of 'substitutes' cf. 'Meditations on a Hobby Horse', reprinted in this volume.

12. For a test concerning the difficulty of interpreting foreshortened images cf. D. Katz, *Gestalt Psychology*, (New York: Ronald Press Company, 1950, p. 63).

13. E. Kris, *Psychoanalytic Explorations in Art* (New York: International Universities Press, 1952, p. 56), and, the same, 'Psychoanalysis and the Study of Creative Imagination', *Bulletin of the New York Academy of Medicine*, April 1953, second series, Vol. 29, No. 4, esp. p. 348.

14. Now reprinted in E. Kris, *Psychoanalytic Explorations in Art, op. cit.*

15. cf. L. Rosenthal, *Sandro Botticelli et sa réputation à l'heure présente* (Dijon, 1897), and my article, 'Botticelli's Mythologies', *Journal of the Warburg and Courtauld Institutes*, VIII, 1945, esp. p. 11 note.

16. *Essays in Applied Psycho-Analysis, op. cit.*, I, pp. 22 ff.

17. This is not to imply that it has no roots in traditional aesthetics. For those who are interested in these roots Longinus' comparison between the faultlessly fluent Hypereides and the rugged grandeur of Demosthenes (*On the Sublime*, XXXIV) may be relevant.

18. For Botticelli cf. my article quoted above and 'Icones Symbolicae, The Visual Image in Neo-Platonic Thought', *Journal of the Warburg and Courtauld Institutes XI*, 1948.

19. *British Journal of Medical Psychology*, IV, 1924. p. 152 f.

20. The example is taken from F. Jourdain, 'L'Art Officiel', *Le Point* (Revue artistique), Souillac, Mulhouse, 1949.
21. I wish to thank Mr. Otto Fein of the Warburg Institute who applied his unfailing photographic skill to my problem and produced a series of photographs of which Figs. 19 and 20 are examples.
22. Even J. Rewald's *History of Impressionism* ˌ(New York: Museum of Modern Art, 1946), the standard work on the movement, to which all histories of modern art will remain indebted, should not be read uncritically by those who are interested in the psychological implications of this story. The Romantic image of the lonely artist facing a hostile world had taken such deep roots in the nineteenth century that success smacked of compromise and threatened a painter's self-respect. E. Kris (*Psychoanalytic Explorations in Art, op. cit.*, chapter 2) has shown how hard it is in such cases to disentangle myth from reality. But even where hostility was genuinely widespread (and not overdramatized by the artists and their friends) a psychological analysis of such situations will fail as long as we see it exclusively in terms of 'progressives' versus philistines. For resistance is not only due to the lazy attitude of those who shun a greater effort (though this, too, plays its part) but also to what might be called the regressive component which seems to

threaten the inner security of those not ready to yield. I have attempted to discuss some of the 'moral' aspects of this question in a paper on 'Visual Metaphors of Value in Art', reprinted in this volume.
23. cf. A. H. Barr Jr., *Picasso* (New York: Museum of Modern Art, 1939).
24. For the concept of the 'logic of the situation' cf. K. R. Popper, *op. cit.*, section 31.
25. cf. A. H. Barr Jr., *op. cit.*
26. e.g. Zervos, *op. cit.*, Vol, I, pl. 70.
27. L. Venturi, *Cézanne* (Paris: Paul Rosenberg, 1936, Nos. 103, 240, 241, 880, 1214). One of these versions was apparently in the possession of Mr. Kahnweiler, Picasso's dealer.
28. How hard it was for Picasso to achieve this regression also appears from the report, quoted by D. Schneider, *op. cit.*, p. 223, that the artist is said to have taken hashish at the time 'to induce a primitive mood'. The element of aggressive caricature, also referred to by the author, fits into the picture.
29. For a most illuminating discussion of the complex relationship between private meaning and public response cf. the interpretation of F. X. Messerschmidt's busts of character types by E. Kris, reprinted in *Psycho-analytic Explorations in Art, op. cit.*
30. cf. my paper on 'Visual Metaphors of Value in Art', which supplements the present paper in certain respects while it may be superseded by it in others.

ON PHYSIOGNOMIC PERCEPTION

1. Georg Christoph Lichtenberg, 'Fragment von Schwänzen', *Baldingers Neues Magazin für Aerzte*, 1783, 5. I am quoting from the reprint in Lichtenberg's *Vermischte Schriften*. Göttingen, Dieterichsche Buchhandlung, 1867.
2. Johann Caspar Lavater, *Physiognomische Fragmente*. Leipzig and Winterthur, 1775–1778.
3. Charlotte Steinbrucker, *Lavaters Physiognomische Fragmente in ihrem Verhältnis zur bildenden Kunst*. Berlin, Wilhelm Borngraber, 1915.
4. Heinz Werner, *Einführung in die Entwicklungspsychologie*, Leipzig, Ambrosius Barth, 1926.
5. Jerome S. Bruner, 'On Perceptual Readiness', *Psychological Review*, 1957, 64.
6. Konrad Lorenz, 'Die angeborenen Formen

möglicher Erfahrung', *Zeitschrift für Tierpsychologie*, 1943, 5.
7. See also the paper, 'Visual Metaphors of Value in Art', reprinted in this volume.
8. Charles E. Osgood, George J. Suci, Percy H. Tannenbaum, *The Measurement of Meaning*. Urbana, University of Illinois Press, 1957.
9. See my book, *Art and Illusion*, New York and London, 1960.
10. I wish to acknowledge my indebtedness to Mr. Donald Hope, with whom I discussed these matters.
11. K. R. Popper, *The Logic of Scientific Discovery*, 1959; and the same author's 'The Philosophy of Science: A Personal Report', in *British Philosophy in the Mid-Century*, ed. Cecil A. Mace, London, Allen and Unwin, 1957. Now reprinted in K.R. Popper, *Conjectures and Refutations*, London, 1962.

12. Max Beerbohm, 'A Clergyman', in *And Even Now*. London, William Heinemann Ltd., 1920.

13. See my lecture on 'Art and Scholarship', London, University College, reprinted in this volume.

14. Meyer Schapiro, 'Style', in *Anthropology Today* (ed. A. L. Kroeber. University of Chicago Press, 1953), p. 302.

15. André Malraux, *The Psychology of Art*. New York, Bollingen Series, 1949-1951. See also my review, 'André Malraux and the Crisis of Expressionism', reprinted in this volume.

16. John Dewey, *Art as Experience* (New York, G. P. Putnam, 1958), p. 90.

17. For similar experiments (emerging from the school of Heinz Werner) see Reinhard Krauss, ' Ueber den graphischen Ausdruck', *Beihefte zur Zeitschrift für angewandte Psychologie*, 1930, 48.

18. Such a theory of the aesthetic response would run parallel to the theory of artistic creation adumbrated by Ernst Kris, *Psycho-analytic Explorations in Art*, New York, International Universities Press, 1952.

EXPRESSION AND COMMUNICATION

1. Roger Fry, Art History as an Academic Discipline. *Last Lectures*, Cambridge, 1933.

2. S. K. Langer, *Philosophy in a New Key*, Cambridge (Mass.), 1942, ch. VIII; *Feeling and Form*, London, 1953, ch. XX.

3. Charles E. Osgood, Suci, George J., Tennenbaum, Percy H., '*The Measurement of Meaning*', Urbana, 1957.

4. Glenn O'Malley, 'Literary Synesthesia', *Journal of Aesthetics and Art Criticism* XV, 1957.

5. Frances, R., *La Perception de la Musique* (Études de Psychologie et de Philosophie, publiées sous la direction de P. Guillaume et I. Meyerson, XIV), Paris, 1958.

6. Deryck Cooke, *The Language of Music*, London, 1959.

7. Colin Cherry, *On Human Communication*, New York, 1957.

8. Leonard B. Meyer, 'Meaning in Music and Information Theory', *Journal of Aesthetics and Art Criticism* XV, 1957.

9. David Kraehenbuehl, and Coons, Edgar, 'Information as a Measure of the Experience of Music', *Journal of the Aesthetics and Art Criticism* XVII, 1958/59.

10. Jonathan Richardson, *The Theory of Painting* (The Works of Jonathan Richardson), London, 1792, p. 39.

11. William T. Moynihan, 'The auditory correlative', *Journal of Aesthetics and Art Criticism* XVII, 1958.

12. L. D. Ettlinger, *Kandinsky's 'At Rest'*, Oxford, 1961.

13. Carola Giedion-Welcker, *Paul Klee in Selbstzeugnissen und Bilddokumenten*, 1962, p. 84.

ACHIEVEMENT IN MEDIÆVAL ART

1. The history of this tradition has been written by E. Panofsky in his *Idea* (Studien der Bibliothek Warburg, Leipzig and Berlin, 1924). E. Kris has discussed its psychological implications, which are highly relevant to what follows, in 'Bemerkungen zur Bildnerei der Geisteskranken' (Imago, 1936) republished as part of Chapter III of his *Psycho-analytic Explorations in Art*, New York, 1952.

2. Some of the older literature is noted in Schlosser's 'Randglossen zu einer Stelle des Montaigne' in his *Präludien*, Berlin 1927.

3. R. Kömstedt takes this approach in his recent work (*Wallraf Richartz-Jahrbuch*. IX, 1936) although he avoids treating the problem of evaluation as a separate issue.

4. Franz Boas, *Primitive Art*. Oslo, 1927. See also C. von den Steinen: *Die Marquesaner und ihre Kunst*. Vol. 1. 1925, for a basic study of one branch of ornament.

5. V. Löwenfeld and L. Münz, *Die plastischen Arbeiten Blinder*, Brünn, 1934, and E. Kris, loc. cit.

6. In the *Jahrbuch der kunsthistorischen Sammlung in Wien*, 1935-36. Garger has taught us to use the art of the provinces as a genuine area of historical experiment, providing examples where we can examine the reduction of classical images. What goes beyond this can be attributed to intentional transformation.

7. The inquiry into this regularity, as is well known, has been undertaken under the influence of Focillon. On the problem of the gold ground see *Kritische Berichte*, Vol. V, parts 2 and 3.

8. One notices the absence of this observation in Sedlmayr's analysis of mediaeval modes of representation (*La Critica d'Arte*, 1936) of which the results are important for the problem under discussion. The same applies to the extended parallels with other enter-prises of his 'mediaeval mentality'. Do these not also exhibit generally primitive features, however they may vary in particular cases?

9. Emile Mâle, *Religious Art in France in the Thirteenth Century*. (London: 1902.)

10. H. Taine, *Philosophie de l'Art*. (Paris 1865).

11. Work by Ernst Kris and the author have considered this problem within a more extensive discussion. Many of the questions raised here I owe to this collaboration.

ANDRÉ MALRAUX AND THE CRISIS OF EXPRESSIONISM

1. André Malraux: *The Voices of Silence*, translated by Stuart Gilbert, London (Secker & Warburg) (1954), 661 pp.

2. A. Malraux *Psychologie de l'art*, Geneva (Skira). English translation by S. Gilbert, New York (Bollingen Series). Printed in Geneva.
 (i) *Le musée imaginaire* (1947). *The Museum without Walls* (1949).
 (ii) *La création artistique* (1948). *The Creative Act* (1949).
 (iii) *La monnaie de l'absolu* (1950). *The Twilight of the Absolute* (1950).
 Les voix du Silence, Paris (1951).

3. Hans Tietze: 'Die Krise des Expression-ismus', *Lebendige Kunstwissenschaft*, Vienna (1925), p.40. This thoughtful essay has lost little of its topicality in the thirty years since its composition. It stands out from a stream of ephemeral literature in which the transvaluation of all values is proclaimed, *e.g.* Oskar Beyer: *Weltkunst; Von der Umwertung der Kunstgeschichte*, Dresden (1923).

4. Max Dvořák: *Kunstgeschichte als Geistes-geschichte*, Munich (1924), p.276.

5. Ernst Robert Curtius: *European Literature and the Latin Middle Ages*, New York (1953) has some scathing remarks on this attitude in his introduction.

6. For a searching criticism of Spengler's position, *cf.* H. Frankfort: *The Birth of Civilization in the Near East*, London (1951), pp.17 ff. The sources of Spengler's anti-humanitarianism and the emotional climate of his views are characterized in K. R. Popper: *The Open Society and its Enemies*, II, London (1952), p.71.

7. *Cf.* Pierre de Boisdeffre: *André Malraux*, Paris (1952), esp. p. 81. For a telling reference to the visual sources of Spengler's intuitions see *The Voices of Silence*, p.619.

8. *The Royal Way*, translated by S. Gilbert, London (1935), pp.55 f. (The French edition, *La Voie Royale*, was published in 1930).

9. For a table of comparison between the two editions, *cf.* the review by S. Lane Faison, Jr, *The Art Bulletin* (March 1954), p.82.

10. Reprinted in *Präludien*, Vienna (1927).

11. *Op. cit.*

12. *Purgatorio*, XI pp. 79–97.

13. *Cf.* my paper on 'The Renaissance idea of artistic progress and its consequences' *Acts of the XVIIth International Congress for the History of Art in Amsterdam. The Hague*, 1955.

14. *Kunstgeschichtliche Grundbegriffe*, Munich (1943), p.249. His 'Revision', published at the end of this edition, contains much insight relevant to Malraux's problem.

15. I have dealt with other aspects of this reaction in 'Visual Metaphors of Value in Art', reprinted in this volume.

THE SOCIAL HISTORY OF ART

1. cf. K. R. Popper, 'What is Dialectic?', *Mind*, N.S. 49, 1940. Now reprinted in *Conjectures and Refutations*. New York and London, 1962.

2. cf. My review of Charles Morris, 'Signs, Language and Behaviour', *Art Bulletin*, XXXI, 1949, p.70 ff.

3. Raffaello Borghini, *Il Riposo*, Florence, 1584, p.71 f.

4. The inscription is quoted by H. Kauffmann, Donatello, 1935, p.172. The MS source (not known to Kauffmann) is a letter of condolence on Cosimo's death to Piero il Gottoso by *F. Francischus cognomento* *paduanus* copied in B. Fontio's *Zibaldone* Cod. Ricc. 907, fol.142.verso. Fontius notes on the margin of the distich '*In columna sub Iudith in aula medicea*'.

TRADITION AND EXPRESSION IN WESTERN STILL LIFE

1. Arts Council of Great Britain, 1960, Catalogue No.57.

2. Charles Sterling: *Still Life Painting from Antiquity to the Present Time*, Editions Pierre Tisné, Paris (1959,) 164 pp. of text, 124 plates and 41 illustrations in the text. The French edition by the same publishers has the same illustrations but only 146 pages of text, the main additions being in chapters IV and V, totalling some seven pages.

3. The allusion is to the astringent essay by Vincent Turner, S.J.: 'The Desolation of Aesthetics' in J. M. Todd (editor): *The Arts, Artists and Thinkers, An Inquiry into the place of the Arts in Human Life*, London (1958).

4. This is a point frequently made by André Malraux, cf. *The Voices of Silence*, London (1954), especially Part III.

5. Colin Cherry: *On Human Communication*, London and Cambridge (Mass.) (1957), p.168.

6. *op. cit.*, p.108.

7. For some of these problems see chapter XI of my book *Art and Illusion*, New York and London (1960), where bibliographical references can be found.

8. 'Renaissance Artistic Theory and the Development of Landscape Painting', *Gazette des Beaux-Arts*, XLI (May 1953), included in the *Essays in Honour of Hans Tietze* presented in 1950 and republished in that volume in 1958.

9. '*Uno quadro pieno de fructi facto per Antonio da Crevalcore, tra nui in questo exercitio singularissimo ma assai più longho che la natura.*' A. Venturi in *Archivio storico dell'Arte*,I(1888), p.278. I am indebted for this important reference to Miss Jennifer Fletcher. (The translation is admittedly conjectural, but even Italians whom I have consulted are not quite certain of its precise meaning.) Antonio da Crevalcore's most famous painting is No.1146 in Berlin, signed and dated 149(?)3. A second work belongs to Messrs Böhler, Munich (illus. The Burlington Magazine (December 1959), Supplement Plate III). A portrait-group in the 1933 Ferrarese Exhibition (No.171) has also been ascribed to him.

10. According to A. Venturi (*loc. cit.*) Filotto Achillini thus celebrates him in his *Viridario*: '*Nel trar da ver si vale il Crevalcore Che qual Zeusigli occi gabba coi frutti*'.

11. Felix Eckstein: *Untersuchungen über die Stilleben aus Pompeji und Herculaneum*, Berlin (1957).

12. *Cf* Eckstein, *op cit.*, p.56.

13. *The Mural Painters of Tuscany*, London (1960).

14. Apart from the book by Ingvar Bergström: *Dutch Still Life Painting*, London (1956), discussed by M. Sterling in the preface to the edition under review, Eckstein (*op. cit.*, p.63) refers to a typescript dissertation by by E. V. Monroy: *Embleme und Emblembücher in den Niederlanden, 1560–1630*, Freiburg i.Br. (1940). Questions of origin are also discussed in Wolfgang J. Müller: *Der Maler Georg Flegel und die Anfänge des Stillebens*, Frankfurt a.M. (1956) who (in his preface) accounts for his rejection of M. Sterling's thesis by the fact that French and German conceptions of history are bound to diverge in 'their assessment of the phenomenon of cultural continuity'.

15. M. Sterling has kindly pointed out that in his text on the page concerned he has shown himself aware of this argument. I should have mentioned this, but I believe that the objection still holds.

ART AND SCHOLARSHIP

1. Letter to Niklas von Wyle, July 1452, in *Briefwechsel*, ed. R. Wolkan (Vienna, 1918), III. Abt., Bd. I, 100.

2. London, 1954.

3. *Cahiers des Annales* (Paris, 1949).

4. *History: Its Purpose and Method* (London, 1950).

5. *The Times*, 23 March 1956. (Since these lines were written evening openings have been arranged by the British Museum.)

6. Julian S. Huxley and A. C. Haddon, *We Europeans* (London, 1935).
7. 'Het aesthetische Bestanddeel van geschiedkundige Voorstellingen' in *Verzamelde Werken* (Haarlem, 1949), VII, esp. pp. 24-5; and 'Nederland's Beschaving in de zeventiende Eeuw', *ibid.*, II, pp. 415-16.
8. *European Literature and the Latin Middle Ages* (New York, 1953), p. 15.
9. *The Voices of Silence* (London, 1954).
10. *Le Vite*, ed. Milanesi (Florence, 1878-85), VII, 657.
11. *loc. cit.*, VII, 686.
12. *op. cit.*, I, 243.
13. See my 'The Renaissance Idea of Artistic Progress and its Consequences' in *Actes du XVIIme Congrès International d'Histoire de l'Art, Amsterdam, 23-31 Juillet 1952* (The Hague, 1955), pp. 291-307.
14. *op. cit.*, II, 93.
15. *op. cit.*, II, 94.
16. E. Panofsky, 'The History of Art as a Humanistic Discipline' in *Meaning in the Visual Arts* (New York, 1955), pp. 1-25, esp. p. 9.
17. K. R. Popper, 'The Poverty of Historicism' (London, 1957).
18. 'Communication Theory and Human Behaviour' in *Studies in Communication*, with introduction by B. Ifor Evans (London, 1955), pp. 45-67.
19. Julius von Schlosser, ' "Stilgeschichte" und "Sprachgeschichte" der bildenden Kunst', *Sitzungsberichte der Bayrischen Akademie der Wissenschaften, Phil.-Hist. Abt.*, I (1935), 3-39; and O. Kurz, 'Julius von Schlosser; Personalità-Metodo-Lavoro' in *Critica d'Arte*, XI/XII (1955), 402-19.
20. *Language, An Introduction to the Study of Speech* (London, 1921), p. 232.
21. *Eskimokünstler* (Eisenach, 1953).
22. *op. cit.*, I, 241.
23. E. A. Burtt, *The Metaphysical Foundations of Modern Physical Science* (London, 1925), pp. 93f. But see also K. R. Popper, 'Three Views concerning Human Knowledge' in *Contemporary British Philosophy*, ed. H. D. Lewis (London, 1956), pp. 357-88. Now reprinted in *Conjectures and Refutations* (London, 1962).
24. *op. cit.*, and *The Open Society and its Enemies* (London, 1945).
25. *Stilfragen* (Vienna, 1893).
26. Julius von Schlosser, 'Die Wiener Schule der Kunstgeschichte' in *Mitteilungen des Österreichischen Instituts für Geschichtsforschung*, Ergänzungs-Band XIII, Heft 2 (1934), esp. pp. 186-90; Meyer Schapiro, 'Style' in *Anthropology Today*, ed. Kroeber (Chicago, 1953), esp. p. 302; and my chapter 'Kunstwissenschaft' in *Das Atlantisbuch der Kunst*, ed. M. Hürlimann (Zürich, 1952), esp. pp. 658-61.
27. J. Huizinga, 'Het Probleem der Renaissance', *ed. cit.*, IV, 231, and 'Renaissance en Realisme', *ibid.*, 276; W. K. Fergusson, *The Renaissance in Historical Thought* Cambridge, Mass. (1948).
28. *Renaissance in Italy; The Fine Arts* London, (1901), p. 23.
29. *Vorlesungen über die Philosophie der Geschichte*, ed. Gans (Berlin, 1840), p. 493.
30. 'Domenico Ghirlandajo in Santa Trinita' and 'Francesco Sassettis letztwillige Verfügung' in *Gesammelte Schriften* (Berlin, 1932), pp. 95-158.
31. 'Problemi di metodo nella interpretazione dei simboli Giudeo-Ellenistici' in *Athenaeum* n.s., XXXIV, fasc. III-IV (Pavia, 1956), 239-48.
32. *Architectural Principles in the Age of Humanism*. Studies of the Warburg Institute, XIX (London. 1949).
33. Meyer Schapiro, *op. cit.*, p. 311; E. Kris, *Psychoanalytic Explorations in Art* (New York, 1952), p. 21.
34. (See now *Art and Illusion*, New York and London, 1960.)

IMAGERY AND ART IN THE ROMANTIC PERIOD

1. B.M. No. 9962.
2. Cf. T. S. R. Boase: 2. 'Illustrations of Shakespeare's Plays in the Seventeenth and Eighteenth Centuries', *Journal of the Warburg and Courtauld Institutes*, X (1947); for Fuseli's version of the subject see Fig. 57.
3. John Piper: *British Romantic Artists*, London (1942), p. 13.
4. B.M. Nos. 9971, 10,059, 10,366.
5. Piper: *op. cit.*, p. 26.
6. A recent book on the subject is J. V. Kuyk: *Oude politieke Spotprenten*, The Hague (1940).
7. I have collected some examples in footnotes to F. Saxl: 'A Spiritual Encyclopedia of the Later Middle Ages', *Journal of the Warburg and Courtauld Institutes*, V (1942), pp. 100 and 128.

8. Cf. K. Fraenger: *Der Bauernbreugel und das deutsche Sprichwort*, Leipzig (1923); the whole genre of proverb illustrations is exhaustively treated in L. Lebeer: 'De Blauwe Huyck', *Gentsche Bijdragen tot de Kunstgeschiedenis*, VI (1939–40). For the psychological aspect of this type of 'literal' illustration, cf. E. Kris: 'Zur Psychologie der Karikatur', *Imago* (1934), republished in *Psycho-analytic Explorations in Art*. New York, 1952. I am greatly indebted to Dr Kris and his approach to a field of research in which we collaborated for many years.

9. The example is from Hogarth's *Evening* (The four Times of the Day).

10. For the Neo-Platonic elements in this approach to the visual image, cf. my article 'Icones Symbolicæ', *Journal of the Warburg and Courtauld Institutes*, XI (1948). The problem of justification is an aspect of this question which I have not treated there.

11. Cf. for instance, B.M. 167, 198, 315, 1047.

12. It is characteristic that Mrs George had to introduce the catchword ghosts and apparitions into her index of selected subjects in Vol. VII (1793–1800) (eighteen entries) and VIII (1801–10) (twenty-three entries).

13. The fact that one of the most brilliant exponents of humorous absurdity, James Thurber, likes to make fun of Dali and the psycho-analysts does not refute, but confirms, the common background. In the same way Gillray's caricature of Monk Lewis and his 'tales of wonder' (B.M. No. 9932) only emphasises the atmosphere that is common to both.

14. B.M. No. 9861.

15. B.M. No. 10,190.

16. Cf. R. Todd: *op. cit.*, pp. 29 ff. The similarity of Blake's views with the neo-platonic tenets on visual symbols as analysed in my article quoted above, is striking.

17. London (1944) pp. 16–20.

18. Cf. José López-Rey: 'Goya and the world around him', *Gazette des Beaux-Arts*, 1945, II. p. 129, where the motif of the Sleep of Reason is traced back to Addison and further instances of Goya's relation to the champions of Enlightenment are discussed.

19. B.M. Nos. 9992, 10,062, 10,063, 10, 095, cf. also Mrs George's introduction, Vol. VIII, pp. xxi and xxxix.

20. The Victoria and Albert Museum possesses diplomas of the Patriotic Society for the years 1803 and 1805 with cartouches drawn by Porter.

21. W. T. Whitley: *Art in England, 1800-20*, Cambridge (1928), p. 93.

22. Porter's sketchbook of the campaign in Portugal and Spain in the British Museum is an interesting document. The fullest biography of Porter is still the one in the D.N.B.

23. Enrique Lafuente Ferrari: *Goya, El Dos de Mayo y los Fusilamientos*, Barcelona (1946), pp. 19 f.

24. Cf. *B.M. Catalogue, loc. cit.* s.v. Spain and Nos. 11,058–11,061. For Goya's interest in English imagery cf. also J. López-Rey, *op. cit.*

25. E. Lafuente Ferrari: *loc. cit.* pp. 1 ff. and F. D. Klingender: *Goya in the Democratic Tradition*, London (1948), pp. 150 f.

26. For important parallels in the fields of science cf. K. R. Popper: 'Towards a Rational Theory of Tradition', *The Rationalist Annual*, (1949). Now reprinted in *Conjectures and Refutations*, London (1963).

THE CARTOONISTS' ARMOURY

1. Roger Butterfield. *The American Past*, a history of the United States from Concord to Hiroshima. New York, 1947.

2. Stefan Lorent, *The Presidency*. New York, 1951.

3. The problems of the emergence of caricature are discussed in a joint paper by Ernst Kris and myself in E. Kris, *Psycho-analytic Explorations into Art*. London, 1952.

4. M. Dorothy George, *English Political Caricature*, Oxford, 1959.

THE VOGUE OF ABSTRACT ART

1. Walter Pach, *Ananias or the False Artist*. New York and London, 1928.

2. Contemporary French Painting, London, 1868, p. 37.

3. London, 1896, pp. 245–6.

ILLUSION AND VISUAL DEADLOCK

1. B. W. F. van Riemsdijk 'Een schilderstuk van Johannes Torrentius'. *Feest-Bundel, Dr. Abraham Bredius aangeboden, Amsterdam,* 1915.

2. *The Graphic Work of M. C. Escher* (Oldbourne Press). London, 1960.

3. L. S. Penrose and R. Penrose, 'Impossible Objects: a special type of visual illusion'. *British Journal of Psychology.* Vol. 49, part I. February, 1958.

4. J. J. Gibson, *The Perception of the Visual World,* Cambridge (Mass.), 1950, pp. 155 f.

5. J. J. Gibson, loc. cit. For other references see my *Art and Illusion*, New York and London, 1960.

6. François Bucher, *J. Albers: Despite Straight Lines*, Yale University Press, London and New Haven, 1961.

1. ISRAEL VAN MECKENEM (died 1503): *Children playing*. Engraving

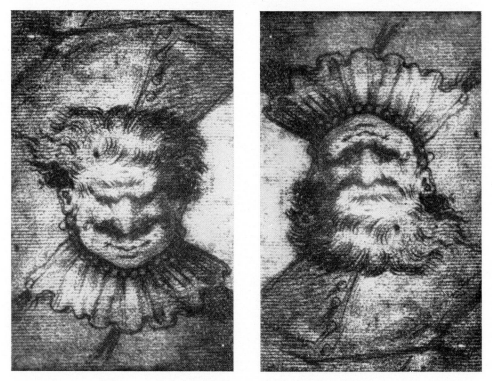

2. G. M. MITELLI (1634–1718): *Reversible face*. Drawing. Bologna, Biblioteca dell'Archiginnasio

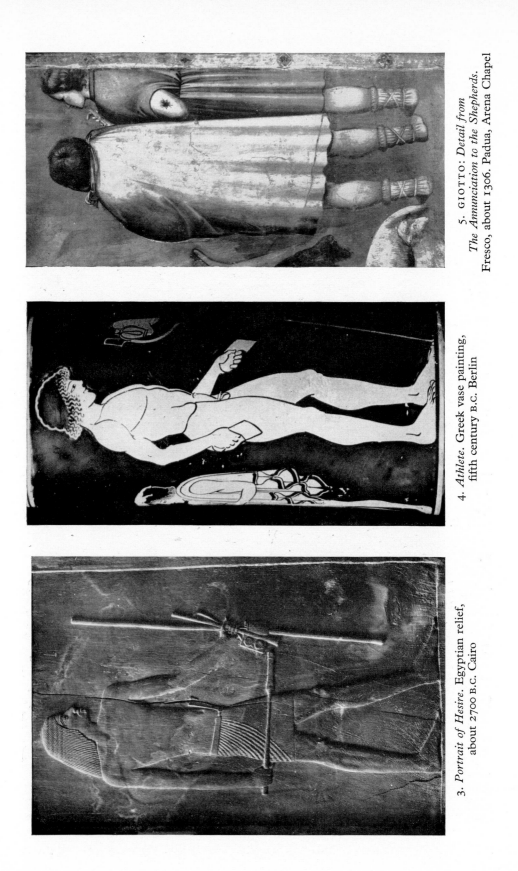

5. GIOTTO: *Detail from*
The Annunciation to the Shepherds.
Fresco, about 1306. Padua, Arena Chapel

4. *Athlete.* Greek vase painting,
fifth century B.C. Berlin

3. *Portrait of Hesire.* Egyptian relief,
about 2700 B.C. Cairo

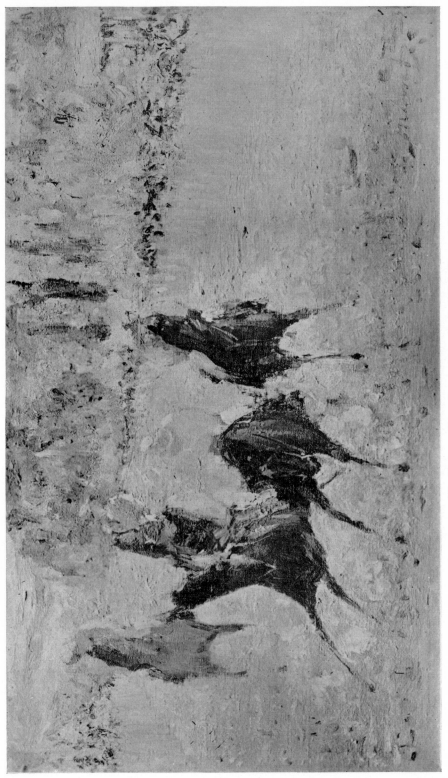

6. MANET: *The Races at Longchamp.* 1872. Paris, MM. Durand-Ruel

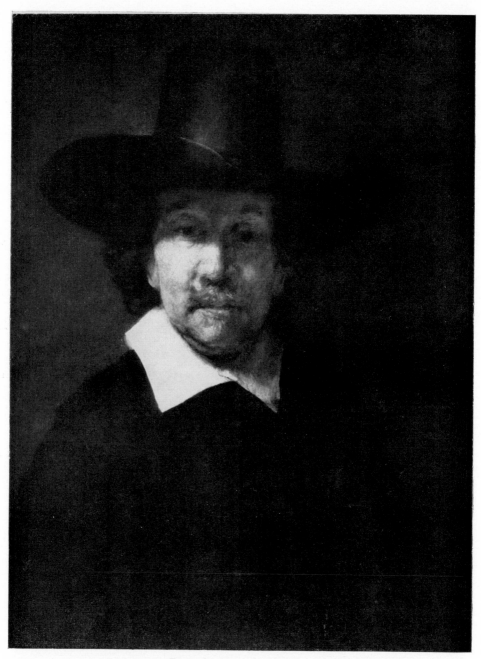

7. REMBRANDT: *Portrait of a man.* 1666. Leningrad, Hermitage

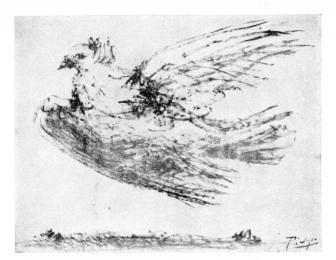

8. PICASSO: *The Peace Dove.* Lithograph, 1950

9. PICASSO: *Les Demoiselles d'Avignon.* 1907. New York, Museum of Modern Art

10–11. *Adam and Eve*. Detail. 1230–1240. Bamberg, Cathedral

12. BOTTICELLI: *The Birth of Venus*. Detail.
About 1485. Florence, Uffizi

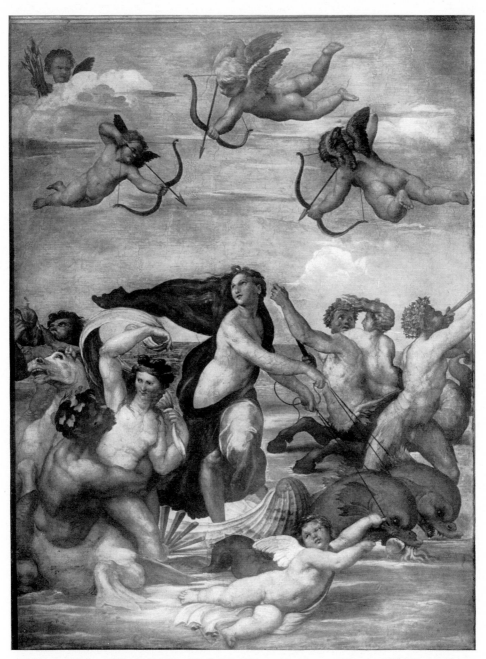

13. RAPHAEL: *The Triumph of Galatea*. Fresco, about 1514. Rome, Villa Farnesina

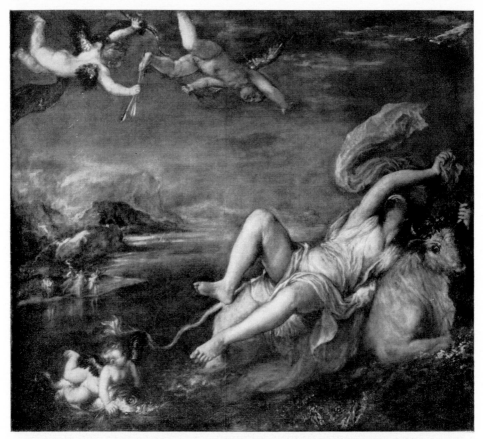

14. TITIAN: *The Rape of Europa.* 1561. Boston, Isabella Stewart Gardner Museum

15. Detail from Fig. 14

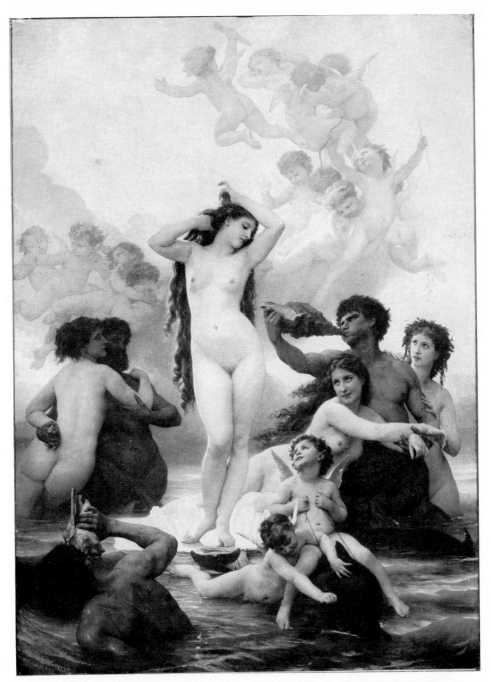

16. A. W. BOUGUEREAU: *The Birth of Venus.* 1879. Paris, Musée du Luxembourg

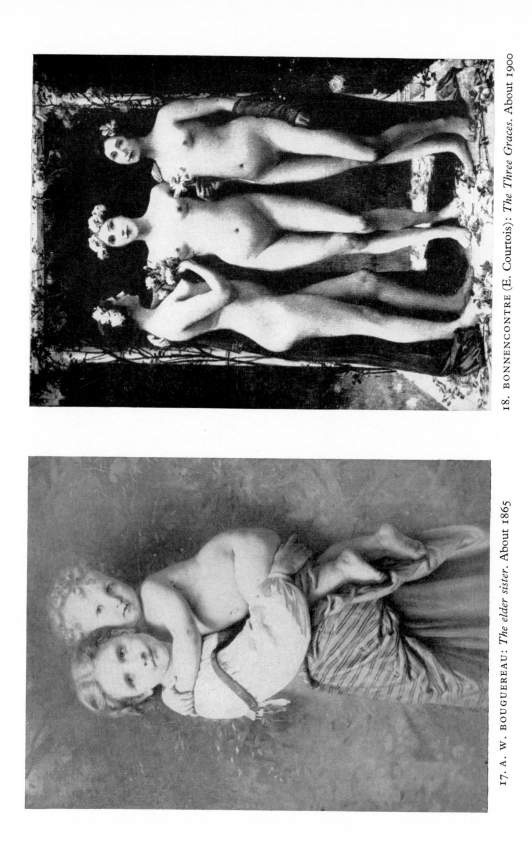

18. BONNENCONTRE (E. Courtois): *The Three Graces*. About 1900

17. A. W. BOUGUEREAU: *The elder sister*. About 1865

19–20. BONNENCONTRE: *The Three Graces* (seen through rolled glass)

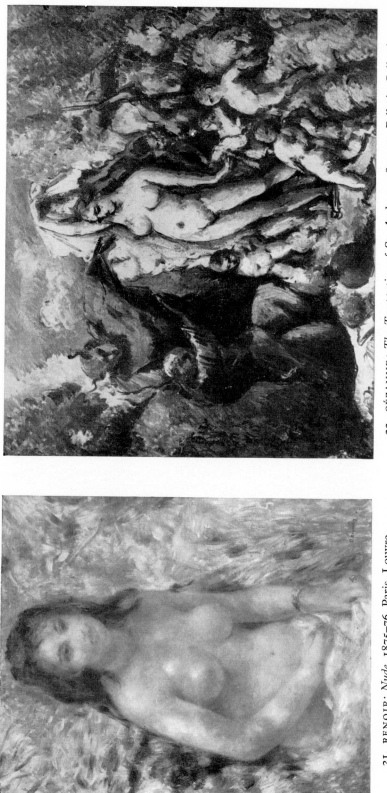

22. CÉZANNE: *The Temptation of St. Anthony.* 1873–77. Pellerin Collection

21. RENOIR: *Nude.* 1875–76. Paris, Louvre

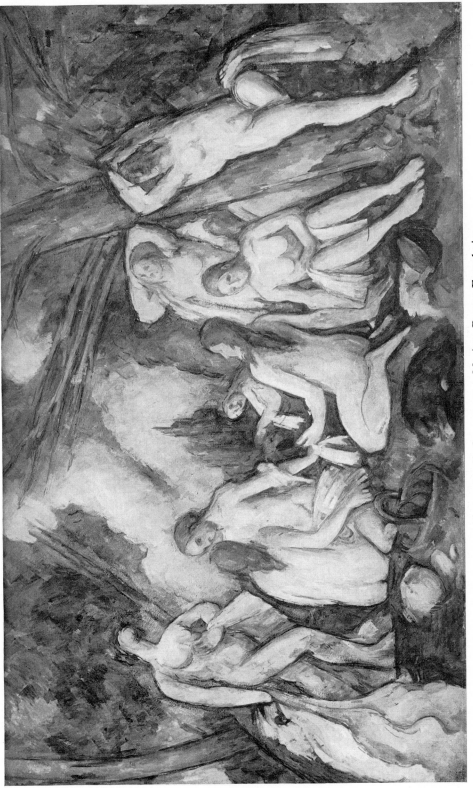

23. CÉZANNE: *Bathers*. 1900–5. Merion, Barnes Foundation

24. HERMANN KAULBACH (1846–1909):
Before the catastrophe

25. PICASSO: *Mother and Child*. Drawing,
1904. Cambridge, Mass., Fogg Art Museum,
Meta and Paul J. Sachs Collection

26–27. PICASSO: *Two drawings for Les Demoiselles d'Avignon*. 1906–7

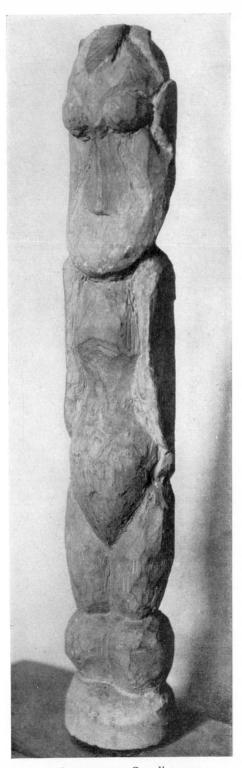

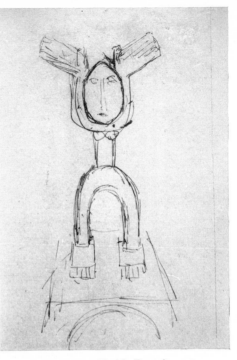

29. PICASSO: *Fetish*. Drawing. 1907

28. PICASSO: *Standing man*.
Painted wood, 1907

30. PICASSO: *Still life*. 1913

31. PICASSO: *Guitar.*
Buff, blue and black papers. 1912

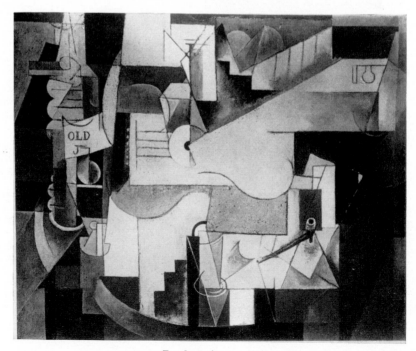

32. PICASSO: *Bottle, guitar and pipe.* 1912–13

33. KLEE: *Bustling harbour.* Drawing, 1927. Berne, Klee Foundation

34. KANDINSKY: '*At Rest*' (Ruhe). 1928. New York, Solomon R. Guggenheim Museum

36. *St. Matthew.* From a Gospel manuscript, about 830.
Épernay, Municipal Library

35. *St. Matthew.* From a Gospel manuscript, about 800.
Vienna, Schatzkammer

37. *The Dance of Salome*. Bronze relief from the door of S. Zeno, Verona,
late eleventh century

38. GIACOMO MANZÙ: *Chair with fruit*. Bronze, 1960

39. TADDEO GADDI: *Cruet and flasks.*
Fresco, about 1332–8. Florence,
S. Croce, Baroncelli Chapel

40. JACOPO DE' BARBARI: *Partridges.* 1504.
Munich, Alte Pinakothek

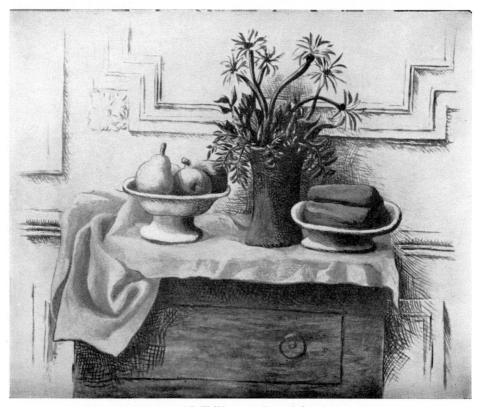

41. PICASSO: *Still life on a chest of drawers.* 1919

42. After an ancient Roman painting in Naples

43. GIUSEPPE MARIA CRESPI: *Shelves in a library*. 1710–15. Bologna, Conservatorio di musica G. B. Martini

44. PINTORICCHIO: *The Annunciation*. Fresco, 1501. Spello, S. Maria Maggiore

45. PINTORICCHIO: *Self-portrait*. Detail from Fig. 44

46. PERUGINO: *Self-portrait*. Fresco, about 1500.
Perugia, Palazzo del Cambio

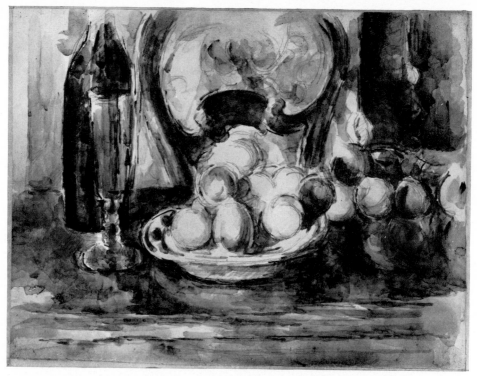

47. CÉZANNE: *Apples, bottle, and chair*. Watercolour, about 1905.
London, Courtauld Institute Galleries

48. GOYA (1746–1828): *Slices of salmon*. Winterthur, Dr. Oskar Reinhart Collection

49. DELACROIX: *Still life with lobsters.* 1826. Paris, Louvre

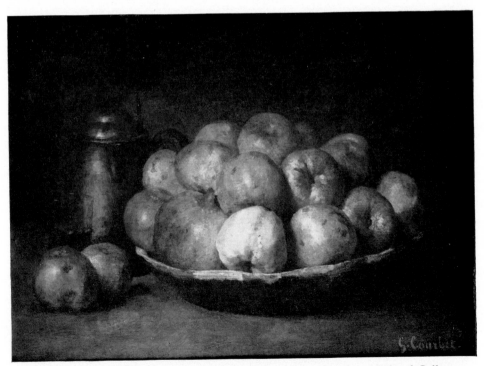

50. COURBET: *Still life—apples and pomegranate.* 1871. London, National Gallery

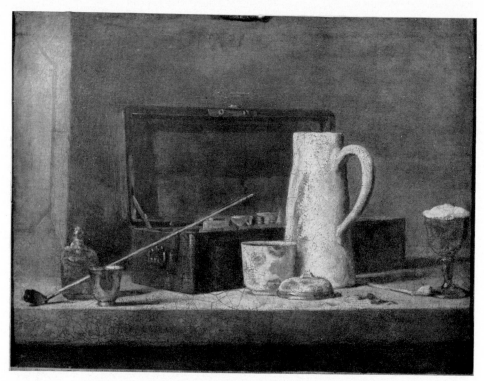

51. CHARDIN (1699–1779): *The Pipe*. Paris, Louvre

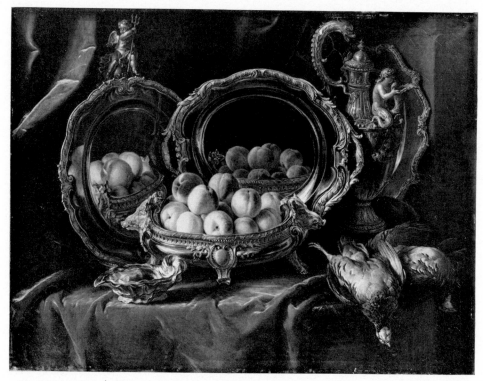

52. DESPORTES (1661–1743): *Peaches and silver platters*. Stockholm, National Museum

53. GILLRAY: *A Phantasmagoria.* Etching, 5 January 1803

54. G. M. WOODWARD: *John Bull taking leave of Income Tax*. Etching, 1802

55. C. WILLIAMS: *A Naked Truth or Nipping Frost*. Etching, 1803

56. R. K. PORTER: *Buonaparte at Jaffa ordering 580 of his
soldiers to be poisoned*. Etching, 1803

57. FUSELI (1741–1825): *Macbeth and the armed head*. Pen and wash drawing.
London, British Museum

BUONAPARTE

Massacring Three Thousand Eight Hundred Men at

JAFFA.

58. R. K. PORTER: *Buonaparte massacring 3800 men at Jaffa.* Etching, 1803

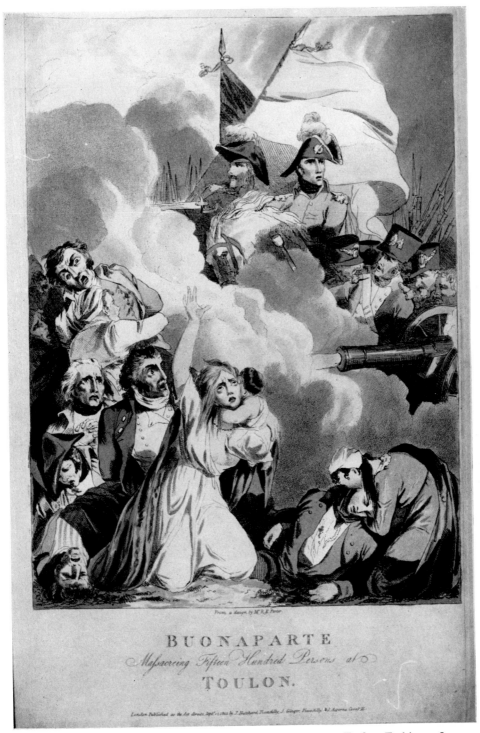

From a design by Mr R.K. Porter.

BUONAPARTE
Massacreing Fifteen Hundred Persons at
TOULON.

London Published as the Act directs, Sept.r 1.1803 by J. Hatchard, Piccadilly, J. Ginger, Piccadilly, & J. Asperne Cornhill.

59. R. K. PORTER: *Buonaparte massacring 1500 persons at Toulon*. Etching, 1803

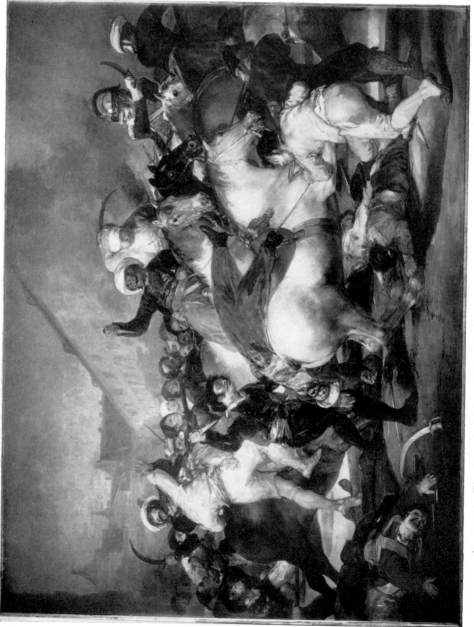

60. GOYA: *The Second of May 1808—The Revolt against the French. 1814.* Madrid, Prado

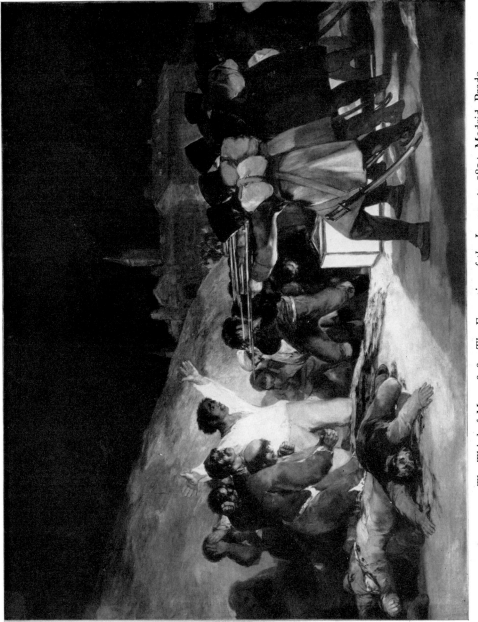

61. GOYA: *The Third of May 1808—The Execution of the Insurgents.* 1814. Madrid, Prado

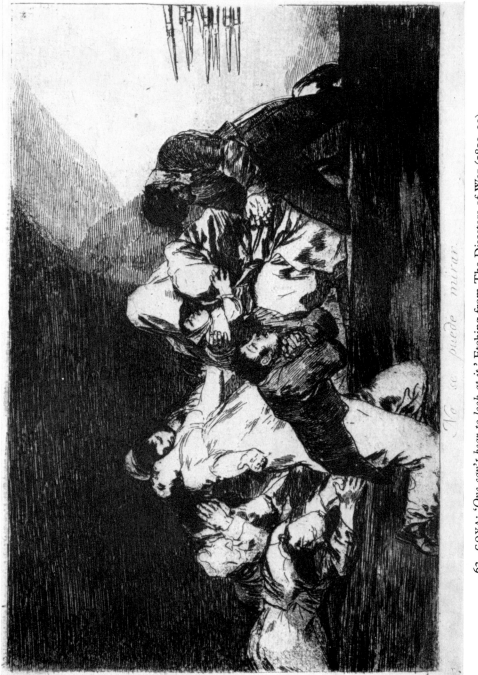

62. GOYA: 'One can't bear to look at it.' Etching from The Disasters of War (1810–20)

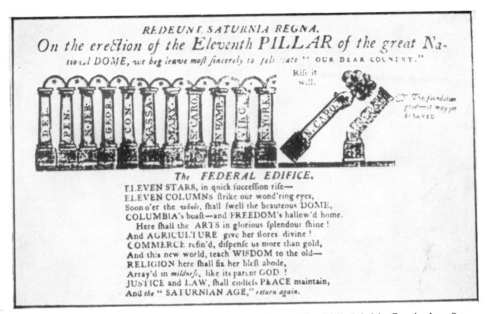

63. *The Eleventh Pillar of the National Dome.* From The Philadelphia Centinel, 1787

64. T. COLLEY: *The Reconciliation of
Britannia and her daughter America.* 1782

65. *The Women's vote.* From Life,
28 October 1920

67. *Gallia and Belgia clasping hands.* After a medal of Louis XIV

68. *Judea capta.* Roman coin of Vespasian after the conquest of Jerusalem, A.D. 72

69. Liberty. Coin of Nerva, A.D. 97

66. *The Treaty between Athens and Samos.* Greek relief, fourth century B.C. Athens, Acropolis Museum

EQUILIBRE EUROPEEN

Renouvelé des Japonais.

71. DAUMIER: *The Balance of Europe.* From Charivari, 30 December 1867

Équilibre Européen.

70. DAUMIER: *The Balance of Europe.* From Charivari, 3 April 1867

Peace Today

Das Veto der Bombe

72. RUBE GOLDBERG: *Peace Today.*
From the New York Sun, 22 July 1947

73. H. M. BROCKMANN: *The Veto of the Bomb.*
From Simplicissimus, 19 May 1956

74. ABU: *Arms Race.* From the Observer, 11 March 1962

THE OLD MAN OF THE SEA

SINBAD THE KAISER: "This submarine business is going to get me into trouble with America; but what can an All-Powerful do with a thing like this on his back?"

76. RAVEN HILL: *The Old Man of the Sea.*
From Punch, 1915

DROPPING THE PILOT.

75. TENNIEL: *Dropping the Pilot.* From Punch,
29 March 1890

77. DAUMIER: *Thiers as prompter*. From Charivari, 7 February 1870

78. *The horse America throwing off his master*. 1 August 1779. British Museum

79. DAUMIER: *The Disarmament Bureau.* From Charivari, 14 May 1868

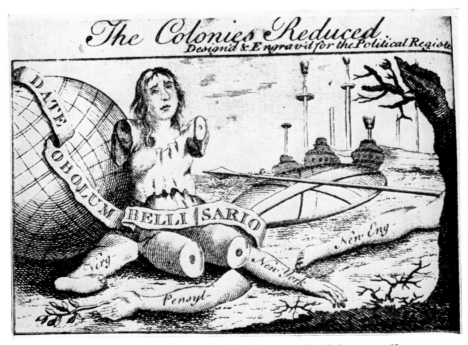

80. BENJAMIN FRANKLIN: *The Colonies reduced.* August 1768

81. M. GHEERARDTS I: *William of Orange as St. George.* 1577. Amsterdam, Print Room

82. *Sheet of caricatures*, Bologna, about 1630. Munich, Graphische Sammlung

83. *The debtor hanging by his feet*. German, 1438

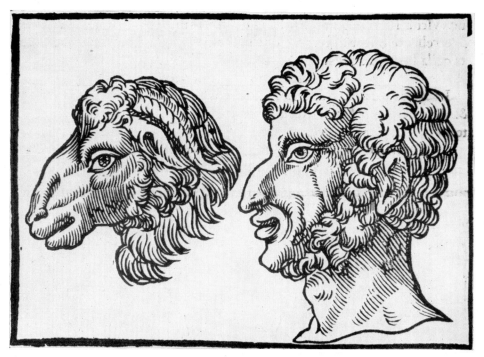

84. G. B. DELLA PORTA: *Physiognomic comparison.* From 'De humana Physiognomia', 1586

85. PIERLEONE GHEZZI: *Caricature.*
About 1700. British Museum

86. GEORGE, THIRD MARQUESS OF
TOWNSHEND: *Portrait caricature of
Lord Holdernesse.* 1756

87. THOMAS PATCH: *A musical party.* 1774. Floors Castle, Kelso, Coll. His Grace
the Duke of Roxburghe

88–89. GEORGE, THIRD MARQUESS OF TOWNSHEND:
The Duke of Newcastle, The Duke of Cumberland. 1756

91. NOLLEKENS (1737–1823): *Bust of Charles James Fox.*
Coll. The Earl of Ilchester

90. GILLRAY: *Charles James Fox.* 22 July 1782.
British Museum

92. GILLRAY: *Fox as sansculotte.* 3 March 1793

93. GILLRAY: *William Pitt as excrescence.* 20 December 1791. British Museum

94. GILLRAY: *The Plumb-Pudding in Danger.* 26 February 1805. British Museum

95. *The Netherlandish lion asleep.* 1567. Amsterdam, Print Room

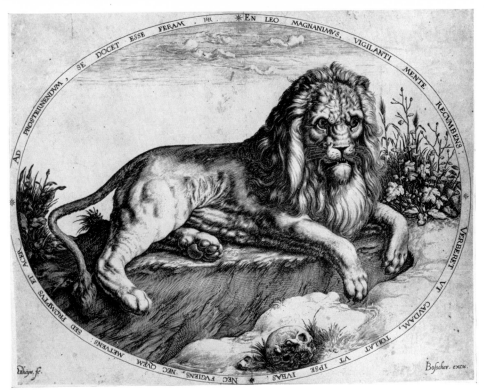

96. JACOB GHEYN II (1565–1629): *The Belgian lion*

97. GOYA: *The carnivorous vulture*. Etching from The Disasters of War (1810–20)

98. NAST: *Caught in a trap.* From Harper's Weekly, 1874

99. DORMAN SMITH: *Riding for a fall.*
15 October 1948

100. REG MANNING: *Hats.*
14 December 1950

101. E. W. KEMBLE: *The latest arrival at the political zoo.* From Harper's Weekly, 16 November 1912

102. THEODORE ROOSEVELT. Photograph by Charles Duprez

103. FITZPATRICK: *Next!* From the St. Louis Post-Despatch, 5 July 1944

104. *Franklin D. Roosevelt.* Photograph

105. DAUMIER: *Le paquebot.* From Charivari,
2 December 1848

106. DAUMIER: *Subscriptions for the Cult.*
From Charivari, 26 February 1851

107. DAUMIER: *La Fontaine renewed.*
From Charivari, 10 October 1867

108. DAUMIER: *The eclipse of liberty.*
From Charivari, 17 March 1871

109. ANDREA POZZO: *Glorification of St. Ignatius of Loyala.* Ceiling fresco in the Church of
S. Ignazio, Rome, begun 1688

III. RAEMAKER: *France unmasking Germany. About 1915*

IIO. BOARDMAN ROBINSON: *Louvain—The Return of the Goth.*
From the New York Herald Tribune. 1914

Mörder Juda

Verbrechen ist dem Juden Religion / Sadismus, seines Blutes Tradition,
So ist er Vampyr – aller Menschheit Fluch / Er saugt ihr Blut und nie hat er genug

112. *The murderer Judah*. From the Stürmer
No. 14, 1937

Raffenschutz

Was Gott zusammengefügt, soll der Mensch nicht trennen,
Was er geschieden, nicht zusammenmanschen!

113. *Protection of the race*. From the Stürmer.
No. 25, 1938

Der rote Drache

Wie kommt die Welt denn so zum Frieden,
Läßt man das Ungeheuer wüten?

114. *The red dragon*. From the Stürmer.
No. 4, 1937

Der Schatten

Auf unsere sonst so schöne Welt der düstere Schatten Judas fällt
Die Menschheit, sie erholt sich nicht, solange Juda steht im Licht

115. *The shadow*. From the Stürmer.
No. 10, 1937

LA PRESSE

Un parricide.

116. DAUMIER: *Thiers as assassin.*
From Charivari, 16 April 1850

REPUBLIQUE FRANÇAISE

—Vous finirez par vous lasser de m'attaquer... pauvres petits myrmidons!...

117. DAUMIER: *The Republic and politicians.*
From Charivari, 19 November 1851

" YOU KNOW YOU CAN TRUST ME "

118. SIR DAVID LOW: '*You know you can trust me.*' From the Evening Standard,
20 December 1935

119. DAUMIER: *The Republic advances*. From Charivari, 29 November 1849

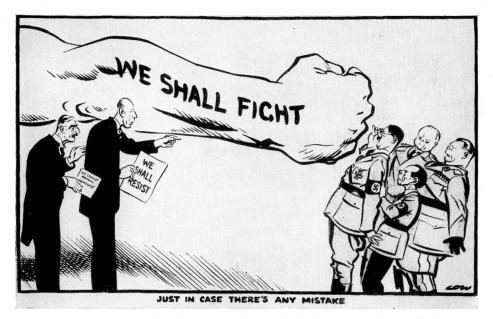

120. SIR DAVID LOW: *Just in case there's any mistake*. From the Evening Standard,
3 July 1939

121. GILLRAY: *George III and Napoleon.*
26 June 1803. British Museum

122. BILL MAULDIN: '*Fresh, spirited American troops . . .*' *1944*

123. SIR DAVID LOW: '*Little men, little men, must you be taught another lesson?*'
From the Evening Standard, 15 May 1933

125. TREBLA DRANSEB: *Abstract*

124. ALBERT BESNARD: *Meteorology*. Paris,
Hôtel de Ville. 1890–91

126. TORRENTIUS: *Still life—Allegory of Temperance.* 1614.
Amsterdam, Rijksmuseum

128. The Colonnade of the Uffizi, Florence

127. Illusionist stage: The Teatro Olimpico. Vicenza, completed in 1584

129. PICASSO: *Table, glasses, cups, mandolin.* 1911. London, Lady Hulton

130. Royalist print from the French Revolution. c. 1793

131. PAVEL TCHELITCHEW: *Tree into hand and foot*. Watercolour and ink, 1939.
New York, Museum of Modern Art

132. M. C. ESCHER: *Day and night*. Woodcut, 1938

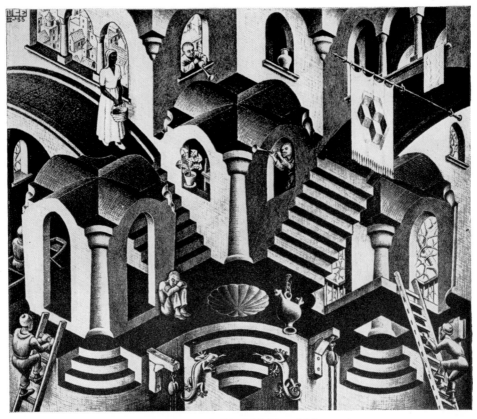

133. M. C. ESCHER: *Solid and hollow*. Lithograph, 1955

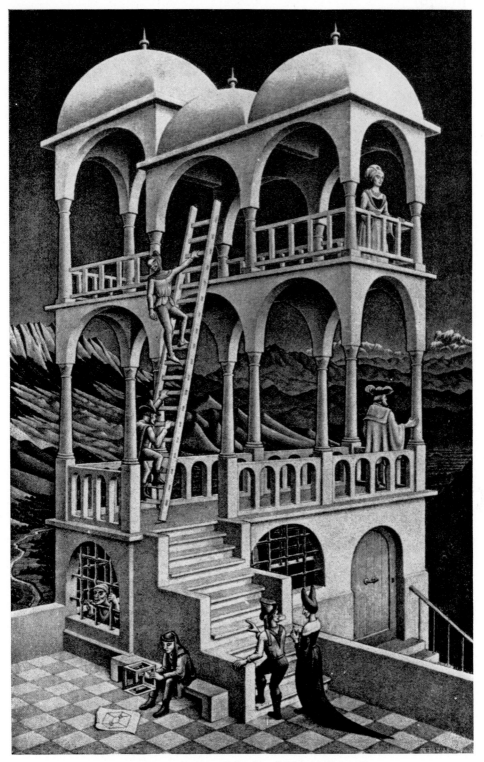

134. M. C. ESCHER: *Belvedere*. Lithograph, 1958

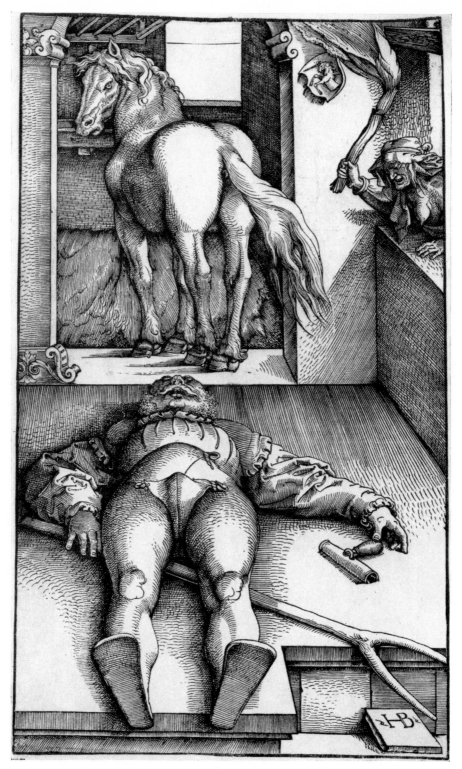

135. HANS BALDUNG GRIEN: *The bewitched stableboy*. Woodcut, 1544

BIBLIOGRAPHICAL NOTE
LIST OF ILLUSTRATIONS
INDEX

Bibliographical Note

Details of the previous publication of the essays and lectures in this volume are as follows:

MEDITATIONS ON A HOBBY HORSE or the Roots of Artistic Form. *Aspects of Form, a Symposium on Form in Nature and Art,* edited by Launcelot Law Whyte. London, Lund Humphries, 1951, and Midland Books, Indiana University Press, 1961.—Republished in *Aesthetics Today,* edited by M. Philipson, Meridian Books, Cleveland, 1961.

VISUAL METAPHORS OF VALUE IN ART. *Symbols and Values, an Initial Study. XIIIth Symposium of the Conference on Science, Philosophy, and Religion in Relation to the Democratic Way of Life* edited by Lyman Bryson, Louis Finkelstein, R. M. Maciver, Richard Mckeon, New York, 1954 (Distributed by Harper & Brothers, New York and London).

PSYCHO-ANALYSIS AND THE HISTORY OF ART. The Ernest Jones Lecture for 1953. *The International Journal of Psycho-Analysis,* XXXV, 4, 1954. Republished in *Freud and the Twentieth Century,* edited by Benjamin Nelson, Meridian Books, New York, 1957, and Allen and Unwin, London, 1958.

ON PHYSIOGNOMIC PERCEPTION. *The Visual Arts Today,* edited by Gyorgy Kepes, *Daedalus, Journal of the American Academy of Arts and Sciences,* Winter 1962 (Vol. 89, No. 1 of its Proceedings).—A further edition, Wesleyan University Press, Middletown, Conn., 1962.

COMMUNICATION AND EXPRESSION. A contribution, without the present title, to the symposium "Art and the Language of the Emotions", at the Joint Session of the Aristotelian Society and Mind Association. *Proceedings of the Aristotelian Society,* Supplementary Volume 36, London, 1962.

ACHIEVEMENT IN MEDIEVAL ART. A translation of "Wertprobleme und mittelalterliche Kunst", *Kritische Berichte zur kunstgeschichtlichen Literatur,* VI, 3–4, 1937.

ANDRÉ MALRAUX AND THE CRISIS OF EXPRESSIONISM. *The Burlington Magazine,* XCIV, December 1954.—A French translation of the first part under the title "Où en est le Malrauxisme ?" in *France Observateur,* 6 December 1962.

THE SOCIAL HISTORY OF ART. *The Art Bulletin,* XXXV, March 1953.

TRADITION AND EXPRESSION IN WESTERN STILL LIFE. *The Burlington Magazine,* CIII, May 1961.

ART AND SCHOLARSHIP. Inaugural Lecture as Durning Lawrence Professor at University College, London. H. K. Lewis, 1957.—Republished in *College Art Journal,* XVII, 4, Summer 1958.

IMAGERY AND ART IN THE ROMANTIC PERIOD. *The Burlington Magazine,* XCI, June 1949.

THE CARTOONIST'S ARMOURY. *South Atlantic Quarterly,* Spring 1963. A Benjamin N. Duke Lecture in the History of Art, sponsored by the Mary Duke Biddle Foundation and the Department of Art, Duke University, Durham, North Carolina, March 1962.

THE VOGUE OF ABSTRACT ART. Originally published as "The Tyranny of Abstract Art". *The Atlantic Monthly* (201), 1958. Copyright 1958, by The Atlantic Monthly Company. Boston 15, Massachusetts.

PERCEPTION AND VISUAL DEADLOCK. Originally published as "How to Read a Painting" in the series "Adventures of the Mind", *The Saturday Evening Post,* no. 234, 1961. Copyright 1961, The Curtist Publishing Company.

The original publishers are in each case thanked for their kind permission to reprint this material.

List of Illustrations

Grateful acknowledgement is made to the undermentioned for permission to reproduce the illustrations listed:
His Grace the Duke of Roxburghe (fig. 87); the Rt. Hon. The Earl of Ilchester (fig. 91); Giacomo Manzù (fig. 38); Reg Manning (fig. 100); Bill Mauldin (fig. 122); Rube Goldberg (fig. 72); Rijksmuseum, Amsterdam (fig. 126); Isabella Stewart Gardner Museum, Boston (fig. 14); Fogg Art Museum, Cambridge, Mass. (fig. 25); Klee Foundation, Berne (fig. 33); Courtauld Institute of Art, London (fig. 47); Museum of Modern Art, New York (figs. 9, 131); Solomon R. Guggenheim Museum, New York (fig. 34); National Museum, Stockholm (fig. 52); Dr. Oskar Reinhart, Winterthur (fig. 48); MM. Durand-Ruel, Paris (fig. 6); Villani, Bologna (fig. 43); Culver Pictures, Inc. (fig. 64); Berry Rockwell, New York (fig. 65); Newspaper Enterprise Assn. (fig. 99); Brown Brothers, New York (fig. 102); McNaught Syndicate Inc. (fig. 100); Associated Press Ltd., London (fig. 104); Evening Standard, London (figs. 118, 120, 123); New York Herald Tribune (fig. 110); The Observer, London (fig. 74); Punch, London (figs. 75, 76); Simplicissimus Verlag, Munich (fig. 73); © SPADEM, Paris, 1963 (figs. 8, 9, 21, 25-33, 41, 129); ADAGP, Paris (fig. 34); University of Illinois Press, Urbana, Ill. (diagrams on page 141).

INDEX